Fahrelnissa Zeid

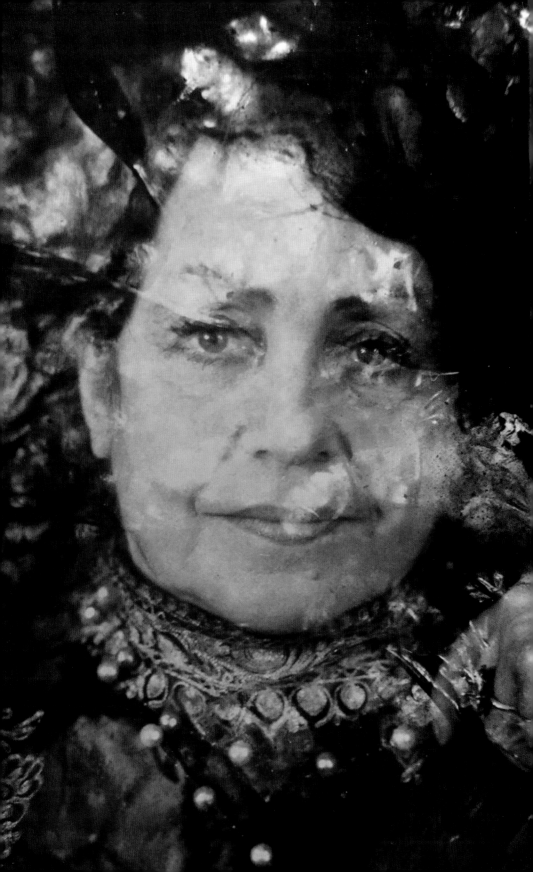

Adila Laïdi-Hanieh

Fahrelnissa Zeid

Painter of Inner Worlds

ART/BOOKS

On page 2: Emil Cadoo, *Fahrelnissa Zeid*, Paris, 1969

Author's note

There is a considerable uncertainty and confusion around the dates of some of Fahrelnissa Zeid's works, partly because her own retrospective dating was not always accurate. The dates given in this book are the author's judgment based on the evidence contained within the artist's diaries and the confirmed events in her life, exhibition catalogues, and reviews, as well as visual analysis of the paintings themselves.

First published in the United Kingdom in 2017 by Art Books Publishing Ltd

Copyright © 2017 Art Books Publishing Ltd
Text copyright © 2017 Adila Laïdi-Hanieh

Art Books Publishing Ltd
77 Oriel Road
London E9 5SG
Tel: +44 (0)20 8533 5835
info@artbookspublishing.co.uk
www.artbookspublishing.co.uk

British Library Cataloguing-in-Publication Data
A catalogue record for this book is available from the British Library

ISBN 978-1-908970-31-2

Designed by Art / Books
Printed and bound in Latvia by Livonia

Distributed outside North America by
Thames & Hudson
181a High Holborn
London WC1V 7QX
United Kingdom
Tel: +44 (0)20 7845 5000
Fax: +44 (0)20 7845 5055
sales@thameshudson.co.uk

Available in North America through
ARTBOOK | D.A.P.
155 Sixth Avenue, 2nd Floor,
New York, N.Y. 10013
www.artbook.com

CONTENTS

	Introduction: 'One is not enough for oneself'	6
I	Formative Years in Life and Art 1901–33	10
II	Dislocation and Wanderings 1934–40	42
III	Coming into Her Own 1941–6	56
IV	London, New York, and the Abstract Turn 1947–57	92
V	Fahrelnissa and the Nouvelle École de Paris 1949–57	138
VI	Personal Tragedy and its Aftermath 1958–61	194
VII	Enter Light, Sea, and Space 1962–9	212
VIII	Renew and Return 1970–4	238
IX	Fahrelnissa's Late Style 1975–91	256
	Chronology	274
	Notes to the text	278
	Acknowledgments	284
	Picture credits	287
	Index	288

INTRODUCTION

'One is not enough
for oneself'

Fahrelnissa Zeid was a painter of light and motion. Her baroque expressionist works, both abstract and figurative, demonstrate her command of the exalted gesture combined with the small fragment. She deployed colour, line, the sublime, and the infinitesimal in a five-decade-long career and oeuvre that I attempt to reconstruct and interrogate in this book.

In this revisionist biography, I investigate the notion, expressed in her lifetime and since, that Fahrelnissa's work constitutes a modernization of Islamic or Byzantine art. Many non-western artists have endeavoured to synthesize their cultures' visual practices with appropriations of western easel-painting styles; Fahrelnissa was not among them. However, coming of age decades before the epistemic shifts induced by Edward Said's theories of 'orientalism' and postcolonial critique, she may not have been sufficiently attentive to the constricting effects of the label 'oriental painter' that was used to describe her to deliberately refute it. In a rare rejoinder, she wrote in 1984 about her canvas *Octopus of Triton, Riviera* (p. 179) that it was, 'my only painting where one guesses my Byzantine side'.[1] Fahrelnissa painted whirling dervishes, quoted the thirteenth-century Sunni Muslim poet Rumi, and was stirred by her visit to the Iraqi holy city of Karbala. But she lived her life in a manner that she summarized as one wherein, 'the artist belongs neither to a country, nor to a religion. I was born on this earth. I am made of this matter, and everything that relates to it interests me.'[2]

Self-portrait (unfinished), date unknown, oil on canvas, 75 × 60 cm (detail)

7

Fahrelnissa is known today mainly for her vast chromoluminarist abstract compositions and for her haunting portraits. In fact, her career spans so many stylistic changes and explorations of different media that they may be the output of a number of artists, rather than only one whose career began late and whose life was beset by numerous turmoils. Her single-mindedness allowed her to develop a consistently innovative output and to overcome her shifting mental state. Her hypomania allowed her to work rapidly and create monumental works. It also afforded her an awareness of sensations and cognitive realms outside the prosaic perceptual frame of the everyday and the here and now. She described it as feeling the vibrations of the universe, as transposing in her paintings cosmic forces that traverse our world. This awareness led her to identify with the writings of Carl Jung and Wassily Kandinsky, among others.

By upbringing and inclination, Fahrelnissa was an intellectual product of late-nineteenth-century European 'high culture' who revered Old Masters, had a passion for Romantic and Neo-Romantic music, and absorbed the French literary canon. Her time in late 1920s Montparnasse broke that spell, however, as she embraced Fauvist and Expressionist approaches to painting and began to explore her century's modernism. At two stages of her career – in Istanbul in the first half of the 1940s and in 1950s Paris – she was an important member of a group of avant-garde critics and artists who strove to forge a contemporary visual expression that reflected their age and place: the D Group and the Nouvelle École de Paris. Yet her output stands the test of time, for no work from any given decade may be easily dated or attributed to that period's trends. She managed to produce a modern and atemporal corpus because her approach to art was a spiritual exploration expressed through light and colour. This investigation reached its apogee in the late 1960s with her unique work in polyester resin, creating slabs of colour, light, and bone for which she invented the name 'paléokrystalos'.

Fahrelnissa lived her life on a Dionysian scale, with her prolific work, omnivorous cultural consumption, and an athlete's love of swimming. She was also hit with violent personal tragedies and was beset with alternating

psychological moods. And yet she thrived, probably because she preserved a light-hearted sense of whimsy alongside a lifelong wonder and curiosity. This sense allowed her to divine unseen worlds and characters in the smallest objects, in the abstract ridges of beach pebbles and desert rocks that she would paint and exhibit as '*pierres ravivées*' (revived stones).

Between her perception of unseen cosmic realms and their transposition onto the canvas, there was always a recognizable Fahrelnissa gesture at work. Her paintings are characterized by a high painterliness, but she was also a painter of linearity. A recurring gesture is identifiable in the portraits that she drew in her sketchbooks, in the figurative interiors and outdoor scenes from the 1940s, in her expansive abstract canvases, and even in her later painted portraits. That gesture is at the origin of the lines that traverse Fahrelnissa's compositions: sharp, rapid, thrusting lines that turn and then return, crisscross, and swarm the pictorial plane. In the interstices of the lines are ellipses of light that create depth in the folds of an *abaya*, between the spindly branches of a tree, and in the curve of a cheekbone. In her highly saturated coloured works, the rapid line is present in a multiplicity of divisionist tangles, vortexes, and bursts. Colour fills their recesses when it is not superimposed onto them. In her late portraits, where she painted large visages with colour-field minimalism, she did not abandon that gesture but handled the palette knife to repeatedly incise the thickly impastoed colour with a weft of furrows.

What drove Fahrelnissa to paint like this for almost five decades, and then to teach painting for a decade in her old age? Perhaps because art was for her a way out of her selfhood, born from an 'overabundance' that 'starts where living does not suffice to express life'.[3] She said before leaving Paris for Jordan in 1975 that one does not paint to 'make *art*' because 'there is no art, no works of art. There is the joy of living, the joy of creating, because one is not enough to oneself.'[4]

Algiers
May 2017

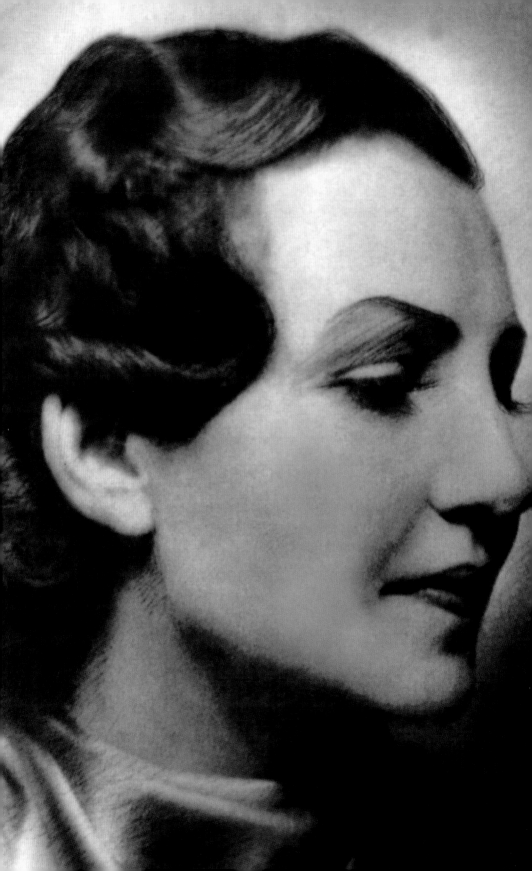

I

Formative Years in Life and Art

1901–33

'Fahrelnissa' is a rare name. Mysterious-sounding and difficult to pronounce for non-Turkish and non-Arabic speakers, it induces astonishment among those who hear it and understand its meaning: 'the glory of women', 'the pride of womanhood', 'the honour of womankind'. While all her siblings bore familiar and unremarkable Turkish forenames, the extraordinary name given to Fahrelnissa seemed only to fate her for great things. Although compound personal names of this kind are common in Muslim societies, they are more popular for boys and increasingly archaic for girls. Nonetheless, Fahrelnissa always carried hers with pride, preferring it to the diminutive 'Nissa'. She did, however, adopt different spellings throughout her life. Early on, she used transcriptions of its Turkish pronunciation, such as Fahrunnissa or Fahrinnisa.[1] One of the stories she was fond of telling was that her name was associated with the invention of the modern Turkish alphabet itself. Five years after the establishment of the Turkish Republic under its founder and first president Mustafa Kemal Atatürk in 1923, the Arabic script with which Ottoman Turkish had been written for centuries was replaced with a modified Latin alphabet. In August 1928, Fahrelnissa was present at a session of the Language Commission that Atatürk had set up to undertake this task, sitting next to the charismatic leader himself. When the decision was taken to adopt the Germanic 'ü' for transcribing the Turkish vowel 'u' (approximate to the sound of 'e' in the English *new*), Atatürk reportedly wrote down the first

Fahrelnissa as a young woman, early 1930s

Turkish word with that letter: Fahrünissa.[2] She took away the card on which he had written her name, but later she chose to discard the umlaut and invented the hybrid Arabic-Turkish spelling Fahr-El-Nissa or Fahr El Nissa, which she then simplified into Fahrelnissa. This book refers to Fahrelnissa Zeid by her first name rather than her last to highlight her singular personality and talent.[3]

Born into an illustrious family

Fahrinnisa Shakir Kabaaghacli was born on 6 December 1901 on the island of Buyukada, about ten miles from Istanbul in the Sea of Marmara. She was the fifth of six children of a privileged upper-bourgeois family. The larger-than-life personalities of many of its members, their cultural pursuits, and their fairy-tale home inevitably moulded the characters and interests of young Fahrelnissa and her siblings. Their improbably colourful and chaotic lives and myriad achievements would later lead her daughter Shirin Devrim (1926–2011) to write the family history, published in 1994 under the title A Turkish Tapestry: The Shakirs of Istanbul. Fahrelnissa's grandfather Mustafa Asim came from central Anatolia, a member of the Kabaaghacli clan. For centuries, his ancestors had been scholars and teachers, having founded and run several madrasahs (theological schools) in the region, but Asim chose instead to pursue a military career. He eventually reached the rank of colonel, and was appointed to the military council advising the sultan and the grand vizier, the sultan's chief minister and head of government. While on duty in Damascus in the 1840s, he married the daughter of a prominent Syrian family of calligraphers, and the couple had a daughter, Sara, in 1849, followed by two sons: first Cevat in 1851 and then Shakir in 1855. The latter was born in the city of Bursa, in north-west Anatolia, the first capital of the Ottoman Empire, where Asim was stationed at the time. When both parents died within a few days of each other in 1863, the three children – then aged thirteen, eleven, and eight – were left orphaned and with no means of support. With much courage and determination, Sara took herself and her two younger siblings to Istanbul, where she sought and gained the protection of a powerful old friend of Asim's, who took the young-sters under his wing. The two boys soon followed in their father's footsteps and

(right) Fahrelnissa's
father Shakir Pasha
with her older sister
Ayshe (far right)
Fahrelnissa's mother
Ismet, on the left,
and her sister-in-law
Nimet, the wife of
Cevat Pasha

enrolled in military school, each graduating with honours. Cevat, in particular, rose rapidly up the ranks and went on to become acting military governor of Crete, before attaining the highest office in the land when the sultan appointed him grand vizier in 1891. Cevat Pasha, as he was now known (*pasha* being a title indicating high office or rank, similar to a British peerage or knighthood), was not just a soldier and a statesman, but also a respected man of letters. He spoke six languages, was editor of the Ottoman army magazine, published a military history of the Ottoman Empire, and owned some five thousand books, the largest private library in Turkey.[4]

Shakir, Fahrelnissa's father, had an illustrious career of his own. Known as Shakir Pasha, he, too, was a prominent military officer, diplomat, and published historian of the Ottomans, not to mention amateur photographer, ceramicist, and orchid gardener. As aide-de-camp to his brother in Crete in 1890, he spotted a fourteen-year-old local beauty at her school graduation ceremony, over which he was officiating, and promptly married her. Ismet Hanim gave him six children over the next thirteen years. She was a formidable yet benevolent matriarch, presiding over the family through changing fortunes and turbulent political times. She also ran an extensive household of numerous servants, which included a Sudanese eunuch. The family home on Buyukada

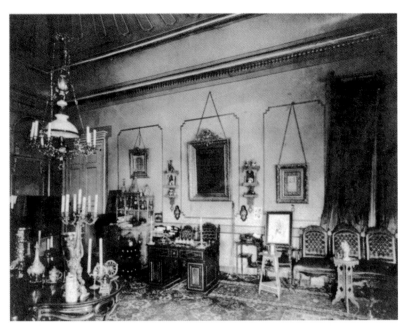

The living room of the family residence on Buyukada around the time of Fahrelnissa's birth

was a three-storey wooden building equipped with its own hammam and surrounded by a large garden. A ferry linked the island to the mainland. The house was decorated eclectically with a mix of artefacts, prefiguring the famed cluttered interiors of Fahrelnissa's later life in Istanbul, Paris, and Amman. The formal living room contained Cevat Pasha's inlaid mother-of-pearl furniture from Damascus, which Fahrelnissa would eventually inherit and transport to all her homes. The room featured heavy, bottle-green fringed velvet draperies. Most striking, its far wall was made into a grotto, with half-moon-shaped shelves filled with moss and earth from which grew geraniums and ferns; water trickled down it in a mini waterfall. The room also contained a piano and a skylight to enable the reading of sheet music; and there were numerous blue-and-white Chinese pots, a Ming vase, and six Japanese screens purported to be gifts of the Japanese emperor to Cevat Pasha.[5]

The family around Shakir Pasha (*at the back*). To his left is Cevat, Fahrelnissa's oldest brother; in front of Shakir is her half-brother Assim. Her sisters Hakiye and Ayshe and mother are in the middle; and Fahrelnissa (*on the left*), her brother Suat, and sister Aliye are at the front.

With sister Aliye and grandmother, c. 1910 With sister Aliye, c. 1910

Among the many misfortunes that Ismet had to endure, the most serious was early widowhood after her eldest son, named Cevat after his uncle, suddenly killed Shakir in 1914. The younger Cevat had studied at an American college in Istanbul before reading history at Oxford University. After shooting dead his father in uncertain circumstances and for reasons that remain unclear, he was found guilty of manslaughter and sentenced to fourteen years in prison. Following his early release after serving half of his sentence, he went on became a celebrated writer, known as 'the Fisherman of Halicarnassus', and a major figure in twentieth-century Turkish letters. In 1925, his political activism resulted in his being exiled to the then remote fishing village of Bodrum in the south-western Aegean region. He lived there until his death in 1973, publishing a large number of novels and collections of short stories. As an ethnographer and mythologist, he popularized the area as a major tourist destination through

his writings and 'blue tours' of the coast. Cevat's influence on Fahrelnissa was considerable, albeit largely indirect. She credited him throughout her life with encouraging her to draw as early as the age of four. She recounted how she would sit at his feet for hours when he was home from university and as he drew portraits in black ink of the various girls with whom he was infatuated. She said that she never forgot the sound of his quill's scratching the paper while he drew. Looking back, she said, 'I think I have been a painter since that time.'[6]

Of her four other siblings, Fahrelnissa's older sisters Hakiye (1893–1970) and Ayshe (1894–1978) both married military men who became generals and governors of the Ottoman state and fought in the Turkish War of Independence between 1919 and 1923. Her *bon vivant* older brother Suat (1899–1972) became a civil servant, a Second World War spy, a trade commissioner, and eventually a restaurateur in the coastal town of Side. Her younger sister Aliye (1903–74) became a celebrated painter and engraver in her own right, thanks in part to Fahrelnissa's encouragement and help.

An age of national change and conflict

The Turkey in which Fahrelnissa was born was a far cry from the sprawling multinational, multilingual, transcontinental expanse that the Ottoman Empire had once been. At the height of its power in the sixteenth century, its lands stretched from the southern tip of the Arabian Peninsula in the south to central Hungary in the north, and from the Persian Gulf westwards across the Middle East and north Africa as far as Algeria. But it had long stopped its expansion and had lost its north African territories, and many of its European ones, during the 1700s. In response to severe military defeats at the hands of the Habsburg and Russian empires in the late eighteenth and early nineteenth centuries, successive sultans promulgated a series of measures to streamline and modernize the Ottoman state by adopting European models that saw the creation of new institutions and infrastructure, as well as reforms in the constitution, the military, civil liberties, taxation, education, banking, commerce, and the administration of the state. The growing number of European legations established in Ottoman cities at this time was accompanied by the introduction

of western – and mainly French – education, which was soon favoured by the bourgeoisie for the schooling of their children.

The Ottoman Empire remained a multicultural dominion after these reforms, and the major cities of Turkey – especially Istanbul and Izmir – were home to large numbers of non-ethnic Turks, including Kurds, Greeks, Armenians, Arabs, and Levantines. The rise of the Young Turks political movement at the beginning of the twentieth century, however, and their access to power in 1908, led to the promotion of a specifically Turkish national identity, one that sought to emphasize Turkish language and culture in opposition to the multi-ethnic and religiously Islamic identity of the Ottoman state. Having sided with Germany and the other Central Powers, the Ottoman Empire saw its remaining Arab territories carved up into a variety of new states at the end of the First World War, and parts of the Anatolian peninsula itself were occupied by the Allies. But after the ensuing four-year War of Independence, the Allies were expelled, the sultanate was abolished, and the new Republic of Turkey was established under Atatürk. In the decades to come, he would accelerate the Turkish nationalist project by enacting a series of westernizing measures, such as the adoption of the Latin alphabet, substituting Turkish and European neologisms for words of Arabic and Persian origins, adopting western costume, curtailing Islamic institutions, and advancing women's rights. Fifteen years later, the German-Jewish literary historian Erich Auerbach, who lived in exile from Nazi Germany in Istanbul from 1935, would critically assess the new ideology of nationalist reinvention in his correspondence with his compatriot Walter Benjamin. He would describe it as a 'fanatically anti-traditional nationalism' that rejected 'all existing Mohammedan cultural heritage', while establishing 'a fantastic relation to a primal Turkish identity, technological modernization in the European sense'. To his mind, the result was a situation of 'nationalism in the extreme accompanied by the simultaneous destruction of the historical national character'.[7]

The Istanbul of Fahrelnissa's childhood and teenage years was no orientalist postcard from The Thousand and One Nights, therefore, but a modern urban milieu that embraced western mores and cultural habits from the

The teenage
Fahrelnissa, some time
in the mid-1910s

highbrow to the popular. Her own family was no exception. Fahrelnissa and her younger sister Aliye and nieces were educated at French schools; and even as they spoke mostly Turkish at home, their correspondence was conducted chiefly in French. Still, they evinced great pride in their Turkish identities, and like much of the Ottoman elites, they would rally behind the nascent Republic and adopt its ideology of associating Turkish identity with both modernization and westernization. Like many daughters of Istanbul's upper bourgeoisie, the Shakir girls learned how to draw, speak foreign languages, and play the piano, to best conform to the imported ideals of westernized modernity. What was remarkable, however, was that the immediate family produced not one, not two, but three individuals who became important female artists: not only Fahrelnissa and Aliye, but also their niece Fureya Koral (1910–97), the daughter of eldest sister Hakiye. Fureya specialized in modern ceramics, creating numerous objects and decorative panels inspired by nature,

Institut Notre Dame de Sion
Pangalti

Sebah Juaye
Iskender

(top) Fahrelnissa's first school, the Lycée Notre Dame de Sion in Istanbul; (middle) the school's inner court; (bottom) girls taking a drawing class at the school

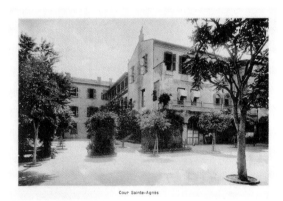

Cour Sainte-Agnès

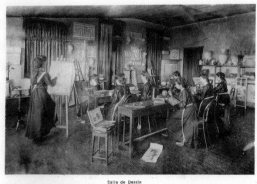

Salle de Dessin

Turkish mythologies and folklore, and Islamic art. She contributed to the establishment of ceramics as a modern art form in Turkey and was one of its first women practitioners. Fahrelnissa's own first two children also went on to pursue artistic careers. Her daughter Shirin studied at the Yale School of Drama at Yale University and worked as a stage actor and director in the United States and Turkey. She was also a tireless promoter of her mother's art. Fahrelnissa's eldest surviving son Nejad (1923–95) had a strained relationship with his mother and, ultimately, his sister too. The reasons for the estrangement are unknown, but appear to have been temperamental rather than artistic. Nejad studied fine arts in Istanbul but abandoned his studies in the mid-1940s to practise as an artist in Paris. Like Fahrelnissa, he participated in Nouvelle École de Paris group shows, often exhibiting alongside his mother. He was a deliberate student of Islamic art, Arabic calligraphy, and Byzantine mosaics patterns and colours, which he abstracted.[8] He was a prolific artist, but did not appear to have his mother's single-mindedness in promoting or developing his practice, which led him eventually to leave Paris for relative obscurity in Poland.[9] In 2006, Shirin assisted in the organization of a posthumous joint exhibition of her mother's and her brother's works at the Istanbul Modern, entitled 'Two Generations of the Rainbow'.

The young Fahrelnissa's education

Fahrelnissa was educated initially at the Lycée Notre Dame de Sion in Istanbul, a French convent school for girls founded in 1856. Shortly after Turkey entered the First World War in November 1914, the nuns abruptly closed the school. Fahrelnissa and Aliye then enrolled at the Pension Braggiotti, a highly expensive private college where she obtained her *brevet supérieur* or diploma. By this time, the family was short of funds, as a consequence of Shakir's death and Cevat's imprisonment, and the two girls had to attend school in patched-up clothing and old shoes. Fahrelnissa showed precocious initiative when she resorted to hand-painting postcards and sold them at a local shop to buy school and art supplies.[10] Her journal of the time shows the extensive French compositions she had to undertake, alongside history and geography lessons

written and copied in Ottoman Turkish. She illustrated each lesson with delicately hand-drawn watercolour maps whose carefully blended colours show a rare mastery at such a young age. This same technique is in full display in the 1915 watercolour she made of her grandmother, rendered in three-quarters, in a naturalistic style, showing the details of an aged face, uneven hair, and headscarf. The small portrait appears to be a careful study from life: the frail face of the sitter is particularly noticeable. Fahrelnissa may have developed this skill during the art instruction that she received at home at this time, after her mother had tired of punishing her for drawing on the walls of the house.[11]

Her diaries from 1915 also show the remarkable breadth of culture that the young 'Fahrunnissa Chakir' enjoyed. Like adolescents the world over, she wrote down all the books that she had read up to that date. Her list included classics by Honoré de Balzac, George Sand, Émile Zola, and Victor Hugo, along with middlebrow popular novels by Alexandre Dumas and Alphonse Daudet; old-fashioned fare by now-forgotten writers such as Octave Feuillet, Georges Ohnet, and André Theuriet; and sentimental tales aimed at a female readership by the pseudonymous women writers Henry Gréville (Alice Durand) and Henri Ardel (Berthe Abraham). It shows that Fahrelnissa's reading choices were not solely dictated by educational requirements, but that she also read for enjoyment, and that her tastes were thoroughly French.

After completing her schooling and passing her diploma some time around 1918, the headstrong and independent Fahrelnissa decided that she did not want to remain within the home like her elder sisters had done, as was still the norm in the conservative Ottoman society of the time. Rather, she convinced her mother to allow her to go out and study art. As part of the state's westernization in the nineteenth century, perspectival drawing began to be taught in the new technical and military schools, but there was no formal academy for the study of art. The first Turkish painters to use linear perspective and other European techniques, such as Osman Hamdi Bey, Suleyman Seyyid, and Halil Pasha, did so only after having studied in France and Italy. It was not until 1882 that Osman Hamdi established Turkey's first school of architecture and fine arts, the School of Fine Arts (Sanayi-i Nefise Mektebi) in Istanbul. A separate

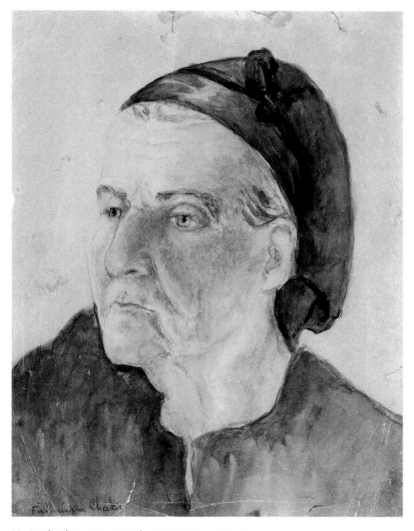

My Grandmother, 1915, watercolour on paper, 25 × 21 cm

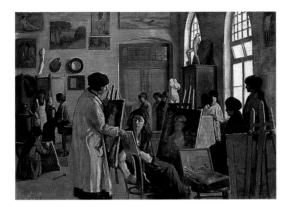

Ömer Adil, *The School of Fine Arts for Girls, Istanbul, 6 December 1919*, 1919–22

School of Fine Arts for Girls (Inas Sanayi-i Nefise Mektebi) was founded in 1914. The teaching at the latter followed the canons of classical *beaux-arts* education, with classes in drawing, perspective, and anatomy. Teachers came mainly from the men's academy, with a few female artists teaching and administering the school. Convincing her mother to study there was a difficult proposition for Fahrelnissa, not least because of the lengthy travelling it would entail. It required a daily ferry trip from Buyukada to Istanbul, which could take anything from two to five hours, followed by a long climb up a steep hill to the academy. However, the decision must have been made easier for Ismet by the knowledge that the school was gender-segregated, and also because it could be seen as an affirmation of the Shakirs' high social status, for only a small number of elite Ottoman women undertook training in the visual arts. Indeed, the most famous female artist of her generation and the first contemporary woman to study art was Mihri Müşfik (1886–1954), the daughter of a prince who was a leading anatomist and prominent instructor at the Military School of Medicine. She became director of the women's school when it opened, a position she held until 1919.[12] Under her direction, it became the first place in Turkey where a female nude model could be drawn; male nudes were drawn from draped statues. Students' instruction was restricted outside the school, in as much as a police officer had to accompany them when they were sketching outdoors.[13]

Fahrelnissa recounted that she learned drawing and perspective by copying models of Greek and Roman statuary, such as the Venus de Milo, the Diana of Versailles, and the Discobolus of Myron. She described having to reproduce them in chalk and enlarging them up to eight times on huge sheets of paper.[14]

By her own account, this was an ecstatic period of learning to which she characteristically gave her all: she would work long after the other students had left, and she stayed until the cleaners chased her out. She would continue drawing back home, and would cover her bedroom walls with her sketches.[15] Even so, she was to stay at the school for only a year, as the mores of polite Ottoman society meant that the issue of marriage soon came to the fore. Until this time, Fahrelnissa had worn the *charshaf*, the black robelike dress similar to the niqab used by Muslim women to cover the head and lower face, but

An eighteen-year-old Fahrelnissa wearing the *charshaf*, but without the veil, 1919

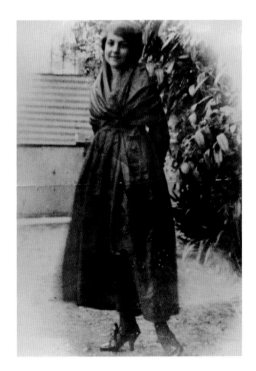

At age eighteen, 1919 On the Buyukade ferry, date unknown

she dispensed with its veil portion in 1919, six years before its abolition.[16] A beautiful young woman, she attracted the attention of female spies – known as *voyeuses* – acting as matchmakers on behalf of the families of unmarried men. Two of these *voyeuses* spotted her on the ferry one day, and she began to receive suitors. Still aged only eighteen, Fahrelnissa appeared to have already selected art as her path and destiny, and she did not cloister the different parts of her life, choosing instead not to separate her interest in art from her social identity as an eligible young woman. This strategy actually helped her when it came to assessing potential husbands. She reportedly turned down one suitor because he blushed at her sketches of nudes. She complained to her mother how 'naive' and 'bourgeois' he had been, and that she preferred to marry 'a real man' who appreciated art and had culture and intellect.

That man turned out to be Izzet Melih Devrim (1887–1966), the Francophile president of the Imperial Ottoman Tobacco Monopoly. As well as being a successful businessman, he was also a published writer, and is now

At the ball of the
School of Fine Arts,
Istanbul, 1921

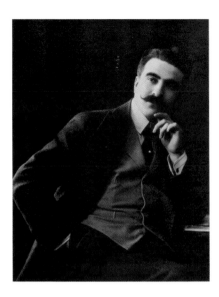

Izzet Melih Devrim,
Fahrelnissa's first
husband, early 1920s

mainly remembered as an important poet, novelist, translator, journalist, and scholar. He was part of the early twentieth-century Turkish literary movement Fecr-i Ati (Dawn of the Future), which was influenced by French literature and advocated art for art's sake. When Fahrelnissa heard that he intended to come and meet her, she was thrilled at the prospect as she had read and admired several of his books. He won her over in person with his smart appearance and by complimenting her sketches and promising to take her to visit museums in Europe.[17]

When Devrim married Fahrelnissa in 1920, he had already a daughter by a first marriage. The girl, Remide, would play a pivotal role in Fahrelnissa's artistic career two decades later. The following year, Fahrelnissa, gave birth to a son of her own, whom they named Faruk. Two years later, in July 1923, she had a second son, Nejad. But then tragedy struck when Faruk died of scarlet fever at the age of just two and a half. More than sixty years later, Fahrelnissa still felt the intense pain of this sudden loss. 'I felt I was a tree whose branches were being hacked off with big axe', she told her daughter Shirin. 'The agony was nothing

I have suffered before or since. I was immunized for life.' After her wedding, she had converted a room of their apartment into a studio where she could paint. Now, she threw herself into painting all day as that was her only form of therapy. Manifesting that this was not an isolated intimate hobby, though, she would show current paintings with which she was satisfied to family members and friends who had called to console her and invite their comments.

Seeking further consolation, shortly after Faruk's death the couple embarked on the first of a series of European trips and extended sojourns.[18] Their marriage was tempestuous and marred by Izzet's infidelities, but its 'redeeming feature' for Fahrelnissa were these excursions to western Europe.[19]

At work in the studio set up in the Devrims' Istanbul apartment, early 1920s

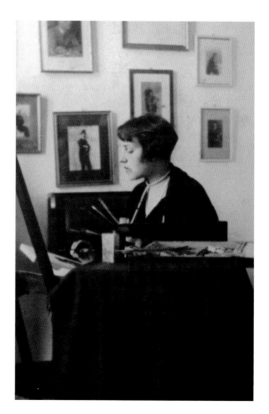

They travelled in great style, staying in luxury hotels and attending the latest plays and revues, while Fahrelnissa patronized fashionable Parisian couturiers such as Lelong and Doucet. These travels helped to affirm her personality and temporarily calmed their marital disputes.[20]

At home in Istanbul, the Devrims had an equally intense social life, which entailed lavish dressing, attending balls, learning the latest jazz dances, watching touring French plays, swimming in the Bosphorus, and socializing with political figures and diplomats and assorted émigrés, journalists, and writers. One high point was meeting Atatürk for the first time in the summer of 1928, an episode that Fahrelnissa copiously described with gushing

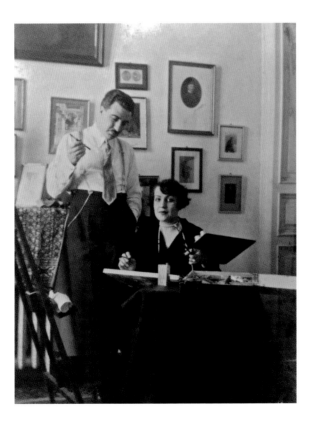

Izzet admires Fahrelnissa's work in the painting studio, early 1920s

A formal photograph
portrait produced in
Istanbul, *c.* 1925

breathlessness in her diary, next to drawings of her dancing and sitting beside the *gazi* (conqueror). Perhaps contributing to their absorption into the social life of the time was the mood of national pride and elation that followed the privations of the First World War and subsequent war of independence, and the declaration of the young republic with its modernist programme to which the Devrims and the Shakirs subscribed. No doubt further facilitating the couple's entrée into society was the much-remarked-upon beauty of Fahrelnissa, who is said to have been 'considered by then the most beautiful woman of Turkey'.[21] Fahrelnissa would be known for taking great pains to maintain and enhance her looks, but as her daughter described it, she was aware not only of her own appearance, but also of everyone else's around her, an interest that she attributed to her 'strong aesthetic sense'.[22] In fact, she appears to have had a heightened sense of visual stimuli, an all-encompassing acute perception, as manifest in the diaries that she kept throughout her life, where drawings would compete with written entries: these included sketches of everything

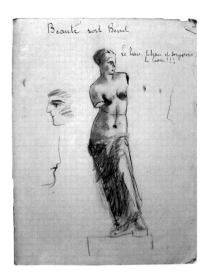

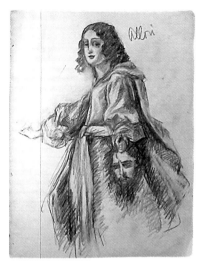

A sketch of the Venus de Milo, drawn in
Paris during the 1926 trip of Europe

Allori's *Judith with the Head of Holofernes*,
drawn in the Palazzo Pitti, September 1926

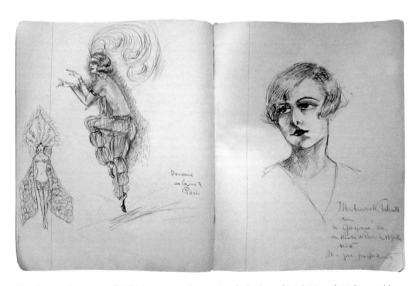

Sketchbook drawings of (*left*) dancers at the Casino de Paris and (*right*) Renée Falconetti in
the lead role of the *La Garçonne*, also drawn in Paris in 1926

from school homework, portraits, self-portraits, the outfits she wore at various functions, *sur le vif* landscapes, architectural drawings, and, later, sketches for her abstract paintings and her exhibition installations.

The Devrims' European trips also sharpened Fahrelnissa's sense of herself as an artist. She filled her diaries with descriptions of art works and sights that had made an impression on her. When the couple travelled to Madrid, she visited the Prado; and when they went to the Netherlands, she discovered the work of Pieter Brueghel the Elder, who was to become her favourite painter. Soon after Shirin was born in March 1926, they travelled to Paris and Italy. Fahrelnissa finally saw the Venus de Milo up close in the Louvre and was able to sketch the statue from real life. They attended first runs of successful plays such as Victor Margueritte's scandalous *La Garçonne* about a free-thinking feminist. Fahrelnissa was so taken with the lead Renée Falconetti that she made several drawings of her.[23] The day that Fahrelnissa marked as the best of her stay in Paris was when she and Izzet attended a production of *Andromaque*, Racine's tragedy of unrequited love, madness, murder, and suicide, at the Comédie-Française. She devoted pages in her diary to a summary of the play's plot and her impressions of its development, along with pencil drawings of the principal actress Caroline Weber's different costumes.

The highlight of that 1926 European tour appears to have been the September trip to Florence, when Fahrelnissa said that she 'nearly lost my mind' upon discovering Fra Angelico's frescoes.[24] Their visit included the Palazzo Pitti, which she described room by room in her diaries, next to her full-page drawing of Cristofano Allori's *Judith with the Head of Holofernes*; the basilica of San Lorenzo, which she sketched and described; the Palazzo Vecchio, which she catalogued extensively, including Eleanor of Toledo's apartments, to which she devoted two pages of sketches. At the Palazzo Pitti, her discovery of the colours of the paintings dazzled her, especially since at that time art books mostly showed reproductions in black-and-white engravings. She was struck in particular by Raphael's Madonnas, to which she gave detailed descriptions of the interplay of colours in their clothing, and to the rendering of the flesh tones of the *Madonna della Seggiola* tondo. The *Madonna del Granduca* also

intrigued her, especially the infant Christ's gaze, leading her to write dramatically, 'One would like to remove her eyelids to see what is hidden therein.'[25] She also singled out other, very different works by Raphael, such as the group portrait of the *Madonna del Baldacchino* for its spatial composition, and the nude bust portrait of *La Fornarina* for its subtle rendering of colours. Her strong observational faculties and attraction to colour are further evident in the two full pages of diary that she devoted to the meticulous inventory and description of ten types of marble revetment (porphyry, alabaster, etc.) that she saw in the Medicis' Chapel of the Princes in San Lorenzo, in which she remarks on their nature, shading, and pearlescence.[26] At night, she recorded her wonder at all the richness that she had seen that day, describing the architectural plan of the city as she progressed through it, past Donatello's statue of *David*, the fountain of Neptune, colonnaded galleries, Dante's house, and the various da Vincis and Michelangelos. She described herself walking silently amid the immortal works that spoke to her, while including the paradoxical sight of a beggar in the midst of all these splendours.[27]

As testament to her precocious and revealing attention to detail and complete relationship to art, she gave five lyrical pages to the effect on her of a visit to the Piazzale Michelangelo, the panoramic square overlooking Florence. Arriving there by carriage, she went to the ramp to take in the view of the city below. She described the movement of her gaze as it passed from building to bell tower to tree-lined street, all the while capturing the reflections of the light, the texture of the air, the silence and the sounds, the colours, and the onset of darkness of the sunset. She wrote also of the emotions that rose in her into physical voluptuousness as she looked upon the scene, until she felt that she had become one with the earth and lost all sense of time and of her own physical identity. This double sensation of a fusion with a visual spectacle and of losing track of time would recur in the future in her descriptions of her own work. Equally striking is her description of the bronze reproduction of Michelangelo's statue of David in that square, and of Michelangelo himself. It may be a conventional rendition of a romantic vision of the artist as tortured genius by a former *beaux-arts* student, but she wrote with an exalted sincerity

and dolorous sensitivity the accents of which would be found decades later in her writings on her own art practice:

> We found ourselves in an immense circular terrace of immaculate
> whiteness. And as if living there, a solitary and unique young man!
> Beauty of multiple forms, God of youth and grace. God of eternal life
> incarnating the perfect form of art, emanation of genius that comes
> from eternity! This marble body no doubt is a symbol. How could
> he not be since he carried in himself the work, the relentlessness,
> the sacrifice of the great genius, the master of masters, but of the
> unhappiest among men, Michelangelo all his life damned, enslaved
> and prey to its own talent? Cruel and despotic master that imprisoned
> him all his life, crushing him with its power, and grinding his spine. It
> was an entire martyrdom; a long and painful torment, it was a calamity
> for the man: the revelation for the world the birth of a god of art.[28]

Two years later, in November 1928, the Devrims travelled again to Europe, this time heading for Germany. In Munich, they visited the city's art gallery, the Alte Pinakothek. Once more, Fahrelnissa devoted pages in her diary to the visit. She began by listing all the paintings that she had appreciated in the museum, such as Lucas Cranach's *Venus*, Hans Holbein's female saints, and Jacob van Ruisdael's landscapes. Again, she admired the collection of Raphael's Madonnas and was especially sensitive to the shades of their colouring, which she described in minute detail. The highlight for her, however, was the work of Peter Paul Rubens, whose paintings she had already seen in Florence, and whom she now called a 'god'. She deemed his canvases alone worth the trip to Munich.[29] As in Florence, where she fell prey to a loss of self before the vista of the city, she wrote in her diary of a similar reaction before his *The Great Last Judgment* (1614–17), a forbidding six-by-four-and-a-half-metre altarpiece representing Jesus sitting at the top of an inverted triangle formed by the naked and writhing bodies of the saved and the damned, with the dead lying at its base. Perhaps struck by the monumental size of the

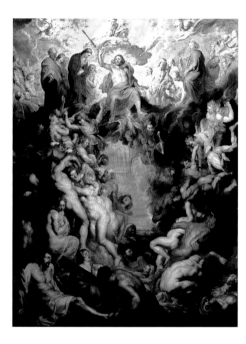

Peter Paul Rubens,
The Great Last Judgment,
1614–17, oil on canvas,
608 × 463 cm

work, she seemed not to notice its symmetrical construction and wrote only of its being a representation of a maelstrom of tortured flesh. She renamed the painting 'Hell' and detailed thoroughly the subtle palette used to represent the lighter and darker colours of the skin tones. Describing this 'painting of hell' writhing with 'human larvae', she neglected to mention the column on the left representing the ascent of the saved, focusing instead on the 'pell-mell horde of human beings thrown in the depths of horror' on the right of the picture. She then went on to write about elements that she must have imagined, for they do not appear in the painting: 'laughing-out-loud, thousand-headed and a thousand-form monsters' that claw the damned into the abyss, for example. She similarly described in detail the colours and flashes of a non-existent hell fire. As in Florence, she considered the artist behind the work. She was perhaps projecting her own subjectivity when she concluded that she was 'seized with fright and shivered with admiration unable to quench [her] gaze at the

masterpiece conceived and executed by the hand of a man ... who becomes so great that one feels the mediocrity and the smallness of thousands of his fellow men'.[30] As an art student, Fahrelnissa must have known that Rubens likely painted this work with the help of assistants. However, her nascent and perhaps still unconscious self-image as an artist led her to conceive of him as a solitary and tortured demiurge.

The most important event of 1928 for Fahrelnissa, however, was her extended stay in Paris, and her entry into one of the numerous free academies set up in Montparnasse as an alternative to the official state-run École des Beaux-Arts. In these private schools, students were generally taught for shorter periods up to a year, and women and foreigners were welcomed.[31] Many of them would remain in France after their studies, and several would later become members of the postwar Nouvelle École de Paris. The Devrims travelled to Paris because Izzet wanted to look for business opportunities and to work at the Académie Française on his doctoral thesis on the French dramatist and poet Henri Bataille.[32] Having already learned drawing in Istanbul, Fahrelnissa was determined to learn painting in Paris, and enrolled at the respected Académie Ranson. The painter Paul-Élie Ranson (1864–1909), a member of the avant-garde group of artists known as Les Nabis (meaning 'prophet' in both Hebrew and Arabic), had founded the academy in 1908 as a centre for teaching art according to Nabis precepts. Like the Impressionists before them, Les Nabis artists rejected the academicism of the Salons and the École des Beaux-Arts. They abandoned traditional perspective, simplified elements of compositions, and used pure saturated colours. Alongside Ranson, the group included Pierre Bonnard, Édouard Vuillard, Félix Vallotton, and Maurice Denis, whose definition of a painting – 'a flat surface covered with colours assembled in a certain order' – summed up the Nabis approach. While often representational, their art was heavily influenced by Symbolism and non-realistic decorative modes of painting. The movement slowly disintegrated in the late 1890s, but its principles became part of wider Post-Impressionist and modernist movements and paved the way for the development of abstract art in the early decades of the twentieth century.

It is not clear how many months Fahrelnissa attended the Académie Ranson, and little is known about the instruction she received there, but she always claimed that the experience led to her becoming a painter. With the education that she had received up to this point – as a child at her two schools, as an art student at the Istanbul academy, and even via her husband's literary models – she was very much a creature of nineteenth-century European, specifically French, high culture. The Académie Ranson showed her that there was an alternative world of art. She often recounted one anecdote about a life-changing interaction with one of its instructors, Roger Bissière (1886–1964), a semi-abstract Cubist painter who taught painting and *croquis* (sketching from life). He did not teach every day, but would come in on Saturdays to view students' work.[33] One day he complimented two Japanese students whose easels were next to Fahrelnissa's. She was surprised, for she thought their bluish nudes uninspired and untrue to life. She felt confident that he would like her work because it was a more realistic rendition of the model's flesh tone and likeness.[34] Instead, Bissière took a long look at her nude, picked it up, and threw it to the floor. Fahrelnissa was horrified and burst into tears. He exclaimed, 'You are not a photographer! You will never be able to imitate nature.' She managed to ask him what was the purpose of the model then, to which he replied that she was only a means. He added, 'If you have something to say – if you have an interior song – you will say it through this means.'[35] Fahrelnissa said that it was a salutary lesson that she would never forget, and that whatever talent she had she owed to Bissière's injunction.[36] She credited the episode with opening her eyes to look beyond faithful figuration and to paint instead the spirit of things. She would later learn that Bissière had said of her that she had 'great talent', but because she was a society woman having fun, he had had 'to break her'.[37]

In addition to her lessons at the Académie Ranson, Fahrelnissa also absorbed the heady mix of culture that surrounded her in Paris. The city was teeming with the modernist work of artists such as Pablo Picasso, Francis Picabia, Henri Matisse, and Tamara de Lempicka – a fellow Ranson graduate – as well as the rise of the Surrealist movement and the explosion of jazz. Montparnasse in these *années folles* was the 'navel of the world' according to

novelist Henry Miller. Fahrelnissa met with many vanguard artists during her time there, including Tsuguharu Foujita and Kees van Dongen, and she would learn from each of them.[38] Indeed, her future portraits of the 1960s and 1980s would owe much to the latter's recognizable style.

Upon returning to Istanbul in 1929, Fahrelnissa resumed her formal art education at the newly renamed State Academy of Fine Arts, no doubt encouraged by her time at the Académie Ranson. Three years earlier, the women's and men's academies had joined to form a single institution. Her main instructor there was the school's new director and one of the most prominent Turkish artists of the early twentieth century, Namik Ismail (1890–1935), who had himself studied in Paris before the First World War. He was part of what became known as the '1914 Generation' of artists who returned to Turkey upon the outbreak of war, and was among the first practitioners of a Turkish form of Impressionist painting. He would be her teacher for the next couple of years.

Before reaching thirty, then, Fahrelnissa had received a year of classic *beaux-arts* education as a teenager in Istanbul and, later, a further two years of academic instruction under a teacher who had affinities with Impressionism. In between, she had studied the Old Masters first hand during trips to Europe and had learned Nabi-style painting at a progressive school in Paris. It is not possible, however, to track the influence of this learning on her own practice because, apart from the 1915 watercolour of her grandmother and a 1926 watercolour profile of her niece Fureya exhibited at the 2006 exhibition at Istanbul Modern, there are no works prior to the 1940s that may be reliably attributed to her. Less naturalistic than the portrait of her grandmother, the watercolour of Fureya (p. 41) demonstrates nonetheless a skilled and polished command of line, shading, and colour, in a profile study recalling Greek classical reliefs. As such, it bears the hallmarks of her early Istanbul education before she travelled abroad. Drawings in her sketchbooks and diaries of the period are generally figurative works in a realist vein without identifiable stylistic inflections.

There are also two untitled works, apparently dating from some time in the early to mid-1930s, that the Turkish auction house Alif Art has recently attributed to her. One is an undated and unfinished orientalist study of a

woman in Turkish costume with exposed bare breasts standing before archi-
tectural details of arches and a mosque's dome; the other is a finished dynamic
work representing a soaring mosque bearing the Turkish flag with a depiction
of modern Istanbul at its base. This oil on canvas is thought to be from 1935,
but the date is not clearly legible. It is not academically classicist like the Fureya
portrait, nor is it an Impressionist-style representation like Ismail's work. Its
upper portion is a skilled rendering of the mosque's mass and architecture
details and command of the perspective, while its lower part is an expres-
sionistic, even caricatural, representation of urban characters and cattle that
undercuts any romantic or idealized connotation suggested by the top half of
the painting.

It is somewhat difficult to form a judgment on the early evolution of
Fahrelnissa's art from these few extant pieces, even if one accepts that they are
all by her hand. The only other evidence that we have is what we can glean from
her writings. Her meticulous written accounts of her impressions of individual
works reveal the bases of her artistic and cultural formation: an intellectual
grounding in nineteenth-century western European notions of high culture,
literature, and a reverence for the Old Masters. This cultural background was
combined in Fahrelnissa with a predisposition to emotional and spiritual
transport, even exaltation, when viewing representations of larger-than-life
sentiments or other grand forms of artistic expression. This sensibility led her
on more than one occasion, as we have seen, to experience a loss of self before
a picturesque architectural vista or a sublime tableau, or to interpret a monu-
mental religious painting as a self-generated vision of hell. At the same time,
she demonstrated an acute awareness – matched by the capacity to express it
– of colour gradations and other subtle nuances in both painting and archi-
tecture. This rare and seemingly antithetical combination of susceptibility to
the all-absorbing spectacle with a fastidious sense of chromatic detail would
appear in her work time and time again over the coming decades.

Portrait of Fureya, 1926, watercolour on paper, diameter 11 cm

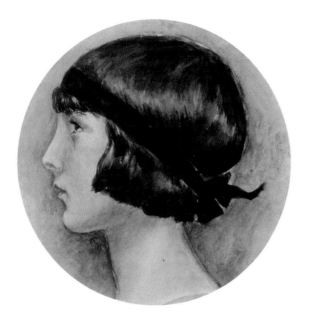

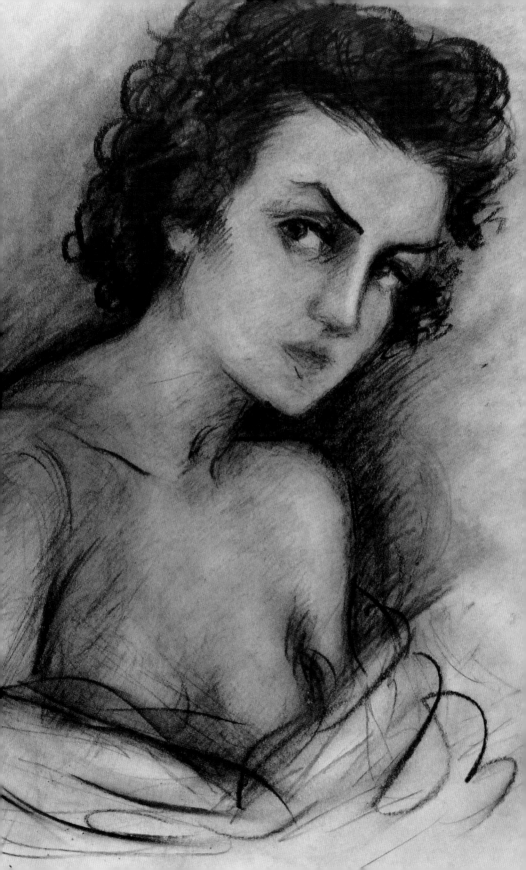

II

Dislocation and Wanderings
1934–40

The years leading up to the Second World War saw Fahrelnissa continue her formation before embarking on her public practice as an artist. It was a turbulent coda to the preceding two decades, during which she had started to assert her own subjectivity, despite the cultural imperative that a young woman of her class was the object of her family, husband, and society. Having rejected the idea of remaining sequestered in the family home before being married off, she went to art school and then throughout the 1920s and early 1930s set about building the bases of her artistic identity with determination. She did so alongside the quotidian responsibilities of her otherwise busy life as a mother and, later, as an ambassador's wife and royal princess. In this respect, she was perhaps trying to resolve Roger Bissière's judgment of her as a mere society woman who had 'great talent' but was playing at art, and whom he had to 'break' to make into a real artist. Her development unfolded in unexpected ways, however, as a result of the personal upheavals that she would encounter over the course of the next few years.

Fahrelnissa's strong personality also affirmed itself during this period. Her daughter later described her as a complex character, larger than life, impractical, generous, extravagant, and hot-tempered, as well as good-hearted, loving, and magnanimous.[1] She was, Shirin wrote, 'a bold woman who made fearless decisions and plunged into situations regardless of consequences'.[2] Even in her old age, acquaintances thought her 'unstoppable'.[3]

Self-portrait, 1936, charcoal on paper, dimensions unknown

Her boldness of spirit was accompanied by an insatiable appetite for two activities that she undertook with both physical abandon and acute mental focus: swimming and painting. These lifelong pursuits would absorb her energies. She began swimming in the late 1920s and continued until the early 1970s. She had the stamina to swim for hours every day, and she did so in the Bosphorus each summer. She followed the popular advice of taking 'thirty dips in the sea ... to ward off winter ills'.[4] She would later write of the sea's sensuous and mystical pull, and one can discern in her exalted descriptions of long swims in deep waters a prefiguration of her monumental dappled paintings of the 1950s and 1960s. Her earliest extant elaboration of her spiritual and physical rapport with the sea is an exceptional thirteen-page stream-of-consciousness diary entry from 1943, which is written with a colourist's sensibility and saturated with the warmth of the sun:

> I spent the whole day frying again in the sun and plunging in the
> light green blue waters, get out, shower, towel dry, enter anew in
> the sea salted and odorous [...] I saw the water and I threw myself
> headlong. I could not wait nicely to reach the spot where the water
> was deep enough to be able to swim. I ran, I wanted to run and the
> water of elusive crystals inflated in a thousand jets of a thousand
> forms [...] I plunged headlong. Wild wild. Shaking my hair [...]
> the aligned sandbanks, in very amusing little swellings where the
> sole of my foot liked to place itself. At last watercolour, again in
> watercolour. Clear shades, nothing fake, abnormal [illegible] etc.
> the watercolour, the light blue watercolour, sky blue, vivid pink, lilac
> mauve, yellow [...]
>
> I was happy, I screamed with joy. I plunged. I flapped
> my legs on the surface of the sea ... like a flesh-and-bone torpedo,
> I slithered, [illegible] and straight swimming like a wild woman.
> Emerging thirsting, on the back, and at each stroke I made,
> my body, my hair tangled to the sea led me farther, farther.
> And my legs arched and my arms went backwards pushing

the little flesh-and-bone ship [...] joyous, happy like a fresh day, like a newborn child. And joy, joy led the little bouncing ship straight ahead going forward, cleaving the sea, happy to see herself participating in this feast.

Sometimes I turned on my belly and then it was something else [...] I saw all of the clear, clear depth of the sea through the bracelets of light that the sun flung [...] It is then that I feel myself living fully, or if the word is not exact, it is then that vibrates an truth within a truth. Maybe not yet defined or ill defined of my being. To be or not to be. Not to be. To be. That is my doctrine. This is my wisdom, if wisdom there is. [...] My cheeks are burning with the sun, drunk and full of a burning intoxication. Yes yes. I drunk the sun today, I swallowed the sun. I said I swallow the sun, I said I eat the sun, I said I love the sun, I said I take the sun. The sun is in me. The sun is in me. I closed my eyes and the sun intoxicated all the deepest of my depths. All the depth of my brain, of my eyes, of my thoughts, I arrived to the extreme limit of the horizon to touch to enter in the sun. And the oval eyelids captured full and luminous all of the sun.[5]

Five years later, sick in bed in Paris, she would write of her longing for the sea with characteristic intensity. Only Fahrelnissa would ascribe firelike qualities to the colour of the water: 'I need this dense blue – this ceramic blue reinforced with purple. I would like to drink the entire sea, all of the Aegean Sea – this blue so marvellous, it is cobalt mixed with the sunset – is it a celestial marine blue – this blue calms me.... I would like to drink all of the blues, intense, languorous, deep, wild, and fiery.'[6]

Her considerable physical energy could not keep at bay the depressive bouts from which she would suffer for the rest of her life, however. As early as 1928, she described the 'waves of spleen, morosity' that arose in her without reason, sometimes crippling her, as a form of neurasthenia or ailments of the heart.[7] In her family memoir, Shirin wrote about her mother's 'tormented psyche', which would often cause her to faint in situations of extreme stress,

and for which she used painting as a 'therapy' because 'when she painted, she immersed herself totally in her work. Some life force seemed to penetrate her and, as if her body were a conduit, release itself in colours on the canvas.'[8]

One source of anxiety was the state of her failing marriage. At first, Fahrelnissa had largely turned a blind eye to Izzet's serial infidelities, or at least contained the anguish that they caused her. But, as the years went by, she grew unwilling to accept his brazen womanizing. The couple had fought constantly throughout their married life, but in the autumn of 1933 the arguments increased in intensity and violence. Always single-minded, strong-willed, and independent, Fahrelnissa now took the decision, still rare at that time, to leave her husband. She had in fact already met and was in love with Emir – that is, Prince – Zeid (1898–1970), the younger brother of King Faisal I of Iraq and that country's first ambassador to the republic of Turkey. By the end of the year, Fahrelnissa and Izzet were divorced.

A new phase of life

Within only a few months of the separation, Fahrelnissa and her Arab prince were married. Prince Zeid belonged to the Hashemite clan of the Arabian Peninsula. They were descendants of the prophet Muhammad and hence bore the honorific title of *ashrafs* or *sharifs* (nobles). Under the patronage of the Ottomans, the Hashemites had ruled Mecca and much of the surrounding Hejaz region for centuries. In 1916, after rising tensions with the increasingly nationalistic rulers in Istanbul, and with the encouragement and military support of the British, then at war with Turkey, the Sharif of Mecca Hussein bin Ali – Prince Zeid's father – rebelled against the nationalist Young Turks government and initiated the Arab Revolt. The rebellion succeeded in driving the Turkish armies from the Arabian Peninsula and northwards out of Damascus. Described by T. E. Lawrence as a cool, calm, and 'beardless lad of nineteen', Zeid fought in the revolt, commanding raids and leading the Arab Northern Army into battles.[9] In the settlements that followed the end of the First World War, British promises of a single great Arab kingdom ruled by Sharif Hussein evaporated into the partitioning of the area into various new states

under British and French control. Three of Hussein's sons – Ali, Abdullah, and Faisal – became kings under British protectorate of the newly formed states of Hejaz, Transjordan, and Iraq respectively. However, in 1925 the rival Saud family successfully led a counter-campaign to unify the major part of the Arabian Peninsula under the new kingdom of Saudi Arabia, subsumed Hejaz, and forced Ali and the remaining Hashemites out.

When he was appointed Iraqi ambassador to Turkey, Prince Zeid resided in the capital Ankara. But two of his sisters lived in the same building in Istanbul as Fahrelnissa and Izzet, in the very next apartment, and it was there that he met her in 1929. Over the next three years, they would encounter one another at social functions, and she became intrigued. 'He was so different from everyone I had known', she told her daughter later. 'He looked at me in a way no man ever had before. This mysterious, dark, quiet prince began to haunt me.'[10] By the summer of 1932, the pair had fallen in love.

As soon as Fahrelnissa's divorce from Izzet Devrim was formalized in November of the following year, she and Prince Zeid met up in Athens, where they married. And so began the next phase in her life, as a diplomat's wife and royal princess. Zeid would serve as an ambassador for the remaining twenty-five years of his career, and on several occasions even acted as regent of the kingdom of Iraq, where his brother Faisal and his descendants would reign until 1958. In July of that year, Zeid became titular head of the Royal House of Iraq following a military coup and the assassination of King Faisal II, his great-nephew. On several occasions over the decades, in times of political upheaval, he would turn down advances by local coup leaders and by European powers with expansionist sights to ascend the thrones of both Iraq and Syria under their domination.

From Istanbul to Berlin

Following their marriage, the couple moved into an old dilapidated house originally built by Zeid's father Sharif Hussein in the Buyukdere district of Istanbul. Overlooking the Bosphorus, the building stood on a hill in the midst of wooded grounds. Fahrelnissa poured her energies into remodelling it, and

furnished it with Ottoman antiques discarded by westernizing Turkish families or sold by Russian émigrés who had escaped the 1917 revolution. Fahrelnissa would keep many of these items throughout her life and transport them to the various homes in which she lived. In the summer of 1935, she moved away from Istanbul for the first time when Prince Zeid was appointed Iraqi ambassador to Germany. Berlin in the mid-1930s was an important posting for any diplomat as the country was re-emerging as an ambitious power under the government of Adolf Hitler. In violation of the Treaty of Versailles of 1919, it had begun to rearm itself, and in March 1935 had introduced compulsory military conscription. A year later, it further violated the treaty by reoccupying the demilitarized zone in the Rhineland, in a stroke changing the balance of power in Europe in Nazi Germany's favour and allowing it to pursue a policy of aggression that would ultimately lead to the Second World War.

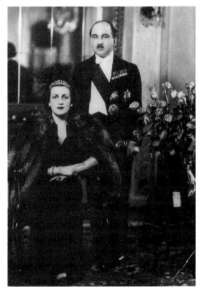

With Shirin and Raad in Berlin, 1937 Fahrelnissa and Prince Zeid in Berlin, 1938

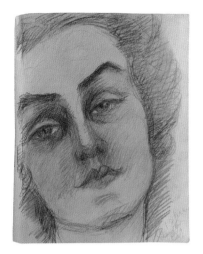 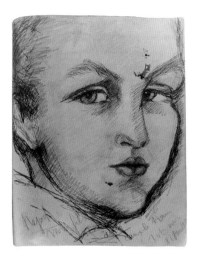

Pages from sketchbooks from the Berlin years, showing a self-portrait from 1937 and a portrait of Nejad from 1936

Throughout all these developments on the world stage, Fahrelnissa kept busy with family and social obligations. The first was dominated by the birth of the couple's son Prince Raad in February 1936, and with settling her older children into new schools. Her social life was taken up by her irresistible rise as an important diplomatic hostess, known as the exotic 'Princess from the East', who charmed all of Berlin society.[11] In addition, she immersed herself in German culture, learning the language, reading voraciously, and developing a lasting passion for Romantic and Neo-Romantic classical music. She attended Berlin Philharmonic concerts conducted by Wilhelm Furtwängler and met the acclaimed violinist Fritz Kreisler.[12] She also discovered Wagnerian opera, which provided her with the exalted emotional stimulation that she craved.[13]

As soon as she arrived in Berlin, Fahrelnissa enrolled in art classes and set up an easel in her bedroom. Busy with family business, she would tell people that eventually she would 'give' herself 'to art' in the future.[14] Her work from this period is unknown, but was described as classically figurative.[15] A 1937 local newspaper described her as a 'passionate portrait painter'.[16] She framed and gave away some of her paintings as presents.

In addition to her drawing and painting, she also resumed in Berlin the museum visits that she had undertaken with Izzet in the 1920s. She visited galleries and museums there and in Cologne, Nuremberg, Munich, and Potsdam, often taking her children, to whom she would explain the different painting techniques.[17] On a trip to Paris in October 1936, she visited the Cubist painter André Lhôte (1885–1962). He had established one of the free art academies in Montparnasse, and had taught a few Turkish painters. She also met on this visit René Grousset, the director of the Musée Cernuschi of Asian art and Oriental historian, who would play an important role in her emerging international career a decade later.[18] Back in Berlin in 1937, as in the Netherlands over a decade before, Fahrelnissa was impressed by an exhibition of the work of Pieter Brueghel the Elder.[19] It is obvious that with her exalted temperament, she would have been attracted to the Flemish painter's ambitious tableaux, to their expansive decentredness, striking depth of field, and improbable combination of panoramic scope with precise detailing. She would speak of his 'meticulous analysis and modern approach, his unsubstantial blue distance'.[20]

The German invasion of Austria in March 1938 cut short Prince Zeid's mission to Berlin, when he was suddenly recalled to Baghdad, probably because of Britain's desire to reduce its profile in Germany and that of its allies following the *Anschluss*.[21] Iraq had become formally independent in 1932, but it was still very much under British influence. It was suggested that the government in London did not approve of Fahrelnissa's growing social connections and was nervous about having a prominent Iraqi royal in Berlin at this time. The family's stay ended in April with a summons for Fahrelnissa to attend a perplexing thirty-minute audience with Hitler, during which he spouted pithy views on art and museums.[22]

Baghdad, Budapest, and beyond: trauma and self-discovery

The Zeid family left Berlin in stages over the next few weeks. Fahrelnissa herself went first to Prague in Czechoslovakia to stay with friends and then to the spa town Carlsbad (Karlovy Vary) to take the waters, before returning to Istanbul in late July. Within a few days, tragedy had struck again when her mother died

after a sudden and quick illness following an operation for breast cancer.[23] In September 1938, two weeks after the funeral, Fahrelnissa, Shirin, Raad, and his German nurse set off on the three-day train journey to Iraq, where they were to join Prince Zeid. She was looking forward to discovering the country, the cradle of civilization, and to visiting its many important historic sites. It had been in turmoil since its founding after the First World War, witnessing a series of popular uprisings, inter-ethnic strife, violent repression and military revolts and attempted coups. Baghdad at the time was a small city lashed by desert winds, and many of its roads were unpaved.[24] When they arrived at the end of the railway line in Mosul, just inside the Turkish–Iraqi border, they met Zeid. He handed Fahrelnissa a package containing a full-length hooded black *abaya* for her to wear in public, a garment similar to the one she had stopped wearing twenty years earlier, but now readily conformed to.[25] Upon entering Baghdad, the family went straight to meet the royal family, which had

An *abaya*-clad
Fahrelnissa and Raad
shortly after they
arrived in Iraq in
September 1938

gathered to greet them. It was a small, tight-knit group consisting of the young King Ghazi (1912–39), his three-year-old son Faisal (1935–58), and Queen Aliya (1911–50), Ghazi's wife and first cousin. She was the daughter of King Ali, the former king of the Hejaz and eldest brother of Prince Zeid. Her illness and death thirteen years later would be at the origin of Fahrelnissa's most famous painting, the monumental My Hell of 1951. Aliya's three sisters were also present in the welcome party. As socializing was segregated by gender in Baghdad, Fahrelnissa mainly spent time with the princesses and sharifas, even as communication with them was limited because they spoke only Arabic, which she did not know.

The family lived in a modern rented home in the Al-Wazireya area of the city; it had a flat roof used for sleeping in the hot summers and a cellar in which to live during the heat of the day.[26] While Prince Zeid worked at the royal court, Fahrelnissa decorated the house and constituted a household staff, but did not have much else to do. There were occasional outings to the royal family's personal movie theatre, excursions to Babylon and Nineveh, and a deeply affecting pilgrimage to the holy city of Karbala.[27] Fahrelnissa would occupy the rest of her time reading, writing in her diaries, sketching and painting, and listening to Pablo Casals's recording of Dvorak's cello concerto and Tchaikovsky's Pathétique, which would become a fixture in her life.

This quiet, monotonous existence appears to have intensified her earlier episodic bouts of morosity into full-blown depressive depths. The decade from 1938 onwards would see her endure her most severe periods of depression.[28] In addition, she suffered a number of physical ailments, including pleurisy, neuralgia, shortness of breath, chest pains, fainting spells, and catatonia.[29] She began to spend her daytimes in bed, a habit that she would keep for the rest of her life.[30] As her moods and low spirits affected her family, she tried to cheer herself with trips to the bazaar, but eventually she was unable to leave her bedroom. She filled the room with her sketches, watercolours, and oil paintings – some framed and hung, some on the floor, others in piles on tables and chairs. With the onset of depression, she preferred to work there rather than in the studio that she had set up in the house.[31] After visiting Karbala, she

was so affected by the sadness and fervour that she experienced around the shrine of Imam Hussein that she painted it for days after her return with only black ink, without a drop of colour.[32]

In an attempt to ease her suffering, Prince Zeid invited the celebrated Austrian psychiatrist Hans Hoff (1897–1969), who had been forced to flee the Nazis before the *Anschluss*, to come and see her in Baghdad. Despite the art works that filled her bedroom, Fahrelnissa told Hoff that she did not feel like painting any more, and just wanted to lie in bed all day. He prescribed a change of atmosphere, but urged her to continue painting, for work would save her.[33] Taking his advice, she left a few days later for Paris, where she consulted doctors who assured her that she was not physically ill. Wanting to prove them wrong, she checked herself into the American Hospital and summoned her sister Aliye to join her from Turkey.

By July 1939, she had apparently recovered sufficiently to return to Istanbul, where her children were awaiting her. Soon after, Prince Zeid joined them from Baghdad and the family was reunited. However, Fahrelnissa quickly fell into a second depressive 'neurasthenia' accompanied by chest pains and fainting spells. Looking for another change of atmosphere, she left again, this time for a famous Hungarian sanatorium, St Gellért Hotel in Budapest.[34] There, her mood oscillated between happiness and loneliness, melancholia and longing for her family.[35] She was forced to cut short her stay and go back to Istanbul after the Nazi invasion of France, but her condition had not improved. She spent the summer of 1940 in a depressive state, during which she painted only sporadically. Sketching her room, producing portraits of her family, and being close to the sea were not enough to quell her depression.[36] She wrote in her diary of an unconscious 'slow suicide' inflicted on her body, and composed long poems, including a sixty-five-verse melancholic and lyrical work entitled 'Rains', which lamented her fate about being seized with an inexplicable pain and facing death head on.[37]

In a bold change of course, she returned to Budapest for four months to consult doctors at the sanatorium, who prescribed her a variety of stimulants, but also determined to concentrate on painting, which she felt sure would

be her only salvation. This time she stayed in a small rented apartment that she equipped with a painting studio.[38] There, she wrote poetry, sketched, and painted daily, mainly a series of oils depicting the life of the city. Happy with her work, which she thought was maturing, she considered holding an exhibition. However, her good moods were fragile and short, and she ultimately checked herself into another hospital in Budapest, the Siesta Sanatorium. There, her depression worsened so much that she unsuccessfully attempted suicide by ingesting a handful of sleeping pills. The doctors who saved her by pumping her stomach informed Fahrelnissa's family that there was nothing wrong with her physically, that her ailments were psychological, and that there was nothing more they could do for her.[39] She was brought back to Istanbul, where she would stay for the next three years. It would not be the end of her problems with mental health.

Fahrelnissa said that her first Budapest paintings were inspired by the spectacle of the street, and as she was fascinated by a book she had read there on the world of Brueghel, she saw all around the city his 'swarming [*grouillement*], the unexpected attitudes, the physical malformations as well as the obsessive beings'. She added that when she painted these canvases, she would place herself at the edge of the composition, as if at the exterior: 'a black silhouette that looks at and measures the stirrings and the eddies, the rhythms of life'.[40] This statement is intriguing for we have no visual record of the works. Fifteen of the Budapest paintings were stolen at the Sofia train station as she made her way back to Istanbul in 1940. When she arrived there, she preferred to stay in a hotel rather than going back to the family home while she mustered the energy to repaint many of the stolen works.[41] It is not known how many of the canvases she remade, but only one survives, *Budapest: View from the Express between Budapest and Istanbul*, which she dated to 1943.[42] Rather than a blurred view from a moving train, the work represents a coloured crowd of animated figures skating on an improbably green frozen pond. At the bottom centre, facing them, is a figure dressed in black with a high hat like the toques that Fahrelnissa herself affected to wear. That may be her, watching the skaters, observing rather than joining in. Unlike the detailed anthropological indi-

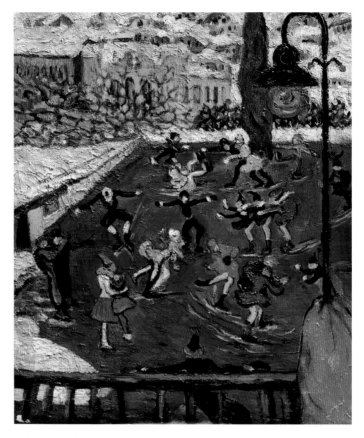

Budapest: View from the Express between Budapest and Istanbul, 1943, oil on canvas, 55 × 47 cm

viduality of Brueghel's figures, Fahrelnissa's appear like writhing colourful silhouettes of carefree happiness, doubly distanced: from the figure observing them, and behind a balustrade and lamp post framing the image on the right and at its base. This painting may borrow Brueghel's visual vocabulary, but the works that most clearly bear his influence are her later 1950s works. Before reaching that point, however, Fahrelnissa would first have to establish herself as a professional painter in 1940s Istanbul.

III

Coming into Her Own
1941–6

Following her travails in Baghdad and Budapest, Fahrelnissa made the decision to remain in Istanbul. In the middle of 1941 she converted parts of the Buyukdere home into a studio and disconnected the telephone so she would not be interrupted while working.[1] Towards the end of the summer, her life would change radically once again. She had remained in contact with her former stepdaughter Remide, who was by now married to an influential Istanbul cultural figure, the writer, critic, collector, and translator Fikret Adil (1901–73). According to Shirin Devrim's account, it was during the couple's visit to Fahrelnissa that Adil saw her paintings for the first time, covering the walls and piled up on the studio floor. Astonished by what he found, he encouraged her to exhibit them and to 'come out of your closet'. He then introduced her to a world that she 'had not known existed for her in Turkey'.[2] Through him, she met the leading Turkish artists of the day, as well as important poets, writers, and thinkers. True to an attitude that she never abandoned, she would not separate her identity as a social figure accustomed to entertaining on a grand scale and her emerging persona as an artist. She welcomed Adil's intellectual and artist friends to her home, showed them her works, and hosted al fresco dinners.[3] Before long, Fahrelnissa would join and exhibit with the artists who called themselves the D Grubu, or D Group. This new wave of painters set itself in opposition to the preceding 1914 Generation of Impressionists, of which her former teacher Namik Ismail had been a key figure.

Self-portrait, 1944, oil on canvas, 123 × 100 cm

Members of the D Group
outside the Mimoza
Hat Shop in Beyoglu,
Istanbul, where they
held their first exhibition,
8 October 1933

Joining the D Group

The D Group was founded in 1933 and was active until 1950. It took its name
from the fourth letter of the alphabet, as the founders considered themselves the
fourth generation of Turkish artists since the late Ottoman era to be working in
a western style of painting and perspective. The first such generation emerged
in the mid-nineteenth century from the ranks of artists who learned drawing
in military academies and then pursued art studies in Europe. The second was
the 1914 Generation of Turkish Impressionists who had studied at the School
of Fine Arts in Istanbul and then at European academies, before returning to
Turkey at the outbreak of the First World War. A third generation of self-styled
independent artists influenced by Fauvism and Expressionism followed in the
mid-1920s.

The D Group grew out of that last ensemble, but more forcefully rejected
the institutional organization of artists and Impressionistic academicism of the
1914 Generation. They originally numbered just six members: painters Abidin
Dino, Nurullah Berk (the group's spokesman), Zeki Faik Izer, Elif Naci, and
Cemal Tollu and sculptor Zuhtu Muridoglu. Almost all had studied fine arts
in Turkey as well as in Paris, notably at its free academies. They held their first
exhibition in a hat shop in Istanbul in 1933, and claimed that their mission
was to bring 'contemporary European artistic trends to Turkey without delay',

meaning Cubism, Constructivism, and Expressionism.[4] At the same time, the group affirmed in their manifesto the primacy of their original visions as Turkish artists over that of any European masters. Rebelling against the academicism of their predecessors, they called for a 'living art'. They exhibited prolifically, in out-of-the-way places. Above all, the group stressed the intellectual foundations of their works of art, underlining the primacy of form and technique, de-emphasizing theme and content, and rejecting as bourgeois correspondences between nature and painting or sculpture.[5]

The D Group intended to shake up the art scene, at least in the beginning. While they rejected 'state-directed' art, they welcomed state financial support and took part in state-sponsored painting tours of Anatolia. By the late 1930s, members of the D Group found themselves accepted by the state and employed in the Academy of Fine Arts. After the early 1940s, several group members turned towards primitive or nativist art and Anatolian folk aesthetics rather than stressing high modernism.[6] With the end of the Second World War, from 1945 to 1951, they began to participate in international exhibitions. Thus, the group, which began as a radical arts association and stood at the crossroads of a high modernism and a nation-building project, ended up as a locally influential art current embodying a 'positive' modernism.[7] By 1946, the group counted fourteen members among its number.[8]

To her delight, Fahrelnissa was invited to show with the D Group at its ninth collective exhibition in late 1941, and then to join the group in the following year. She went on to show work in several of its exhibitions in 1942,

The exhibitors of the D Group's ninth exhibition at the Academy of Fine Arts, Istanbul, 1941

1943, 1945, and 1946. Quite apart from her social rank and personal ties, she must have been an uneasy fit for the group, though, in terms of its socio-intellectual dynamics as well as aesthetic conception. She became involved during its mature period, joining when its early radicalism was evolving into that of a national group of contemporary artists.[9] Her apolitical stance would not have fitted with her fellow members' progressive politics. She did evince, however, an artist's pride in their anti-bourgeois society happenings. As she explained, 'I myself was never politically "*engagée*", but many other members of the group were. I shared their enthusiasm for an art that would no longer appeal exclusively to the well-to-do bourgeoisie, which, in Istanbul, displays in any case but a limited interest, in general, in the efforts of the local *avant-garde*.'[10]

She was also one of the group's very few female members. The only other woman to exhibit work in its exhibition in March 1945 was the Romanian-born Eren Eyuboglu, wife of fellow D Group painter Bedri Rahmi Eyuboglu. Norms of interaction between the sexes and social and familial expectations stood as barriers to the professionalization of women in the arts. In the first half of the twentieth century, entry into the field was still, as in many non-western contexts, limited to an elite, and was part of westernizing practices and fashions adopted under the guise of modernization. It was only in the 1970s that the number of Turkish women artists rose vis-à-vis their male counterparts. In the Ottoman period, painting was such an elitist pursuit that the daughters of pashas, wealthy merchants, and senior members of the military were among the first generation of female art students and artists.[11] However, painting and drawing were still considered performative markers of class affiliation rather than future career choices. Unless they travelled abroad to pursue a career, these women and their successors met with several obstacles before they could become professional artists; they would have to prioritize family obligations instead.[12] Fahrelnissa, who held her first solo exhibition at the age of forty-four, is a prime example of this social pressure. The fact that she had the means to entertain fellow artists at home, rather than being obliged to leave her house in order to socialize with them, may have been a facilitating factor in a still conservative society. As for her own identity as a working female artist, she

shunned the label of feminist. She would state in a 1959 interview that she did not consider herself a pioneering 'lady of the Turkish feudal nobility who has thrown her yashmak … and set her heart … on becoming the first woman painter of her country, much as other emancipated women of her generation have become politicians, physicians … I have never been a militant feminist and I hate to think of my paintings as expressions of a faith of this kind.'[13] Still, her own life and actions are those of a woman who lived life according to her own terms and in defiance of many gendered expectations, and who encouraged her daughter to be financially independent.[14]

Lastly, Fahrelnissa was also not a natural fit with the D Group in terms of aesthetics either. Her sensibilities could only be at odds with the group's, which veered somewhere between Futurism, Cubism, and Anatolian traditions. The British writer and curator Derek Patmore, who presented the D Group painters as the nucleus of a number of travelling exhibitions of modern Turkish art that he organized from the 1940s, described the group's project as 'aiming at keeping contemporary Turkish painting in the great classical tradition whilst not sacrificing the lessons learnt from abstract painting and cubism. They also sought inspiration from the colours, patterns and designs to be found in the peasant arts of Anatolia.'[15] British critic George Butcher dismissed one of Patmore's exhibitions as 'most disappointing' and amateurish in conception and in execution, and criticized the sterility of self-consciously nationalist revivalist art movements, while singling out Fahrelnissa's work for praise.[16]

At the time, Fahrelnissa's own preference was for painters who commanded colour rather than line, form, and space, or any political-nationalist concerns. This had already been manifest in her written impressions of her 1920s museum visits. However, it would persist in her repeated statements of admiration for Pierre Bonnard and Henri Matisse, and for Picasso's 'first period', implying his pre-Cubist Blue and Rose periods.[17] Conceptually, she was profoundly impressed by a classic treatise of nineteenth-century French aesthetic theory. She devoted pages in her 1940 diary to enthusiastically copying, paraphrasing, and underlying excerpts from the 1867 *Grammaire des Arts du Dessin* by critic and director of the École des Beaux-Arts Charles Blanc, a manual

that influenced a number of later artists, including Vincent van Gogh and the Neo-Impressionists. In particular, Blanc's arguments on the optical mixing of pure colour influenced the emergence of chromoluminarist techniques, such as the Pointillist movement, and may have been at the origin of Fahrelnissa's late 1940s and 1950s divisionist kinetic abstractions. Fahrelnissa privileged passages that highlighted art's metaphysical dimension via the emotions it communicates, the primacy of the emotional element of art over the materialist, and the equation of beauty with colour and an almost kinetic dynamism. She thus appeared to describe her own future work.[18] On the importance of the spiritual over the physical and technical aspects of art-making, she wrote:

> The metaphysical meaning of art ... what is art ... is characterized by emotion ... the most profound emotion 'its essential domain is the world of sentiment! The supreme art [...] is the shining reflection of the being ... there is mystery in the beautiful because it is elusive, ineffable [...] The beautiful is not grossly reduced to a harmonious schema of lines, ingeniously created by the habile hand of man ... it is something added to matter, to the inert object.' The beautiful bears the seal of eternity.

Consequently, she favoured an acutely anti-materialist and spiritual understanding of the creative act:

> Art that fills men with a divine joy is real at the highest point; therefore it cannot be a physical fact, meaning something unreal [...] something immaterial is found implicitly in the works of great artists.... What overflows in the work of art is life [...] The artist must manifest a religious emotion, philosophic dimensions, a general conception of life, the object of ... art, the human body is sacrificed! It is subordinate to an idea.

As for the expression of that beauty, she privileged a tortured lyrical sensibility in her copying and paraphrasing of Blanc's words, which match her own

exalted appreciation and conception of art, and anticipate the evolution of her 1950s work:

> The beautiful manifests itself in lyricism: in the profound pain that
> explodes in the prophets of the Bible, in Shakespeare, in Beethoven, in
> Michael-Angelo ... the beautiful is not static, because the painter or the
> sculptor evoke the expression, meaning the real gesture of our being
> or of beings. The beautiful in its veritable essence is dynamic when it
> implies a rhythm identified with the personality of the artist, then one
> approaches the work of the supreme creator.[19]

A room of her own

Encouraged by the enthusiastic reception of the city's art scene, Fahrelnissa decided in late 1941 to rent a twelve-room apartment in Istanbul proper, in the Ralli building, which was situated in the fashionable central Macka area. She also leased a three-room apartment in nearby Kiraz Sokak (Cherry Street), which she turned into a studio where she worked non-stop every day. Combining her new public artistic profile with her social skills, she would host weekly salons in the spacious Ralli apartment for artists, poets, and intellectuals.[20] She also redoubled her intellectual, cultural, and physical activities. She read Kierkegaard, Jung, Spinoza, and biographies of Mozart, Bonnard, and Vuillard; she read and reread Rimbaud and wrote poetry of her own that her Armenian friend concert pianist Koharik Gazarossian would put to music; she started work on two novels; and she swam avidly and exercised at the beach in the summers. Even so, she was still struck by waves of 'cafard' (melancholia) and complained of not understanding why she was seeing death 'when I have all the happiness'.[21]

She spent the next couple of years working frenetically to produce as many pictures as she could, drawing and painting landscapes, nudes, and portraits. One material challenge that she faced in this period of wartime privations was that she had to work as much as she could – from five to six hours a day in the summer – before art supplies ran out from the city's stores.[22]

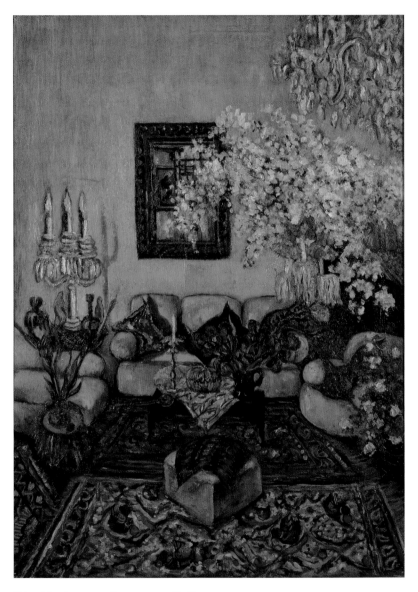

Oriental Interior, 1943, oil on canvas, 118 × 85 cm

Turkish Bath, 1943, oil on canvas, 54 × 64.5 cm

Three Moments in a Day and a Life, 1944, oil on canvas, 105 × 205 cm

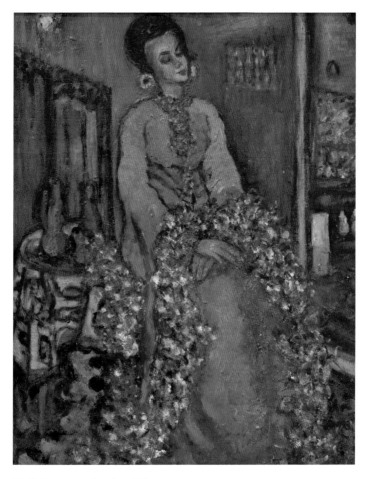

Untitled, 1940–5, oil on board, 65 × 51 cm

Her considerable output prompted Adil to encourage her to think about mounting her first solo exhibition. He suggested she hold it at the State Academy of Fine Arts, where she had already exhibited with the D Group, but she thought it would be better to show in her apartment instead. There is no available information as to how or why she came about the idea, but it was clearly her own. As there were few galleries in Istanbul at the time, she may have

wanted a space that she could control in which to present all her output. Her flat was not an obvious choice, however, since it was in a residential area out of reach of public transportation. She nevertheless decided to hold the exhibition there as a challenge to herself, telling Adil that if people came and liked her work, she would continue to paint, and if not, she would give up altogether.[23]

To the depths of despair

In February 1944, amid her extended preparations for the exhibition, Fahrelnissa returned briefly to Baghdad, as she had not been there in six years. Pre-empting the melancholy that she thought would reoccur, after fulfilling essential social calls, she sent word that she was too ill to receive visitors, and she spent the rest of her time in the Iraqi capital sketching.[24] Nevertheless, even while she was finally realizing her dream to be a recognized artist, she endured a second major depressive crisis and bout of suicidal despair. Again, Dr Hoff was summoned. This time she would leave for Istanbul to resume her artistic career, never to return to Baghdad. Her recovery was short-lived, however, as she suffered other deep depressions in June and October back in Turkey, leading her to fill pages of her diaries with thoughts of contemplating and accepting death. Each time, she was prescribed stimulants and total convalescence, but to no avail, as the desperation seemed to lift just as inexplicably as it fell.[25]

These episodes of despondence and withdrawal from social and familial interaction would recur throughout her life, well into the mid-1960s, but they appeared to subside in her final two decades, when other, more physical ailments overtook her.[26] After moving to Europe in 1946, she would treat her mental illness with medication as well as with short seaside stays in Brighton, Eastbourne, Torquay, and the Italian and French rivieras. There she would spend days sketching passers-by and seagulls, and finding the pebbles that she would transform into works of art. Shirin Devrim conceded in her memoir that Fahrelnissa's family and friends did not understand nor take seriously her condition, which they dismissed as mere mood swings. She retrospectively diagnosed her mother as suffering from a clinical depression caused by chemical imbalance, and an undiagnosed hypoglycaemia.[27]

A pen-and-ink self-portrait drawing from a 1944 sketchbook

Self-portrait, 1944, charcoal on paper, 33 × 25 cm

While Fahrelnissa herself also did not try to understand her mental health, she did make a link between it and her work. She would often tell the story of how Dr Hoff had prescribed painting as a remedy for her malaise.[28] And she would credit two other doctors, a Professor Hoynol in Budapest and a Dr Fuller at the American Hospital in Paris, with having encouraged her to 'seriously work on her painting', adding that she owed them her 'artistic activity'.[29] It appears that this was not false modesty or self-pity on her part, as she was convinced that painting was her way out of the pall of her mental condition. She elaborated this notion as early as 1948 in a letter to the British art critic Maurice Collis (1889–1973). In anguished terms, she described this period of serial hospitalizations as an 'unjust' and 'inexplicable tragedy' that plagued her in the form of ailments – pulmonary embolisms, anginas. She explained in her halting English that she had saved herself from death by sheer force of will, thanks to art: 'Only by painting, drawing – this painting has saved

my life.... I was working. The only thing which helped me was to see the colour of the world which I could no more see.'[30] A year later, she would add that her condition could even help her work. She wrote to Irish painter Louis le Brocquy (1916–2012) that she was 'not sorry to be ill. Illness sometimes helps you. Keeps you away from too many distractions. And obliges you to enter in your "real one", your real personality [...] but not when I cannot paint – then – the real – oh! The only real illness starts – because I then understand how of no use I am. I have no meaning.'[31]

Her diaries and sketchbooks evidence the correlation between Fahrelnissa's mental state and her art. All her accounts of depressive bouts and hospitalizations are accompanied with descriptions of her spending days sketching. She intersperses pages about her moods with sketches of her bedroom or vistas from her windows. The most striking such occurrence is in her 1944 diaries, where during one of her gravest crises, she mustered the energy to draw tens of figures of Bedouin women in coloured gouache.

Sketches of Bedouin women wearing their *abayas*, Baghdad, 1944

Alongside a two-page sketch filled with raven silhouettes walking with their *abayas* floating in the air, she wrote little complaints about her sadness, loneliness, and despair. However, she could also have a sense of humour about her illnesses. She told le Brocquy: 'Red piles [pills]. Green piles. Orange piles. My doctor I am afraid will finish by being a painter. As he knows the magic attraction of the colours on my senses. He has divided his medicines in very colourful balls indeed.'[32]

As for the effects of her illness on her painting process, they appear to be inversely correlated. Fahrelnissa had always had a voracious tendency to sketch, as an extension of her being. Before the invention of ballpoint pens, she would carry in her handbag wherever she went a sketchbook and a bottle of black china ink, and she would take them out during breaks in shopping and running her errands. In Germany, she would sketch while listening to a recital of chamber music;[33] on her trip to the United States, she could spend a luncheon drawing her surroundings if she liked them, rather than eating; and at the theatre, she would spend an evening sketching a performance rather than merely watching.[34] This energy for a quasi-instinctive drawing did not leave her during her illnesses and depressive episodes, when she would lie in bed, on the seashore, or in hospitals spontaneously sketching nurses, doctors, or the view from her room.

On the other hand, the works that she painted so prolifically and at great speed in the coming decades required her to stand or sit for hours and days, and therefore necessitated a different type of energy. Despite what she wrote to Collis, willpower alone is not enough to turn a depressive person into such a painter. The stimulants that she was prescribed may have provided her with the euphoria and physical energy to initiate a work, but they ceased to have an effect after a while. It appears that Fahrelnissa's episodically depressive condition alternated with periods of physical endurance and mental focus. The deep absorption and lasting stamina that she exhibited when swimming also manifested itself when she painted. In the early 1940s, when she was preparing for her first group exhibitions in Istanbul, she would often write in her diary of standing for hours at her easel. In London after 1946, she would lock herself

in her home studio with a concentration described by Shirin as so 'absolute' that she would routinely forgo meals and prohibit any interruption at all.[35] Fahrelnissa did not shy away from publically discussing her hyper-focus, and as early as 1945 she would speak of wishing for the 'complete annihilation of the woman, the wife, the mother [with all her duties], to leave the way to the artist'.[36] Indeed, she described painting as a depersonalized act, as a sort of trance where her subjectivity was lost:

> Often I am aware of what I have painted only when the canvas is at last finished. Sometimes, I am almost shocked by the alien quality of one of my paintings, or by the sheer mass and variety of my works. If I return to my studio after a long absence abroad, I find so many pictures that I no longer remember having painted that I sometimes ask myself how I can possibly have produced so much work.... The pictures come into being, and I stop working only when I'm interrupted, or too exhausted to continue.[37]

Bursting onto the Istanbul art scene

Despite her mental turmoils, she continued to work after her return to Istanbul. In March 1945, she took part in a D Group exhibition and then threw herself – with the help of her sister Aliye – into preparing her own solo show. Because she was so prolific, she had accumulated a large number of works, painted in Baghdad and Istanbul, and could not decide how to select which ones to exhibit. In the end, she chose to show the majority of them, a total of 172 works, a hard-to-imagine figure for a first-time artist. To accommodate them, she sent her furniture to storage and emptied four large rooms in her apartment in the Ralli building. Photographs show the works hung close together and sometimes superposed, but they did not seem crammed or hard to take in. To show that she was a serious artist, she said, Fahrelnissa exhibited nude paintings and priced all her works. She admitted later that she had been petrified before the exhibition opened on 14 April. 'When I took a last look at myself in the mirror, I saw I was white with fear. To my reflection in the mirror I said, "You are

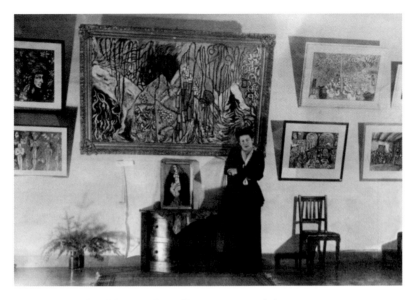

The April 1945 solo exhibition in her Ralli apartment, Istanbul,
standing in front of *Three Moments in a Day and a Life*

Sketches of visitors to the 1945 solo show looking at her painting *Three Ways of Living (War)*

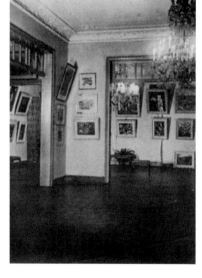

The catalogue of her May 1946 solo show The 1946 exhibition in her apartment

going public. Be prepared to be torn apart."' She need not to have worried. The exhibition lasted two weeks and was thronged from the start, including with schoolchildren, to whom Fahrelnissa took pleasure in explaining her works.[38] The brochure ran out and had to be reprinted.[39] Expectedly, she drew sketches of the space and of the different visitors. She would later say that it was her most 'marking' show, and that the governor of Istanbul had told her that it was not an exhibition, but a revolution.[40] During this period, she became sufficiently famous to be solicited for numerous press interviews, and was asked to illustrate a poetry collection by a well-known poet.[41]

Given this critical and popular success, her exhibition was followed in short order by more. She had a solo exhibition in Izmir (Smyrna) on Turkey's Aegean coast in May 1945; participated the following year in another D Group show; and then in May 1946 replicated her experiment by holding a second solo exhibition at her Istanbul apartment, this time showing 183 works, followed in quick succession by another solo show in Izmir, at the House of the People.

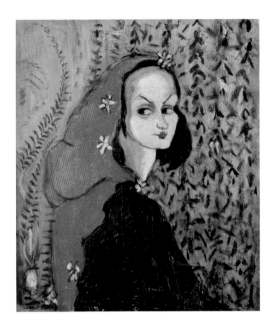

Untitled, 1940–5, oil on
canvas, 50 × 45 cm

A painter of 'decorative expressionism'

The body of work that she produced between 1940 – when she repainted her stolen Budapest paintings – and 1946, when she made her last works of a Turkish subject matter, belong to her high figurative period. The works are numerous but do not appear to show a marked difference in style. Judging from available photographs and the titles in exhibition brochures, they are all figurative works: interiors, city scenes of Budapest and Istanbul, landscapes of Izmir, Baghdad, and of the Bosphorus bay, portraits and self-portraits, nudes, and two symbolist works. Overwhelmingly they are oils on paper and wood, with a few on canvas. They generally range from small to medium size, but also include four larger works, the scope of which she would develop in the next decades.[42] She may have wanted to replicate the large Old Masters paintings that had impressed her so much on her travels, and she probably had the means to buy hard-to-find canvases of this size. At any rate, her exalted temperament

and the metaphysical subjects that she had in mind must have predisposed her to work on larger surfaces.

By the end of this period, Fahrelnissa would have reached such fame that she could be the object of coverage in various magazines like a celebrity.[43] However, available Turkish reviews are remarkable when compared with her future European reviews for focusing on components of her work, rather than ascribing properties projected from her social status and origin. They identified characteristics that would remain in her work after her evolution towards abstraction: maximalism and even decorative expressionism. One reviewer of her solo 1945 exhibition, for example, noticed her modernism and remarked that 'abundance' is the 'dominant trait' of her work.[44] Another tied her work to her struggle to overcome illness and suffering, while also praising the 'essential truth' and universality of her Istanbul sunsets, mosques, and skylines, devoid of orientalist 'soppiness'.[45] Another reviewer remarked that Fahrelnissa had not yet adopted at the time a definite style but was still searching for one according to her 'interior world'. Thus, she is divided between what he called the vaguely surrealist, meaning symbolist, works that were somewhat hermetic to viewers and a 'temperament' that gives 'free rein' to a 'decorative expressionism'. That temperament was on evidence, for example, in the manner in which she painted her nudes, which he disliked for their 'voluntary trait' in underlining form and in abandoning the model's likeness for a 'richness and violence of colours'.[46] In 1945, Fikret Adil praised her 'sincerity', modernity, and 'artistry'.[47] In Paris, when Fahrelnissa showed works from this period at the Musée Cernuschi – two landscapes, two still lifes, and four gouaches – a leading modern art critic favourably compared her works to those of Henri Matisse and Raoul Dufy.[48]

The oddity among the works from this period is her *Three Ways of Living (War)* of 1943, a painting alien to the rest of her output in its heavy symbolism and dark fatalism.[49] Yet Fahrelnissa was proud of it, even 'adored' it. She posed in front of it for the press, sketched visitors before it, and put it on the cover of her first exhibition brochure. The work depicts life and death, side by side. On the left is a large panorama of a Turkish Muslim cemetery with its white marble tombs surmounted by turbans and surrounded by tall cypress trees. One of the

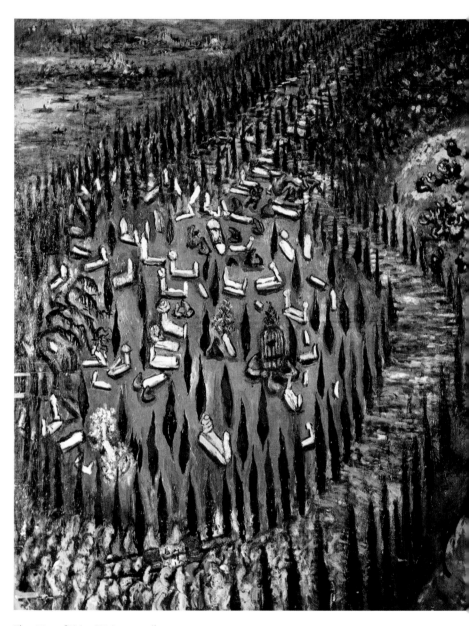

Three Ways of Living (War), 1943, oil on canvas, 205 × 125 cm

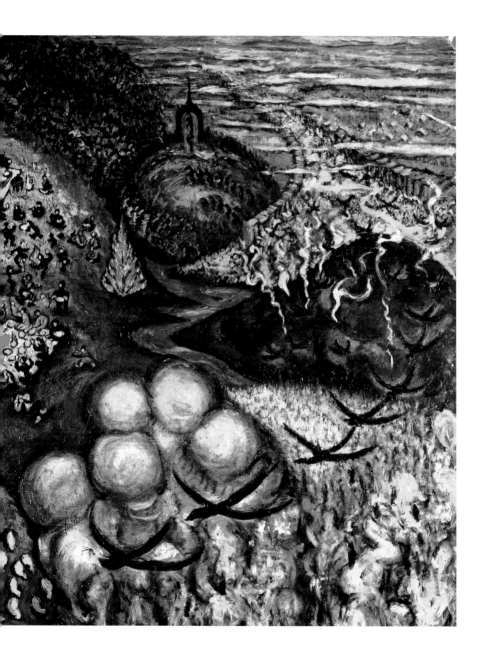

tombs is freshly dug, while a winding cortege ascends towards the cemetery carrying a stretcher aloft. In the middle of the canvas are two contrasting scenes of pulsating life, one at the top shows dancers, men and women dressed in black, while in the middle is another group massed around a large tablecloth having a picnic. Separating them from the right side of the painting is a lone tree, ablaze like a tree of life that Fahrelnissa would later reference in her career. Finally, on the right is a scene of destruction, with dark thin birds flying in formation above billowing clouds, plumes of smoke, and rising flames. The painting could be called two ways of dying, for it is conceivable that those perishing on the right of the canvas, presumably under the bombs in Europe, would not know the dignity of a burial and the tranquillity of the verdant setting at the left. The composition recalls more a nightmare by Hieronymous Bosch than a celebration of life by Pieter Brueghel. It may have been born out of

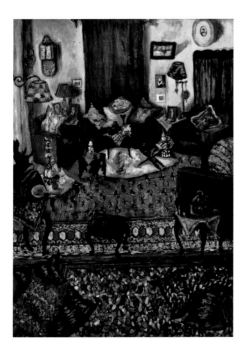

*My Winter Flat
in Istanbul,* 1943,
oil on canvas,
72 × 55 cm

My Summer House,
Buyukdere, 1943,
oil on canvas,
80 × 50 cm

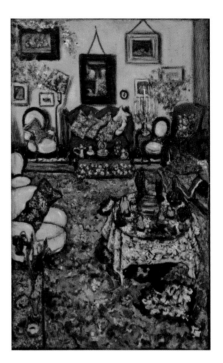

Fahrelnissa's feeling of isolation from Europe, which she was unable to visit during the war, and may express a fatalism influenced by some of her readings at that time.

This period's other works have been consistently compared by contemporary critics to Bonnard's. Fahrelnissa did share his interest in colour and in portraying interiors, and her four surviving interiors paintings could be documentations of her hard work painstakingly assembling the furnishings in her various houses. However, each interior's flattened space is possessed of a singular force far from Bonnard's tranquil rooms. In My Winter Flat in Istanbul, the swarming motifs of the carpet compete for attention with the large throw pillows on them. In My Summer House, Buyukdere, the motifs on the blue carpet appear like the depths of a busy seabed, whose motifs compete with those of an equally busy yellow tablecloth covered with enamel and coral Buddhas.

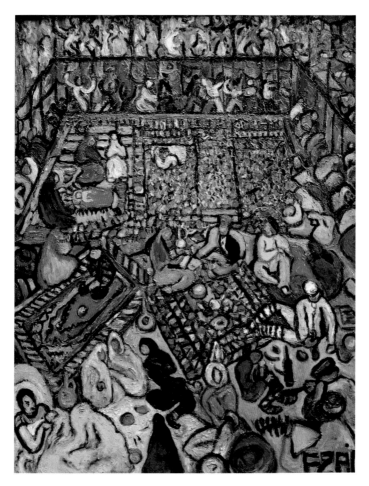

Third Class Passengers, 1943, oil on canvas, 130 × 100 cm

There is hardly any respite for the eye. This work and *Oriental Interior* (p. 64) stand out for their clearly defined *cloisonnement*. A web of black lines separates volumes and figures from each other and from space, even forming a complex contrasting interplay of angles and diagonals and of juxtaposed gridlike patterns inlaid with clashing primary colours, as in *Third Class Passengers*. In all

these interiors, the vividness of the colours and the piling up of objects and of people are not relieved by an exterior light or shadow, rather each colour plane appears possessed with an innate incandescent luminosity. The clash of colour dominates everything, even the quality of the brushwork, which appears secondary. In the darkened *Beshiktas, My Studio*, it is rough and unfinished; in *Third Class Passengers*, colours look blended by hand; while in *My Summer House* and *My Winter Flat*, very fine brushstrokes are visible. For Fahrelnissa, what appears to matter when painting is the distribution of colours in space. Uniquely, she creates a dynamic representation of these interiors by enclosing and separating off each object and highlighting their colours. Her untitled 1945 oil-on-wood painting of fish resembles Matisse's 1912 *Goldfish* in centring its receptacle. Here, however, the fish are very much dead, lying in a round plate. What is striking is the complementarity in colour between the orange and black paisley-like motifs on tablecloth and the tigerlike yellow stripes of the carpet. This makes for an incongruous vivid dynamism and unusual choice of colour in a prosaic kitchen still life that is anything but still.

Beshiktas, My Studio, 1943, oil on canvas, 60 × 50 cm

Untitled, 1945, oil on canvas, 70 × 60 cm

The Blue Tree, 1943, oil on canvas, 54 × 45 cm

As for Fahrelnissa's outdoor scenes, a tentacular tree straight out of Brueghel's *Winter Landscape with a Bird Trap* (1565) dominates many of them. It invades the plane of the dramatic ink on paper *The Tree* of 1943, as well as the oil on canvas *Blue Tree* from the same year. It also appears in 1944 at the centre of the bucolic *Polones Koy*, and is multiplied into a menacing row of tall black trees with naked branches traversing *A Winter Day, Istanbul à la Brueghel's Hunters in the Snow* (1565). While the tree may be a simple interpretation of a motif by one painter admiring the work of another, its representation differs in each instance. *The Blue Tree* is a happy painting of a specimen growing in her Buyukdere garden; while the menacing black tree in the work on paper represents one of those found in Beyazit Square – it was such a visitors' favourite at her first Istanbul exhibition that she put it on the cover of her Izmir brochure.

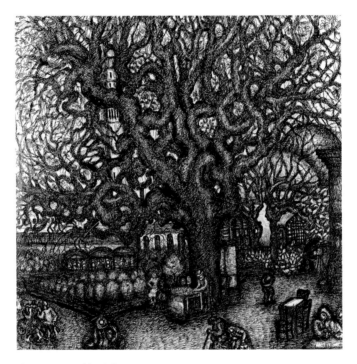

The Tree, 1943, china ink on paper, 74 × 74 cm

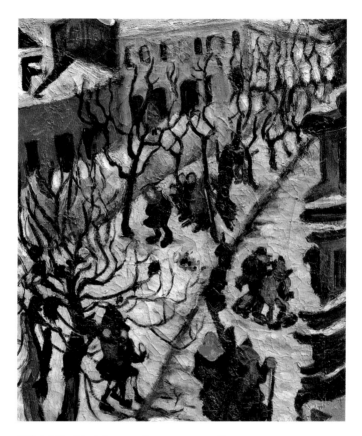

A Winter's Day Istanbul, 1944, oil on canvas, 70 × 60 cm

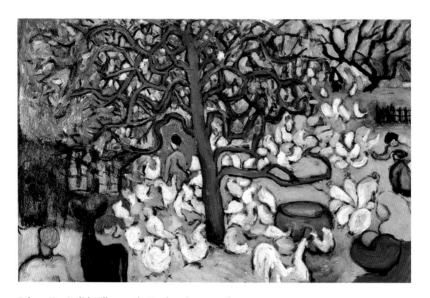

Polones Koy (Polish Village on the Bosphorus), 1944, oil on canvas, 91 × 59 cm

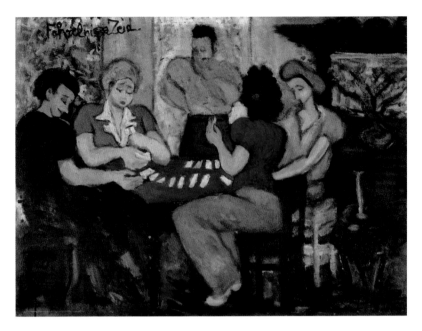

Concan Players, 1944, oil on canvas, 99 × 72 cm

The spindly branches in all these compositions may be a stylized transposition of the black lines of her interiors and of their gridlike *cloisonnements*, but here the lines are liberated to undulate and roam over the canvas and dominate its surface rather than being disciplined into grids or webs. The trees appear almost as free explorations of dynamism and movement for their own sake. If they are a homage to Brueghel, they are also an anticipation of Fahrelnissa's later abstract kinetics.

Her outdoors works are characteristically rushed and quick compositions pulsating with life. In *Emin Efendi Lokantasi* (1945), *Concan Players* (1944), or *Boats on the Bosphorus* (1944), the paintings are free of studied details of the faces of the card players or revellers in the hotel, or of the boats on the bay. What matters in these works is the dynamic capture of colour and of movement, seized in an all-encompassing panoramic manner, viewed from above, from an

all-seeing perspective. Fahrelnissa paints the overall visual effect, with volume created by colours floating on the canvas. The impact is one of a joyous and dynamic representation of life.

 Also noteworthy is her regular inclusion of nudes in her exhibitions and catalogues. Despite the constraints on nude painting at the official School of Fine Arts, the first nudes in Turkish art began to appear with the 1914 Generation. Slowly, desexualized male and female nudes found their way into further exhibitions, in a realist style as well as in different modernist currents. Having thoroughly absorbed the requirements of her *beaux-arts* education, Fahrelnissa was proud of her own nudes, showing them to her suitors at the age of eighteen. It was also while painting a realist nude at the Académie Ranson that she experienced an epiphany that would shape her future course. She continued to produce nudes through the 1930s and 1940s in her sketchbooks, and had a nude model come to her house in Istanbul twice a week to pose. Two 1944 nudes, *Nude* and *Study*, show the integrated setting of Fahrelnissa's work. She, who said in a 1945 interview that she hoped to annihilate the mother and

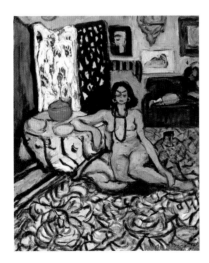

Nude, 1944, oil on canvas, 80 × 65 cm Study, 1944, oil on canvas, 55 × 56 cm

the wife in favour of the artist, represents here the slightly ungainly nude in her own living room, rather than in a generic studio. She paints the model amidst her recognizable domestic furnishings, and includes in the background of *Nude* her daughter Shirin lying on a sofa. She does not eliminate or idealize; she fuses and moulds quickly and expressively what she sees, and what she feels.

On the move again

The following year, 1946, Prince Zeid was appointed ambassador of Iraq to London, an all-important diplomatic post for the country, which was in the political and financial orbit of the United Kingdom. It was also a key position for the Iraqi royal family, which had sought refuge in Britain during the short-lived 1941 nationalist military coup in Iraq; the young boy-king Faisal II was enrolled at Harrow School, alongside his second cousin Hussein, who went on to become King Hussein of Jordan. For Fahrelnissa, the move was a welcome change. Despite her successes in Istanbul, she had tired of the local art scene and the 'jealousies and rivalries of her painter group'.[50] In the self-introduction letter that she wrote in 1948 to Maurice Collis, she described in her beginner's English how she had to wage a 'fight' against the artistic milieu that dismissed her for being a 'woman – a society lady' who could only be a 'very superficial doll' until she was able to 'find myself'.[51]

Fahrelnissa ended her short but intense Turkish period with a stopover in Paris in November 1946, her first visit to the French capital since the start of the Second World War. She used her brief time there to satisfy her voracious cultural appetite and attended plays such as Federico García Lorca's *House of Barnarda Alba*, *Hamlet* with Jean-Louis Barrault, and Jean Giraudoux's *La Folle de Chaillot*.[52] More importantly, she participated in two group exhibitions along with other D Group artists and her son Nejad, who had recently settled in the city. The newly established UNESCO organized the first exhibition, which was held at the Musée d'Art Moderne and featured more than one thousand works by a who's who of international art, including Tarsila Do Amaral, Francis Bacon, Roger Bissière, Pierre Bonnard, Alexander Calder, Marc Chagall, Raoul Dufy, Georgia O'Keeffe, Wifredo Lam, Joan Miró, Henry Moore,

and Pablo Picasso. The second show, which opened two weeks later, was held at the Musée Cernuschi and displayed modern Turkish art alongside Ottoman antiques and Islamic art.

Over the course of less than five years, Fahrelnissa had managed to overcome considerable personal health difficulties and emerge as an artist who was respected on both the local and the international stages. She did so on her own terms, free from many influences that had ostensibly structured her practice: the classicism of her early studies, the mysticism of the Nabis' Académie Ranson, and the D Group's ambition to cultivate a Turkish modernism inspired by Anatolian aesthetics and western futuristic syntheses. She cultivated her own practice further by forging ahead and exhibiting alone in the unconventional setting of her house and outside the Istanbul art centre. As for her painting, what she lacked in a unifying style she compensated for with the integrity of her approach, regardless of subject matter. Her works combine a Fauvist sensitivity to stark colouring and an Expressionist exaggeration of form with her own rapidity of line and brushstroke. With her acceptance into the D Group, and her successful forays outside it, Fahrelnissa achieved in a short span of time all and more that she could hope for in postwar Turkey. Prince Zeid's posting to London was an opportunity to meet new challenges.

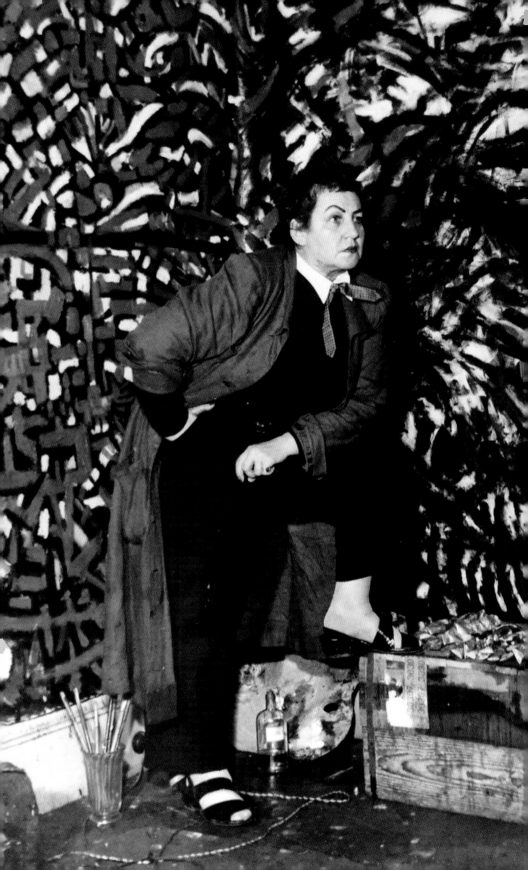

London, New York, and the Abstract Turn 1947–57

It was only after the Second World War that I began to feel at my ease as a painter. In 1946, shortly after my second show in Istanbul, I moved to Western Europe and soon began to exhibit in Paris and London too. As long as I had still lived and worked in Turkey, I had seemed to distrust my own artistic initiatives. I was too isolated, too unsure of myself. Now I feel that I am at last understood and accepted, whether in London or in Paris, as an artist rather than as a kind of freak.[1]

The 'freak' of which Fahrelnissa spoke in this interview published in 1960 was a woman of the Turkish upper bourgeoisie who dabbled in painting. Despite the success she had seen in Istanbul, she remained something of a peculiarity there. But as a foreigner living in a large metropolis such as London, she would not be defined so much by her place in the local socio-historical structure. She was freer to be who she wanted to be. Perhaps for that reason, within just a year of arriving in Britain she had reinvented herself by shifting to abstraction. With characteristic boldness and ambition, she painted works incomparable in scale and kinetic chromatics. She also managed the rare feat of conducting a career in two separate cultural-linguistic areas. Today, she is mostly associated with her presence in postwar Paris (the subject of the following chapter), but she also exhibited her work in London

Fahrelnissa in her London studio, 1950s

in the late 1940s and 1950s, as well as in New York at the height of Abstract Expressionism. Indeed, her new abstract style was first produced and shown in Britain and the United States, before being developed and conceptualized in France. In turn, her Parisian reputation fed back into the London art scene, allowing her to become the first woman to have a solo exhibition at the Institute of Contemporary Arts (ICA) in 1954.

A double life

The decade after she and Prince Zeid arrived in London was a high point of Fahrelnissa's life, in terms of social activity, artistic development, and recognition. She managed to lead two different kinds of lives, despite her ever-shifting moods.[2] The first was a busy existence as a famed diplomatic hostess living in the Iraqi embassy's Robert Adam-designed rooms at 22 Queen's Gate, South Kensington, also known as 'Millionaires Row'. There she entertained reigning Iraqi and British monarchs and assorted international royalty and diplomats, hosted and cared for visiting family members for months at a time, and managed a large domestic staff. Meanwhile, she pursued her second life as a successful artist active on the international stage.[3] She devoted large amounts of time to working in a studio that she converted on the third floor of

Fahrelnissa hosts the Iraqi royal family – Queen Aliya, King Faisal, and Princess Abdiyah – at the embassy, late 1940s

The private quarters of the Iraqi embassy residence were filled with Fahrelnissa's own paintings and works by other artists.

the embassy residence, sometimes days on end. She coped with her depressive episodes by making frequent trips to the seaside, especially to Brighton and Eastbourne, which she spent in contemplation by the shore, sketching, and developing a new minor art practice of collecting pebbles and painting them.

As was her wont, Fahrelnissa refused any separation of these two lives, inviting diplomats, royalty, and other dignitaries to her exhibitions. Dressed in fur, she received two British queens to her first exhibition in London in 1948 – Queen Elizabeth, the current queen's mother, and Queen Mary, the wife of George V and Elizabeth II's grandmother – and gifted them two of her works.[4] The non-formal areas of the Iraqi residence were covered with her paintings, which she displayed beside the sculptures that she owned by César, Henry Moore, and Lynn Chadwick.[5] There, she also entertained in an attempt to have a

At home in the Iraqi
embassy residence,
South Kensington,
London, late 1940s.

salon like the one she had organized in Istanbul. She welcomed César, Giorgio de Chirico, and other cultural figures from overseas to the house, alongside local figures such as poet Kathleen Raine, writer and critic Maurice Collis, actress Luise Rainer, sculptor Kenneth Armitage, art historian and ICA founder Roland Penrose, writer John Haywood, Irish poet Louis MacNeice, Irish painter Louis le Brocquy, historian Steven Runciman, art publisher Richard Gainsborough, painter Francis Rose, and Tate Gallery director John Rothenstein.[6] Nor did she compartmentalize in her artistic life either. She participated in lower-profile group exhibitions organized by the Women's International Art Club, while pursuing and obtaining invitations to exhibit at significant private galleries and the ICA. Even in the years when the focus of her artistic activity was Paris, she cultivated friendships with a great number of artists in London, via her two gallerists in the city, Lea Jaray (1880–1968) and Philip Granville (1911–2003).

As for her connections to Iraq, they were chiefly familial. Members of the royal family were frequent visitors. The young King Faisal II attended the

Fahrelnissa and Prince Zeid in the embassy, photographed for a *Daily Telegraph and Morning Post* feature on 22 August 1947. She wrote on the photograph that she had been wearing a 'royal blue Schiaparelli jacket'.

openings of Fahrelnissa's London exhibitions, and accompanied her to an exhibition of Iraqi artists that she opened in 1949.[7] Perhaps with her encouragement, he even participated in another group exhibition of Middle East and Arab painters that Fahrelnissa opened in 1950, showing an 'amusing study of marine life' that he had painted.[8] She kept him apprised of her work, and they corresponded about it even when he returned to Iraq after reaching his majority in 1953.[9] In Baghdad, the modern art and architecture scene thrived in the late 1950s, becoming one of the most innovative in the history of Arab modernism. She participated in 1957 in an All Iraqi Artists Exhibition in Baghdad, sending a lithograph.[10] Nevertheless, Fahrelnissa appears to have been solicited by artists there, or by the Iraqi Artists' Society at least, more as a potential patron than as a practitioner herself. The art scene there boomed in the early republican period after 1958, but Fahrelnissa, living in Europe, may have been too associated with the *ancien régime* to be included. She did come to the attention of some artists and collectors there, however, via an interview that the Iraqi

painter Jamil Hamoudi conducted with her in Paris in 1950 to coincide with her first solo show in the French capital, at the Galerie Colette Allendy.[11]

A new city, a new profile

Relatively little is known about the circumstances surrounding her first London exhibition in February 1948, nor what was exhibited. Her daughter Shirin wrote that it was the initiative of Lea Jaray, who visited Fahrelnissa at home and was impressed by her paintings, and suggested that she exhibit them at the St George's Gallery in Grosvenor Street, where she was then working.[12] Jaray was a well-known Jewish art dealer in Vienna before the war, and a friend of many German and Austrian Expressionists.[13] She had fled the Nazis to London when her gallery was Aryanized and her paintings confiscated.[14] As a supporter of Expressionism, she would have noticed Fahrelnissa's figurative works from her Istanbul period. The one known photograph of the event shows that the St George's Gallery space was small, with many of the works stacked above one another. Perhaps following the example of the D Group, which had their exhibitions opened by government ministers, Fahrelnissa had the show inaugurated by the wife of the then foreign secretary, Ernest Bevin, and later invited queens Elizabeth and Mary to visit the gallery. She sold five works on paper – gouaches and etchings of Istanbul cityscapes mainly – for a total of £84 14s.[15]

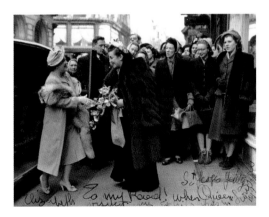

Fahrelnissa greets Queen Elizabeth to the exhibition at St George's Gallery in February 1948

The exterior of
St George's Gallery,
81 Grosvenor Street
in Mayfair. A photograph
of the exhibition (*below*)
shows Fahrelnissa's large
1944 canvas *Three Moments
in a Day and a Life* on the
right-hand wall.

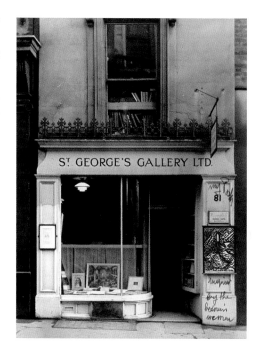

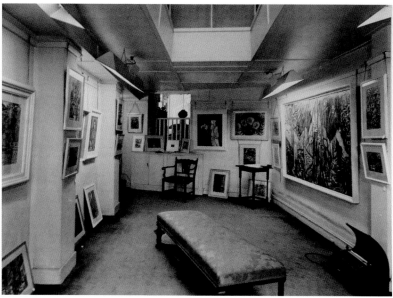

99

Two important sources for understanding how Fahrelnissa's work of these London years was received by the public and the arts establishment are the texts that were written to accompany her exhibitions and the reviews that were published afterwards. What is striking are the similarities between these two forms of written response to her art. Both the formal interpretations and the journalistic criticism largely followed the same pattern of engaging with the works, focusing on the skill and colour of the paintings and the emotional strength that they convey, rather than concentrating on the artist's persona and social status. Important art critics such as the *Guardian*'s George Butcher, the *Daily Telegraph*'s Terence Mullaly, and Maurice Collis, who contributed to the *Observer*, the *New Statesman* and *Time and Tide* magazine, wrote about Fahrelnissa more than once, giving these writers a familiarity that allowed them to consider the artist's aims and the properties of the works. If some reviews referred to her royal title, that does not detract from the overall tenor of the articles' engagement with the paintings and her artistic intentions. Collis, for example, who wrote the only available review of the St George's Gallery exhibition, recommended the show highly, emphasizing her 'talent' and singling out various works for their 'sweep', 'matured technique of great virtuosity and beauty', and 'imaginative conception ... exceptional assurance and power'.[16]

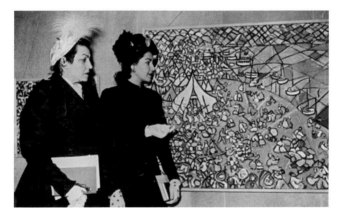

Fahrelnissa and Shirin look at *Loch Lomond* at the 1948 show at Gimpel Fils

Fahrelnissa exhibited again only three months later, in May 1948, this time showing work in a radically different style and on a bigger scale, in the larger premises of the recently founded Gimpel Fils gallery, then on South Molton Street. The gallery specialized in postwar British avant-garde and École de Paris artists. Fahrelnissa exhibited thirty new works, oils and watercolours, reproductions of which do not survive, apart from just one work, *Loch Lomond*. They were named after places she had visited: *Camping in Scotland*, *The Golden Ray of Baghdad*, *From the Eiffel Tower*, *Regent's Park*, *Torquay Beach*, *Excursion Boats at Brighton*, *High Seas at Eastbourne*, and so on. She would exhibit again at Gimpel Fils eight months later, in January 1949, but no records survive.[17]

After these three early shows, Fahrelnissa did not have a solo exhibition in London for another five years, while she was busy establishing herself in Paris. She did, however, also look across the Atlantic for new opportunities.

Facing the New York avant-garde

Soon after the second exhibition at Gimpel Fils, Fahrelnissa went to the United States for the first time. Her daughter Shirin had gone to study at Yale after the Second World War and had married a fellow university drama student and settled there, so she already had family reasons to visit. Then her son Nejad was invited to be part of a large group show of young French and American artists that New York dealer Leo Castelli was planning for the following year, which may have further encouraged Fahrelnissa to make her own transcontinental foray in the spring of 1949.[18] It would be not only her first trip to America, the lengthy flight with refuelling stopovers in the Azores was also her first time on an aeroplane. Always sensitive to visual stimuli, what impressed her most about New York was the sky. 'There is no night, no darkness in this city. The buildings go into the sky, and their lights mingle with the stars. One feels surrounded and never lonely.' She painted a Dufy-like watercolour of Central Park with yellow clouds, because she said the 'taxis are yellow'.[19]

While she was in New York, Fahrelnissa consulted with Alexander Iolas (1907–87), the flamboyant Levantine Greek manager of the Hugo Gallery, who soon agreed to organize a show of her work. There is no information about

how this connection was made, although it may have been because of shared Parisian acquaintances. The Hugo Gallery had opened in 1945 and first showed Surrealists' works, including a 1947 group exhibition with Arshile Gorky, Isamu Noguchi, and Roberto Matta, and a Magritte show. Iolas would later become a major art dealer and patron, founding an important eponymous gallery that represented European Surrealists and championed Minimalism and Pop Art, including exhibiting and commissioning works by a young Andy Warhol.[20]

Fahrelnissa's exhibition at the Hugo Gallery opened in January 1950. She showed just seven paintings, all entirely geometric kaleidoscopic abstract canvases, including a few that she had shown previously in London, and a collection of painted pebbles. Unlike the earlier works that bore the names of places that had inspired her, the paintings shown in New York had titles evocative of her interest in otherworldly universes: Adam and Eve, Circus – This World, The Other World, Stratosphere, Men Before Birth. They ranged in size from the small to the monumental Voyage of the Man Moon (pp. 104–5), which was almost six metres wide. Most of these works have disappeared. The paintings were severely geometric and painstakingly detailed, and were traversed by chromatic compositional subdivisions imparting depth and dynamism.

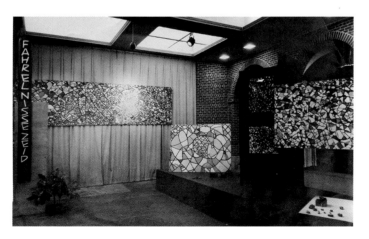

The exhibition at the Hugo Gallery, New York, January 1950

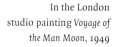

In the London studio painting *Voyage of the Man Moon*, 1949

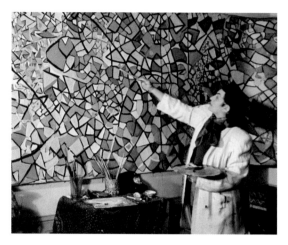

Fahrelnissa was alone and a newcomer to New York, without social or artistic connections, and lacking in the cultural references that she recognized in Europe. The Hugo Gallery's presentation would be all-important in introducing her work to a new audience – and it was clear how it wanted to present her. The black-and-turquoise exhibition catalogue described her as an 'Oriental Painter', and was adorned with the stylized Arabic calligraphy of her name that she would use in later decades to sign her paintings. A biographical text further highlighted a real or imagined exoticism of Fahrelnissa's multi-civilizational family and cultural background. A preface, written by the French author André Maurois for a very different exhibition at Galerie Colette Allendy in Paris a month earlier, was reproduced in the original French. This short text praised Fahrelnissa's work for its originality, while seeing in it evocations of 'oriental carpets', 'primitive Byzantines', and 'Batiks of Java', which are 'dictated by her hereditary instincts', among which are the influence of 'Arab artists' and of their 'Saracen disciples', to whom 'figurative art was forbidden [...] [and who] had to express themselves by forms with no other precise meaning than their beauty'.[21] Only a black-and-white photograph of the artist, showing her standing in a white smock before a giant canvas horizontally unfurled on two walls, denoted any contemporariness.

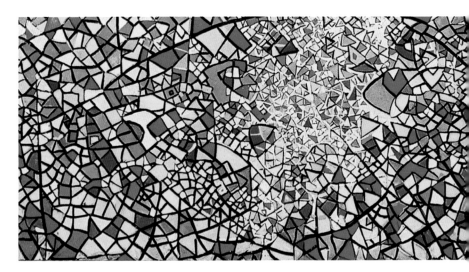

Voyage of the Man Moon, 1950, oil on canvas, approx. 600 × 160 cm

This exotic presentation may have accounted for the disappointment communicated by Iolas in an extraordinary letter that he sent to Fahrelnissa a few months later, about the obstacles he faced in marketing her work. This letter is an important historical document bearing witness to the nationalist development of the New York art scene. Writing in French, he referred to the existence since 1949 of 'an American school, very nationalist and very anti--foreigner ... whose principal residence is the Parsons Gallery, which issues quasi divine and superhuman condemnations and protections. This group is considered as the important one that will save world painting.' He gave Jackson Pollock as an example, and asserted his dislike of nationalism in art. He added that if the trend continued in its limiting and narrowing way, it would risk adopting the motto of 'the Betty Parsons factory formula'. He further imparted some more extraordinary information, about three small gouaches that Fahrelnissa had offered to the Museum of Modern Art, but which had been rejected, on the pretext that the museum was holding out for more 'evolved art' by her in the future. Referring to the favourable critical coverage Fahrelnissa

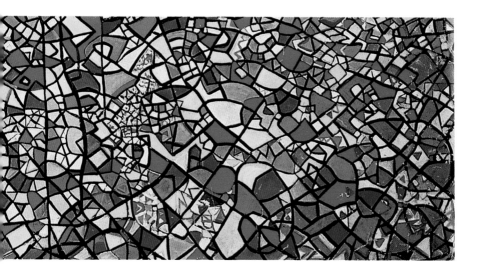

was then receiving in Paris, Iolas violently bemoaned the 'mentality' of local art critics, concluding that it was unfair to compare French 'finesse and understanding' with that of Americans.[22]

The Parsons/Pollock reference was due not only to Betty Parsons' importance as a dealer, but also to the increased profile of Pollock after his famous profile in *Life* magazine in December 1949, which led Parsons to sell nearly all the stock of his work immediately thereafter.[23] Parsons represented the New York avant-garde, which had been left without a gallery after Peggy Guggenheim closed the Art of This Century and returned to live in Europe in 1947. Her gallery espoused the new postwar American self-confidence in the arts. The avant-garde art of the day was Abstract Expressionism, which represented an individualist abstraction of obliteration and erasure. American artists would pride themselves on their unfinished and unselfconscious works compared with those of their European peers.[24] This outlook was common not only among New York avant-garde painters, but also among the institutions that promoted them. One can easily understand why Fahrelnissa could not

make inroads in this atmosphere. She did not attend her New York opening, and her abstract works were demonstrations of vibrant maximalist layerings rather than anguished self-expressions. Under these conditions, any attempt to understand her unfamiliar approach may have been obviated by the Franco-Orientalist aura that her gallery constructed, at a time when French art influences were being rejected in the United States as passé. Regardless of what one saw on the canvas, the gallery had already defined her as an oriental women undertaking sophisticated maximalist work under the influence of centuries of decorative tradition.

Beyond what Iolas's letter reveals about the New York art scene, it also gives us an insight into Fahrelnissa's aspirations and approach in promoting herself. Still, she did not give up entirely on the idea of being collected in the United States. At least one canvas and a few lithographs are in the permanent collection of a New York museum; other works can be found in regional institutions; and one key painting has been in an important American corporate collection for many years.[25]

Towards abstraction

The exhibitions held in London in 1948 and 1949 and then in New York in 1950 provided evidence of a dramatic shift in Fahrelnissa's work over that period from a quasi-expressionistic figurative approach to full-on abstraction. Rarely does an artist display such a rapid evolution in their style, and it raises the question of what caused the change. Her own published statements on the timing and reasons for this move towards abstraction are somewhat contradictory. However, clues are provided by reconstructing the timeline of the transformation.

The shift apparently occurred at some point during the course of 1947 and 1948, because her earliest truly abstract sketches began to appear as geometric colourful designs in her sketchbooks of 1949 and alongside diary entries of trips to Paris and the United States in that same year. As for her paintings, the works in the first London exhibition at St George's Gallery in February 1948 were mostly from her earlier figurative 'expressionist-symbolist' Turkish

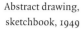

Abstract drawing, sketchbook, 1949

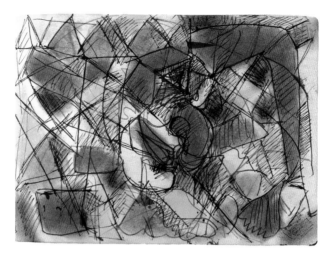

shows. The decision to show again at Gimpel Fils just three months later must have been motivated by an impatient desire to exhibit new work in a new style. Unfortunately, there are no available images of works from that show, except for the semi-abstract *Loch Lomond* in the catalogue, which also mentions the fully abstract *Adam and Eve*. A month later, in June, she entered a single abstract painting into the Gimpel Fils summer exhibition. We do not know what she exhibited in her January 1949 exhibition at Gimpel Fils, but the works on show at Galerie Colette Allendy in December of that year appear to have been wholly abstract (of which more in the next chapter);[26] and at the Hugo Gallery in New York the following month, the show was also entirely abstract.

Complicating this timeline, however, is some dubious dating of several works. The primary reference until now has been a 1984 monograph edited by two of her students, Suha Shoman and Meg Abu Hamdan, and published with her input.[27] However, that volume features several obvious errors in dating, perhaps due to Fahrelnissa's advanced age and faulty recollection at the time. These clear mistakes lead one inevitably to question other dates in the book that seem to be wrong judging by the works' appearance. For example, two

paintings of Bedouin women in Baghdad are listed as having been painted after her shift to abstraction: the figurative *Bedouins Selling Yoghurt*, which is given as 1949 despite resembling work from at least five years previously; and the proto-abstract *Bedouin Women (Towards Abstract)*, which the book attributes to 1950 – that is, after her fully abstract shows in Paris and New York. What is more, neither painting appears in any exhibition list from those two years, as one might expect for works deemed so important to feature in her 'definitive' monograph thirty years later, but a canvas entitled 'Bedouin Women Yoghurt Sellers' (*Yogurt Satan Bedevi Kandinlar*) does appear in the brochure for the first exhibition in her Istanbul apartment in April 1945. On the other hand, other semi-abstract works from 1947 and 1948 do seem to be correctly dated in Shoman and Abu Hamdan's publication. *Fight Against Abstraction*, for example, is dated to 1947; *Loch Lomond* can be reliably dated to 1948, since it was shown at Gimpel Fils in that year; and the similar *Bath and Tents, Scotland* are also dated to 1948.

Taken together, all the evidence suggests therefore that the years 1947 and 1948 were indeed when she started to shift towards abstraction, and that 1949 saw its full flowering. Having established these dates, what were the reasons for the transformation? The only apparently relevant occurrence of 1947 was the March opening of Nejad's solo exhibition of abstract paintings at the Galerie Allard in Paris.[28] Fahrelnissa's trips to the French capital would have been her first exposure to a postwar art scene characterized by its adherence to abstraction. Her son's exhibition of abstract works must have further stimulated her to delve into it. Even her former instructor Roger Bissière had moved to abstraction in 1946.[29]

As for Fahrelnissa's own statements as to why she moved away from figuration, they indicate a gradual and sometimes painful process consisting of several liberating moments rather than a single conscious and deliberate decision. In the early 1980s, she would tell her long-time friend art critic André Parinaud (1924–2006) that what influenced her to turn to abstraction were two visual and perceptual shocks involving receding and appearing objects and colours in space: the twin effects of the sight of advancing and vanishing Bedouin women in their coloured dresses and black *abayas*, whom she saw in

Baghdad in 1938 and 1944, and the visual and psychological impact of experiencing air travel for the first time in 1949.[30] She would tell her son Prince Raad much the same thing when he asked about the meaning of her abstract art: that abstraction is how one sees the world from an aeroplane window – space parcelled into squares and strips of blotches of colour.[31] She told Parinaud that she did not 'intend to become an abstract painter':

> I was a person working very conventionally with forms. But flying
> by plane transformed me. You see the horizon in front of you ... and
> then you enter the plane ... what a shock! The world is upside down.
> A whole city could be held in your hand: the world seen from above.
> I wanted to fix that in my head; I was stupefied [ahurie] the first time.
> When I went to America ... I watched from above the sky the little
> dots that were cars, houses, monuments. Your brain cannot accept
> this immediately [...] it is so powerful! [...] Another souvenir that
> played a role in my abstract evolution was during my first trip to the
> orient in Baghdad. I saw in the great expanses, the Bedouins 'fly' ...
> from my window, I saw from dawn the very distant road, coloured
> orange in the morning. This is how I saw six or seven silhouettes
> that came from the depth of the horizon, as if flying over the sands.
> I was petrified. They had on top of their heads a pyramid of pots of
> yoghurt, that looked from afar like very high chimneys ... and their
> veils floated in this gold [hue] that was ablaze. I ran to the window,
> but they had already passed.... This little event played a role in my
> abstract painting.... While looking at the Bedouin women, I was
> seeing space, speed and movement.[32]

If we take Fahrelnissa at her word, then, the initial catalyst for her transition towards abstraction was the sight of these *abaya*-clad women during her 'first trip to the orient in Baghdad' in 1938. While that may be true, we have no visual evidence of the fact. What we do have, however, are the visible traces of an evolution in her style after she saw similar women six years later. There

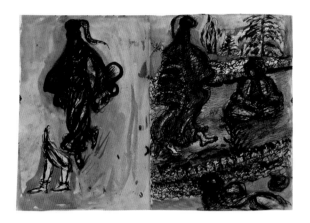

(*above and opposite*) Drawings of Bedouin women, Baghdad, 1944

are plentiful sketches that she made in 1944 in Baghdad, shortly before her second major depressive episode there. The drawings are a series of forceful and rapid representations of various women wearing black *abayas* against coloured backgrounds of golden ochre horizons or green lawns. Sometimes she replaced black with ochre and orange, perhaps as the figures merged in her sight with the intense colour of the horizon at dawn. They show a skilled draughtsmanship and command of colour devoid of ethnographic detailing. The women are depersonalized, their faces de-emphasized, and only aspects of

their silhouetted forms and the articulation of movement are explored. These are obviously studies of colour and motion in space, the two principal formal concerns of Fahrelnissa's work in the coming decades. She charts the flapping of the black shapes in the wind, sometimes the deployment of the sail-like *abayas*, and sometimes the forward progress of the figures' advancing silhouettes. She draws the folds of the *abayas*, at times like dark billowing clouds, at others like deflated hot-air balloons, even like raven-coloured flames. In some sketches, she paints a naked leg emerging from the folds, or bare feet circled by anklets; in others, she draws the yoghurt and *gaimar* sellers with their piles of baskets melded into chimney-like columns on their heads, the women, veils, and containers forming one entity moving through space. In two sketches, a woman alone and a group of three women appear like black sails distended by a stormy wind. In another sketch, she draws a seated woman in a pyramidal shape, with a large faintly coloured basket in front of her. The woman's *abaya* is open showing two infants in her lap and an older child in front of her. This remarkable silhouette is drawn in a tangle of fine black lines characteristic of the sketches Fahrelnissa did during her depressive and convalescent episodes of the late 1930s and early 1940s. The woman is formed from an incandescent jet *grisaille*. Creating depth and shape with her quick handling of the ink and her delimitation of space, Fahrelnissa treats the black ink as if it were a colour.

Bedouins Selling Yoghurt, 1944/5? (originally dated 1949), oil on canvas, 48 × 70 cm

As for her painted works on the subject, the most famous is *Bedouins Selling Yoghurt*, which is of questionable date, as we have seen, but presumably from 1944 or 1945. Here, Fahrelnissa paints the women more straightforwardly: five in a line, three of them wearing coloured dresses, golden bangles, and opened black *abayas*, with piled baskets on their heads. The painting could have belonged in a D Group exhibition, and perhaps it did, because of its expressionistic style and anthropological detail. More intriguing is the follow-up *Bedouin Women (Towards Abstract)*, which arguably dates from roughly the same time and not 1950, as the 1984 publication would have it. Fahrelnissa herself commented that in this small oil on paper, she 'began decomposing towards the abstract'.[33] The yellow work represents a barely discernible silhouette of a woman with a white pillar on her head, her arms open and laden with bangles. On the horizon is a cityscape of minarets and domes. However, covering the surface of the painting, almost as an afterthought, is a loose and incomplete grid of black lines at the bottom and a grid of droplets of yellow and white paint at the top. In the middle, are more spatters of white, cloudlike

*Bedouin Women
(Towards Abstract)*, 1944/5?
(originally dated 1950),
oil on paper, 60 × 50 cm

paint. The whole effect appears as an unfinished experiment with line and colour, unrelated to the subject matter, which has been produced rather rapidly. And yet not only does the painting appear in the 1984 book, it is also framed under glass in the Fahrelnissa Zeid Archive in Amman, evidence perhaps that Fahrelnissa considered it completed, and indeed as a precursor to her abstract work. It shows none of the sharp delineation or parcelled kaleidoscopic colour of her first abstract and semi-abstract canvases, but like those later works it is a loose and dynamic composition of dispersed elements of line, pigment, and shape. It appears that after painting a conventional figurative rendition of a Bedouin, Fahrelnissa may have had the sudden intuition to depersonalize the figure and cover it with a deconstructed vocabulary of things to come. Whatever the motivation, this radically different work demonstrates that her overriding concerns were with movement and colour, regardless of the style she adopted at any given time.

Bath, 1948, oil on canvas, 115 × 138 cm

She continued to produce and exhibit mainly Istanbul cityscapes until 1948, when she painted the visibly hybrid *Loch Lomond*. Her process with this work appears more systematic, and the painting's elements clearly announce her subsequent abstraction. It depicts an outdoor country holiday with numerous people captured from a panoramic height, à la Brueghel. Unlike the work of the Flemish painter, however, the painting is not a wide centre-less composition. Its left side shows a large white tent pitched on a bank surrounded by a multitude of small coloured pod shapes representing people and smaller tents. In the middle is the loch, its top half painted red and criss-crossed by diagonal black lines, while its bottom half is painted green like the 1943 Budapest frozen skating pond (p. 55). It is also criss-crossed by black diagonal lines, and is dotted with canoes from which emerge black fishing rods and lines. A horizontal multicoloured mesh bars the horizon. This improbable composition was later explained by Fahrelnissa as having been the result of a combination of whimsy and various mixed memories. She wrote that during a trip to Scotland she had visited Edinburgh's Holyrood Palace and noticed the

kilts of two of the guards. They told her that they were from different clans and that each clan had its own colour and design of kilt. When Fahrelnissa returned to her studio in London and began to paint the loch, the memory of the guards' kilts appeared to her, so she 'began doing abstraction at the same time by amusing myself'.[34]

Regardless of the reasons for the irruption of the kaleidoscopic in this painting, what strikes here is the mirror effect between the teeming humanity on the left side of the painting and the geometrical alveoli of the top and right hand of the canvas. Both sides evidence the twin characteristics of Fahrelnissa's figurative and abstract work: her rapidly drawn thick black lines and her swarming accumulation of elements. The mirroring is achieved via colour and size, but in the process a transmutation is operated that makes this painting a case study of an evolution from the representational to the abstract. The campers in the lower part of the canvas slowly morph to the extreme left into minute biomorphic shapes, while the tents above them gradually recede into a blur of triangular shapes. The shapes of the holidaymakers and their tents are then projected and distilled into their simplest expression, into triangles, squares, and lozenges of colour framing the horizontal top half of the work and at the

Loch Lomond, 1948, oil on canvas, 103 × 194 cm

Tents, Scotland, 1948. oil on canvas, 60 × 50 cm

top-right corner. Fahrelnissa said that the memory of kilts injected itself, but what she achieved here is a real-time sleight of hand, the incarnation of a visual process of transformation of recognizable figurative shapes into abstraction. What could be explained by animation on film – the way figures might morph into abstract shapes – is here realized and laid out statically in painting.

Not the full picture?

The question remains, though, should we take Fahrelnissa at her word about the timing of and reasons for her shift towards abstraction? The chronology suggests that we should treat her clear-cut explanation to André Parinaud with at least some scepticism, for, as we have seen, her abstract style emerged in London during 1947 and 1948, a whole decade after her first trip to Baghdad and many months before she flew for the first time. It was only during her second trip to Iraq in 1944 that she began to draw the women extensively and methodically, initially as they appeared and then progressively paring them down to silhouetted forms; and even if her semi-abstract and abstract paintings of the early London years, such as *Loch Lomond* and *Tents, Scotland*, do resemble

parcelled strips of land as seen from an aeroplane, these predate her earliest air travel by at least a year.

It seems, therefore, that the transformation to abstraction may not be due to these two visual shocks, at least not entirely. Fahrelnissa was certainly hyper-susceptible to visual stimuli, but while she may have experienced perspective-changing epiphanies and perhaps psychic shocks when she travelled, these were not the origin of her switch to abstraction. Rather, it was a variety of memories, impressions, and experiences that she drew upon and realized on canvas once she had decided to shift to abstraction. Her work in abstraction must have been latent, a long-awaited liberation, as she explained: 'With abstract painting, it was my unconscious side that looked to express itself, by translating my inner exigencies, without giving a definitive point, without fixing things.'[35] However, that liberation may not have been easy. Fahrelnissa described it as a painful decision, a struggle. Indeed, in 1947 she painted a large painting of a whimsy mélange of symbolist figurative corporeal fragments surrounded and submerged by attacking geometric shapes and shards of colour, entitled *Fight Against Abstraction*. Fahrelnissa would in fact say decades later that she had 'fought abstraction' because she believed that there ought to be recognizable 'forms' in art.[36]

Fight Against Abstraction, 1947, oil on canvas, 103 × 153 cm

Resolved Problems, 1948, oil on canvas, 130 × 97 cm

Abstraction, c. 1947, oil on canvas, 75 × 63.5 cm

Untitled, 1949, oil on canvas, 127 × 182 cm

Mosaics, 1949, oil on canvas, 105 × 156.5 cm

Complicated Stagnancy, 1949, oil on canvas, 132 × 180 cm

By 1949, however, she had embraced a conception of abstraction as a process of artistic maturity, of communion with the absolute, as a voyage into the infinite, a purification, and a liberation from the limited world of objects and figuration. That is how she defined it in a remarkable diary entry she wrote that year, presumably before she had read Wassily Kandinsky's influential 1912 treatise on the abstract, *Concerning the Spiritual in Art*.[37] Already she was using terms that reflected her characteristically exalted outlook:

> The abstract has always existed. [In the past] we had to deal with perspective, composition, but this essential rhythm which was the hard nucleus of the work [of art] had to be dressed, furnished if one can say that for the satisfaction of the eye that searched for visual and sensual beauty.
>
> Today with the abstract, man has reached the summits – man goes towards the infinite – space – it is a window open from our world

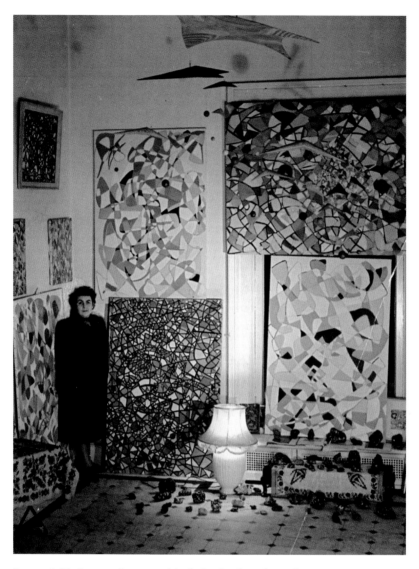

Surrounded by her new abstract work in the Iraqi embassy in London,
date unknown, thought to be c. 1949/50

to other worlds. It is the reach of a boundless and limitless thought. It is the ultimate superiority of the human brain.

Why must we always see with the eyes of this world, why not see farther and enlarge the visual orb and reach even the divine, in a circle traversed by cosmic waves? [...] So why hold on to primary and infantile details, a portrait, a chair, and a child? All this has been done and redone. It can add nothing to the spectator's mind who wants to learn, to be struck by sensations, like one who searches for the north wind at sea in the midst of winter to feel washed, refreshed and cleansed of all that has been accumulated in him of miasma and refuse from the city.[38]

Given this spiritualist outlook, it is a wonder that Fahrelnissa did not adhere to abstraction earlier. This explanation appears as the more radical and convincing reason for her switch to abstraction.

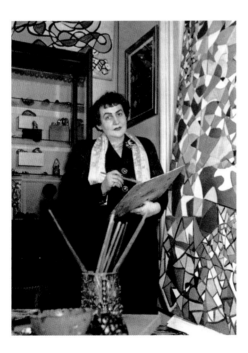

In the London studio, working on one of her early abstract compositions, c. 1949/50

The Summer and Winter 1951 issues of *Poetry London*, featuring a lithograph by Fahrelnissa

A return to London

Earlier in 1949, she had bought a small apartment in Paris to use as a studio there. For the next five years, while she continued to work also in London, she focused most of her efforts on establishing a presence in the French capital. Accordingly, her public activities in Britain in the early 1950s were limited to participation in a handful of group shows. In 1951, the literary magazine *Poetry London* featured one of her lithographs on its front cover. As we shall see in the next chapter, she used her time in Paris to develop and mature her emerging abstract work, producing and showing several key paintings while she was there. She also cultivated a number of connections with important French critics and promoters of avant-garde art that put her in good stead when she resumed exhibiting in London.

She did so in style with a major exhibition at the prestigious Institute of Contemporary Arts in July 1954. At the time located at 17 Dover Street in Mayfair, the ICA had been founded eight years earlier in 1946 as a space for radical modern and contemporary art. It presented the work of living greats such as

Recent Paintings by

FAHR-EL-NISSA ZEID

Private View Friday 9 July 1954 3 to 6 pm
Roland Penrose will open the exhibition at 5 pm
in the presence of the artist

The Exhibition will remain open until 31 July 1954
Monday-Saturday 10.30 am - 6 pm closed Sundays

Admit two (Private View only)

ICA Gallery 17-18 Dover Street W1

The invitation card to Fahrelnissa's exhibition at the Institute of Contemporary Arts in London, July 1954

Picasso, Moore, Henri Cartier-Bresson, Wilfredo Lam, Oskar Kokoschka, and Max Ernst. Not only was Fahrelnissa the first woman to have a solo exhibition there, she was the only female artist to receive that honour in the first twenty years of its existence, apart from a handful of small displays in the library after 1961. She was in esteemed company: her show immediately followed one by Georges Braque and preceded Francis Bacon's first solo exhibition in a UK institution.[39] In it, she showed eleven oils and thirty-five gouaches painted in London and Paris between 1951 and 1953, including her two monumental canvases *My Hell* of 1951 (pp. 158–9) and *Towards a Sky* from 1953 (p. 163).

The two texts in the exhibition catalogue imply that it was on the strength of her Parisian reputation that Fahrelnissa had earned the show. The main text was by Roland Penrose, one of the ICA's founders and chairman and the principal promoter of Surrealism in Britain, who introduced Fahrelnissa as 'a painter who must astonish us all by her courage, her talent and her unfailing sensibility'. As a champion of African art, he inevitably chose to tie the 'ease and conviction' of her abstract works to 'the nonrepresentational traditions of her native art'. However, he did not essentialize her and added, 'It would be a serious mistake to see no more ... than pattern making or superficial doodles. As the artist has told us, all the pictures are founded on her observations of life in its various forms and the emotions caused by the events of everyday existence.' He also referred to her 'visions of inner nature of the world'.[40]

Reviewers of the ICA show were more direct than Penrose. One wrote in the *Guardian*, 'The princess's red is indeed so eloquent that to enter the room is like walking into a shout. The uproar comes mainly from one or two enormous pictures in which the artist has developed her mosaic-like technique on a truly startling scale.'[41] Terence Mullaly was more detailed, writing that her original work appealed to both the emotions and the intellect. She was of 'patent sincerity', he wrote, and 'combines with great manual facility the ... double gift of insight and ability to communicate'. Unlike other critics over the years, he noted justly, 'the actual size of the picture seems irrelevant. So subtle is her actual practice of painting, so persuasive her vision.' Turning to colour, he noted, 'her work is deeply rewarding. One of the most impressive characteristics [...] is her extraordinary ability to speak to us through colour. [...] Worth noting the great purity of her colours [...] dazzling intensity she achieves in her large canvases [...] Sparkling, glittering, vibrating joyousness, through which we can obtain a new insight into the natural world. [...] She can evoke ... not only elemental forces, but also a whole range of varying moods. Above all, she succeeds in conveying an enormous degree of emotional intensity.' He then

The ICA exhibition, showing *My Hell* on the far wall

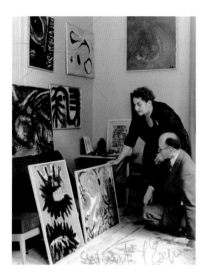

Selecting work with
Philip Granville for the
1957 Lord's Gallery
exhibition

shifted into culturalist exegesis by arguing that Fahrelnissa drew upon 'the wisdom and the technique of Europe and the Middle East'; he also compared her work to Islamic metalwork.[42]

Fahrelnissa's next and final London solo show was the inaugural exhibition of the Lord's Gallery, established in June 1957 by Philip Granville, another art dealer who had escaped the Nazis, in his case from France. He founded the small and subsequently commercially successful gallery in his home in St John's Wood – in the shadow of the famous cricket ground that gave the business its name – as a showcase for British and European modern art. There he exhibited artists such as Robert Delaunay, Paul Delvaux, Jean Tinguely, Ben Nicholson, Man Ray, and Victor Pasmore; he also championed the German Dadaist Kurt Schwitters and promoted historic poster art.[43] Because of his French background, he spoke and corresponded with Fahrelnissa in that language. Before opening his gallery, he was already selling her works, travelling to Germany and Belgium to do so.[44] He remained her London dealer until the 1980s. In her first show at the new gallery, she showed twenty-three paintings, including the six-by-two-metre *Towards a Sky* again, twenty-one gouaches and sixty-three

painted pebbles. Granville presented Fahrelnissa in his exhibition text as 'one of the most outstanding contemporary abstract painters'. He stated that her works were driven by her own internal thought processes, as they 'express her own compelling visions and have a strong suggestive power [...] The world that lives within our minds has also a reality, and [she] expresses it visually.... [She] carries in the tradition of imaginative painting, seeking her inspiration from the sea and sky, from the world around her and the world within her.'[45]

Mullaly, in his *Daily Telegraph* review of the exhibition, returned to the properties of her paintings and their saturated chromatics. He judged the impact of her work as immediate and lasting, and said that, 'If we fail to surrender ourselves to this undersea world of deep, but glowing colour, we miss much.'[46]

Granville inspects
Towards a Sky, installed
in the garden of Lord's
Gallery, June 1957

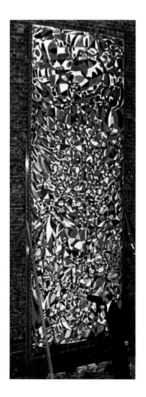

Guardian art critic George Butcher was more insightful. A specialist of non-European modern art, he had earlier praised her works in the touring Turkish exhibition organized by Derek Patmore, and then wrote a lengthy piece about her Lord's exhibition. Again, he underlined that her inspiration came from sea and sky, from the world around her and from the world within. However, he argued that she was not a literalist, for on a 'more psychological level', she 'works with a double vision – the inner eye (the unconscious) and her outer eye [...] [T]hese two visions are integrated into what becomes – literally – a single abstract-expressionist vision.'[47]

An intense process of working

What characterized the reception of Fahrelnissa's work in London in the 1950s is that these writers and reviewers invariably focused on the properties of the paintings and on her intentions, or at least on her inspirational working process. They appear to have had direct access to Fahrelnissa herself, not to the exotic persona elaborated by the lyrical texts that had been appearing in her

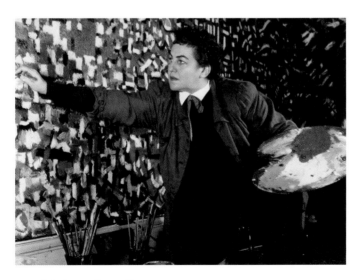

At work in the London studio, 1950s

When working on wide paintings in her studio space in the London embassy, she had to wrap the canvases along two walls and around the corner.

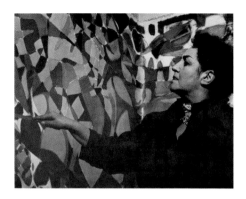

Paris exhibition catalogues (discussed in the next chapter). This is one reason why so many of them presented her art as an expression of the artist's inner life, of her inner perception of natural phenomena.

This inner perspective and outer vision was also combined in an arduous creative process, in which Fahrelnissa engaged in quasi-physical combat with her canvases. That process encompassed everything from periods of static contemplation and manic activity, a unique melding of torrents of physical and intellectual energies, careful compositional planning, whimsical inspiration, and spiritual possession. An insight into her complicated methods in the studio is provided by two separate accounts that she wrote in 1951 and 1956.

The first was a diary entry about the production of *My Hell*, perhaps her most celebrated work. She painted it to deal with the pain that she felt after the death of Queen Aliya, Prince Zeid's niece, in 1950. She had spent months being treated for cancer at the London Clinic, where Fahrelnissa visited her daily, bringing her home-cooked food. Afterwards, Fahrelnissa locked herself in her studio, contemplated the large canvas that she had specially commissioned from Winsor & Newton and had carried there by two of her butlers. She sat in her painting chair, which she called her *fauteuil critique*, and considered at length the vertiginous expanse, made brighter by the sun's illumination. She was petrified, as she did not know what to paint. She 'began to feel miserable [...] after so many preparations of the mind, and expenses it cost [...] lost in

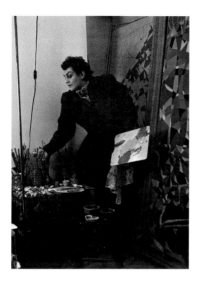

In the London studio,
c. 1950. A work in
progress can be seen
behind Fahrelnissa, with
charcoal lines drawn
across the surface in
preparation for painting.

the incommensurable depth of my mind'. Suddenly, a fly appeared and began to move on the canvas. Fahrelnissa described it in her halting English: the fly's shadow 'coming towards my work. I took from my bag a small pencil and I rushed exactly like mad, I was rushing from one side to the other side, rushing what was this terrible struggle terrible, which brought me from one corner to the other corner of the canvas. Six metres and a half. I began to laugh with myself.' Finally, she had done by hand what today would be generated by computer and projected onto the surface: she had drawn the lines of her kaleidoscopic grids onto the canvas in pencil and charcoal, before painting over them. She finished the drawing in one hour. 'The whole canvas was fixed, and the drawing was there. Not an empty place. The whole canvas was *composé*.'[48] She would then have another stage of filling in the alveoli with different undulating colour blocks that traversed the black grids, but at least she had devised the compositional structure.

In the second written account of her methods, from her diary entry for 24 January 1956, Fahrelnissa described an even more arduous and longer process of painting another large work. It was an extraordinary nineteen-page

document that she wrote as she worked in her Paris studio late one evening and into the early hours of the morning. The text is part dark night of the soul, part hand-to-hand combat, where she struggles physically and intellectually to build the right equilibrium of dynamism, space, and colours, while fighting against fatigue, ill health, telephone interruptions, and outside noise. Above all, she wages this battle with a tumultuous psyche veering from determination, exaltation, lucidity, and criticality to confusion and abandon. Despite the expenditure of intellectual and physical effort, she also took the time to transcribe her observations and describe her actions. She referred to herself in the second person in places to encourage herself, and addressed her painting and ideas as if they were sentient and physical presences that observe her and defy her.[49] Unlike the seemingly random approach in 1951, her painting process here revolves around a deliberate idea that she tried to realize out of an unpredictable equilibrium of contradictory lines, chromatic clusters, and kineticism. The relationship among these elements is one of force and power, as weakness and fragility are anathema to her. She writes:

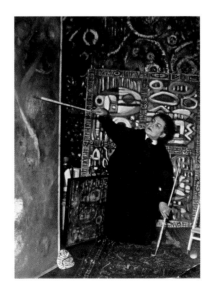

A later photograph shows Fahrelnissa in the studio, seemingly on her knees, tackling a large canvas. The painting *Alice in Wonderland* can be seen in the background looming over her.

I have to sustain in the corner above, the fire of the cadmium red at
the same degree as the dominant red, the summit of the tableau like a
bloodied horizon of intense life [...] [in] the middle the death blow is
given. [...] I return to the tableau. The hardest starts by where to paint
after the attack of directions. One must advance. Charge. Reinforce,
solidify, advance expressions, necessity, to coordinate, coordination
of the jet – and this cataclysm of a thousand ideas! The different jets
twisted in the past hours ... my brain traversed, assaulted on all sides

[I]

Must first create

must then see

must then judge

Must follow the hand that calls me to follow her – God knows she runs!

Must find the proper colour

Must juxtapose the secondary colour necessary to its bursting –

Must in addition to all this suffer from indigestion, must feel the
bitterness of the stomach, unfolding on the bitterness of the painting
that becomes a fiasco. Must damn destiny and eternity.

Must run to the telephone [...]

Everything seems suddenly empty of its veritable content. What? What
is this colour? What did I want to do with these other two colours?
What was the major idea that dictated the life of the tableau? Where
is the idea, the idea? Gone the idea. [...] What to do? Brought low,
harassed. Begin again, study the tableau with all its pros and cons,
look for the corner, the source ... take contact again [...]

The hours can flee. They drop in the silence of thought. One shall not,
one must not let them go this way. Impossible it is barely 20 minutes.
Since I write on these sheets. Yet how many turns around. I have turned
around the dance of ideas [...] in my head [...]

What is this tableau? Is it someone? [...] What a gaze! Me too I

look at him yes head on ... and I ask the tableau tell me at last what preoccupies you. What do you desire and what do you want with me? Why do you lazy about or play the mean lazy lazy naught one. But look how he looks tranquil without embarrassment [...]

Now sound of cymbals, I crush this monticule; I make it burst. Then on what side [to] take by surprise this gold colour, this boreal whiteness of eternal snows! Or here again this corner at the base, of a colour of a red, wide, undefined; too undefined for me ... And the tableau defined, purged of its miasma and its hesitations and its weaknesses and indecisions!

[...] It is a quarter to 11.
I am going towards a trip in my canvas. She has not told me her secret nor anything. Yet I wrote. I wanted to take notes of thoughts that crossed my brain – the thoughts the ideas – the coordination of thoughts and why the brush held at the hand, at the edge of the arm, commanded by a tiny cell of my head. Commanded also by all this 'being'. English word that adapts admirably to the state that I desire to explain. 'Being', means *être* but being for me is much vaster as a meaning. And stop with amplitude and the amplitude or the indefinite is Allah or Divine. Divine because it is unique and is without end.

[...] It is a quarter to two.
Returning from the kitchen, I have stage fright. Where to enter in my atelier. I dare not go frontally. Through the door of my bedroom, I would have an oblique vision! No no, I will not see well the canvas. Then I could make a mistake – taking it for a good painting when it is bad ... courage then let us go frontally. From the other door. [...] Meaning I want to see the canvas from the first room, which makes a direct gap of six metres. A good retreat and by advancing, I could best inspect the work. Courage. I choose the door opposite. I open it – I look – Eh eh! I am happy. The painting at first glance seems suddenly

to rebound and surge from I know not where. Finished its serene tranquillity. There is cohesion in indecision. There is consciousness in the unconscious and especially entente. An entente among the elements and its colours seem real for an eternity – an imponderable unification. The movement continues and returns … it is the first impression that strikes me. Impression that jumps to the eye and to the senses … but let us look in detail more. This line does not please me at all. Suddenly it has changed direction under the new push of colours, yellows, golds, lemon yellows and white […]

She is hard without signification nor vibration without stirring nor tenderness. Impossible too stiff … let us change it […] but how to remove all this scaffolding, a whole system – tight precise built under its invisible outside. Where and how to transport all this system or transport the system to another angle of sight – and to anther departure point. No no, it is dangerous, infinitely grave, too grave. I have no hold. If I touch, it is the tumble. So look, farther […] could it be this side where a discharge of gold and sun-gold seems to veer and hesitate in its position and its language does not [illegible] at all with the general theme, the orchestration? What to do? What to do my God? I will leave it for a time this will be better.
Let us wait then
Let us wait and let us the newcomers speak with the veterans. Let's go my girl. Again goodbye. Finish darling! Darling!
Am happy in this moment
It is probable that you will not be later.
[Doodles]

The same day at four thirty.
The lighthouse! All the light on me – I just closed the shutters on my [boulevard] Raspail […] it is spring weather outside. When the voices of the schoolchildren of the Saint Thomas d'Aquin school across

throw nightingale trills in the air! But I do not feel tired; [...] I like to be swallowed up in my big and so comfortable paternal *fauteuil*. [...]

I must be hard
Hard with myself!
Not to let myself be taken by the charm and joy for the first look. I must with reflexion unearth the defects [...] The canvas once finished but not finished, because a good number of important details and finally essential are demanded [...] but patience my child I mean I, Fahr El Nissa. Better to catch my breath. Physically you are starting to decline [...]

Divert yourself, distract yourself, rest. Then let anew your mind gambol in your brain. There. Look, follow the little fish in your aquarium. Eternally in movement [illegible] and in all directions. When your neck will not bear heavily on your white starched collar, when in an hour and a half you will not feel any more like sitting, then start at least criticizing severely, very severely like an impossibly severe judge your painting, and then you will put yourself back to work right away, if work is necessity!

After a good cup of warming tea! [...] It is 10 minutes to five.[50]

The remarkable articulateness with which she expressed herself here, and her struggle to discipline her thoughts and order her intentions, at last found free rein in her abstract work, which had been liberated, as she had written in her diary in December 1949, from the infantile imperatives of figuration. From writings such as these, we gain not only an understanding of her transition from figurative art to abstraction, and the motivations for it, but also an insight into the way her state of mind was reflected in her painting process, during this period of working in studios in two different cities, where she was able to consistently produce monumental canvases. It is a matter of conjecture what path she would have taken had she chosen to pursue her career exclusively in London. Typically, Fahrelnissa sought further challenges elsewhere.

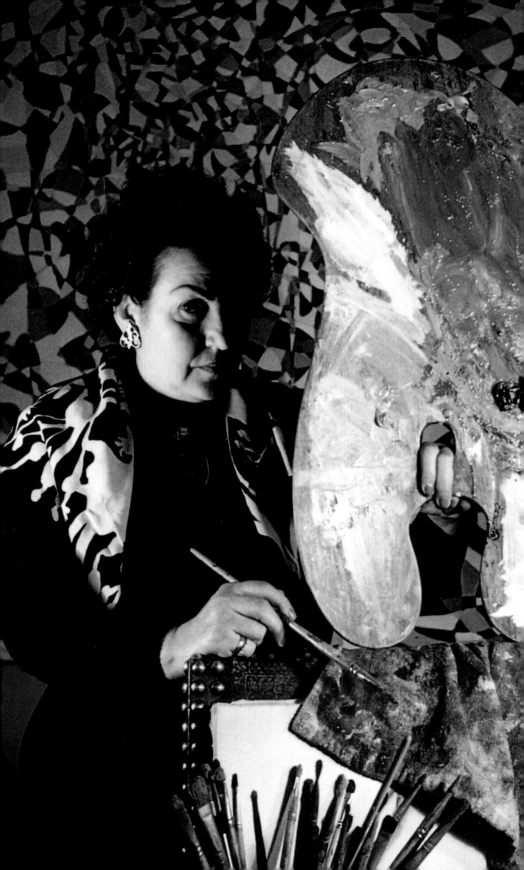

Fahrelnissa and the Nouvelle École de Paris
1949–57

F ahrelnissa's French education, her early introduction to French culture, and her personal Francophilia made Paris the logical place for her to seek recognition. It was her favourite city, and the place where she had received her artistic epiphany in 1928. The contacts she had made in the Montparnasse arts community in the late 1920s appear to have helped her later in Istanbul to solidify ties with her fellow D Group members, who were mostly educated in Paris; they also made it easier for her to re-enter the Paris scene at the end of the 1940s. Her son Nejad had moved there himself in 1946, and he had become part of the postwar constellation of artists from around the world working in the city in gestural and lyrical abstraction that would become known as the Nouvelle École de Paris. Unlike Fahrelnissa, he had studied Islamic and Byzantine colour schemes and endeavoured to modernize and replicate them in his abstract painting.[1] One of his acquaintances in the Parisian avant-garde was the American-born Alice B. Toklas, whom he introduced to his mother.[2] She congratulated Fahrelnissa on her first London exhibitions and encouraged her strongly to exhibit in Paris.[3] While she had already participated in the vast exhibition of international contemporary art organized by UNESCO at the Musée d'Art Moderne in November and December 1946, and also in the smaller show of Turkish and Ottoman art held at the Musée Cernuschi in the same months, it was not until her switch to abstraction that Fahrelnissa began to focus on establishing herself in Paris. Initially staying in hotels, she eventually

Fahrelnissa in her Paris studio, in front of the untitled work now in Tate, early to mid-1950s

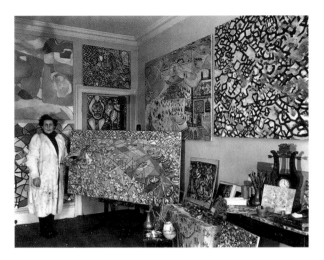

(above and opposite) In one of her rented Paris studios, *c.* 1950

rented apartments in the Montparnasse-Notre-Dame des Champs area of the Left Bank, first in rue d'Assass then rue Jean Bart, before buying a small apartment at 39 rue de Grenelle in 1954, in the Saint-Germain quarter, that she would keep and use as a studio for the next twenty-one years. As decades went by, she also rented three basement-storage spaces across Paris to house her art works and objets d'art.

In 1949, she met the influential critic Charles Estienne (1908–66), who was the driving force behind the emergence of the Nouvelle École de Paris. Her foreign origin and the lyricism of her abstract painting made her a natural fit for the loose group of international artists who were associated with the nascent movement, and like Nejad she became a member. The next decade was to be a period of prolific and changing production for Fahrelnissa, whose artistic practice matured and soared above the confines of the Nouvelle École de Paris. Even so, over the next seven years, she took part in most of its group shows, including its founding exhibition in 1952, while also holding numerous and frequent exhibitions of her own. Her profile as an artist and connections in Paris allowed her to meet her idol Henri Matisse; to have important avant-

garde figures such as Tristan Tzara and Francis Picabia visit her exhibitions; to sit for Gisèle Freund, one of the most important portrait photographers of the century; to exhibit alone in Brussels and Zurich; to become friends with the Surrealist leader André Breton; and to show work alongside such greats as Fernand Léger and Marc Chagall.[4] As early as 1952 she was included in a French art book dedicated to popularizing abstract art by profiling and presenting thirty-four contemporary abstractionists, with portrait photographs by CoBrA member Serge Vandercam. The book included Hans Arp, Sonia Delaunay, Serge Poliakoff, Nicolas de Staël, and Victor Vasarely, among others, and contained a detachable *pochoir* plate of the artists' works.[5]

An entrée into the Parisian avant-garde

Fahrelnissa had four solo exhibitions in Paris during this period. Their number, frequency, and locations testify to her productivity and connections, as well as her importance and integration in the local scene. Through her Musée Cernuschi contacts, Nejad's associates, and her numerous visits to the city, she had accumulated several leads, and she settled upon the Galerie Colette Allendy as the choice of venue for her first show. Originally a painter and

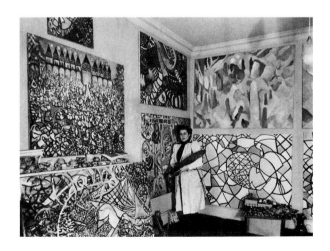

illustrator herself, Allendy (1895–1960) founded her eponymous gallery in the 16th *arrondissement* in 1946. She had begun by showing Dadaist artist Picabia's new work, at times alone and sometimes as part of the so-called 'HWPSMTB' group.[6] An early supporter of abstraction and of women painters, she also organized many important group exhibitions of the postwar avant-garde, such as 'Le Cubisme et l'Art Concret', early shows of the Nouveaux Réalistes, and the first exhibitions of Yves Klein.[7]

Fahrelnissa showed twelve abstract and semi-abstract oils at Galerie Colette Allendy in December 1949, five of which were based on her crossing of the Atlantic by plane earlier in the year, fourteen gouaches, and a few coloured pebbles that she called '*pierres ravivées*', revived stones. There are no available images of these works save for *Loch Lomond* and a kaleidoscopic gouache in the catalogue, and one *pierre ravivée*. The titles of the works and the reviews indicate that none of the works was figurative, and that some had been shown at the May 1948 Gimpel Fils exhibition.

Allendy was well connected and secured for Fahrelnissa the prestigious patronage of esteemed novelist and member of the Académie Française André Maurois, who wrote a preface to the ten-page exhibition catalogue, an excerpt of which was quoted in the previous chapter. As we have seen, in it Maurois emphasized Fahrelnissa's eastern origins above all else. It is intriguing, however, that he would end his oneirically orientalizing text by comparing her work with that of the French Fauvist and Expressionist painter Georges Rouault. Rouault was

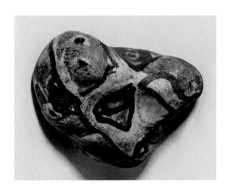

One of the painted
pierres ravivées shown
at Galerie Colette
Allendy in 1949

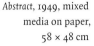
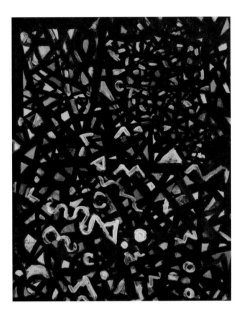

Abstract, 1949, mixed
media on paper,
58 × 48 cm

a figurative artist, but his landscapes do recall the colour palette of Fahrelnissa, while his heavily impastoed black lines delineating elements of a landscape and his portraits are similar to the black lines that traverse her early abstract paintings. The comparison was prescient also because her 1950s and 1960s portraits would indeed resemble those of Rouault. Maurois could have further explored these formal connections, but that task was left to art critic and historian Denys Chevalier (1921–78), who wrote the second and principal text in the catalogue. He deemed the artist 'unclassifiable' and her art as 'independent, solitary, and original ... rich, powerful'. Apparently familiar with her work, he argued that her renewal and inventiveness were at the service of a quest for an 'authentic personal expression'. Of the properties of her works, he noticed an opposition between the 'miniaturist spirit' of the 'indefinite fragmentation of planes' and the 'monumental ambition of the technique and dimensions' of her works, translated in paintings of 'mural character'.[8]

These texts directed the subsequent reflections on Fahrelnissa's work in Paris in two diverging directions: Maurois's preface viewed it reductively as

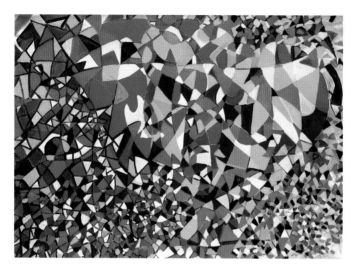

Abstract Composition, 1949, oil on canvas, 131 × 182.5 cm

an atavistic form of dictation-taking, simply taking its lead from the artist's 'hereditary instincts', while Chevalier's essay engaged with the characteristics of the individual works, their 'plastic fact'. Both the presentation and perception of her as a fantastically exotic artist were established with Maurois's text, reinforced later by Estienne's writing. Many reviewers would use the piece almost verbatim in the following decades, no doubt because of Maurois's reputation, even across the English Channel in Britain.[9] What may have helped to perpetuate this impression and focus on Fahrelnissa's origins was the self-construction of the Nouvelle École de Paris as a transnational, cosmopolitan movement rather than a national one. Further, Fahrelnissa's radically different and challenging paintings probably made it more expedient for a reviewer to impute their difference to her gender, social status, and cultural background. It was as if her nationality was an atavism that would surface on her canvases, if not in her actual behaviour and intellectual references. Such a view was not limited to French critics. Other European reviewers were also influenced by this orientalist framing; even Turkish writers and the Iraqi artist Jamil Hamoudi would provide similar exegeses of her work.

The reviews of Fahrelnissa's work that appeared in the most important art publications of the day in Paris and London, and even in Beirut, not only reappropriated the catalogue texts of each exhibition, they also reflected the reviewer's individual background. For example, the only available review of the 1949 Allendy exhibition is an English-language piece written by the prominent Bulgarian historian of Byzantine and abstract art Dora Ouvaliev (aka Vallier) that surpasses even Maurois's in its culturalism. It mentions Fahrelnissa's 'atavistic remembrance' and works 'full of sparkling light ... sumptuous and rich – like a Byzantine mosaic ... that is why [a Fahrelnissa] painting has so strange an aspect. [...] Faithful to the ageless wisdom of the East, she does not seek in painting an outlet for a frenzied individualism [...] her work bears witness to an extremely rich interior life. But the artist does not shelter behind

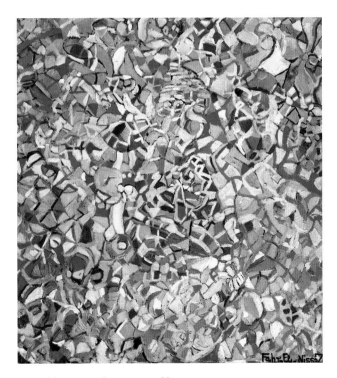

Composition, 1950, oil on canvas, 188 × 175 cm

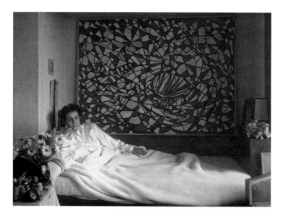

Fahrelnissa sent this photograph of her in bed in the daytime, with *Adam and Eve* behind, to Shirin from Paris on 26 July 1951.

the introspection inherent in westerners.'[10] Hamoudi, who visited the Allendy exhibition and then interviewed Fahrelnissa for the Lebanese publication *Al-Adeeb*, wrote a similar review for that magazine based on a nativist interpretation, disregarding her own words. He opened his article by implying that Arab artists invented abstraction, and assured his readers that Fahrelnissa's work had 'an oriental character that reminds viewers of ancient Arab art'. This contrasted sharply with his own quotes from Fahrelnissa, who spoke about her existentialist concerns, true to her exalted vision of art-making as a form of psychic survival: 'If we want to arrive in our art to possess a complete artistic personality, so we have to paint life, which we draw its sinuous lines in a continuous movement diverging in direction through this great void. And we must create what fills this void with colour [...] a living colour illuminated by the depths of the soul.' Despite what the artist had told him, Hamoudi concluded that she was inspired by the ancient art of Arab Islamic civilizations.[11]

This interpretation would persist. It was still apparent ten years later in an interview by the Turkish-American art historian Édouard Roditi (1910–92). Fahrelnissa's voice strains to be heard through his repeated questions about her Ottoman family history, but also about a series of unrelated topics, such as

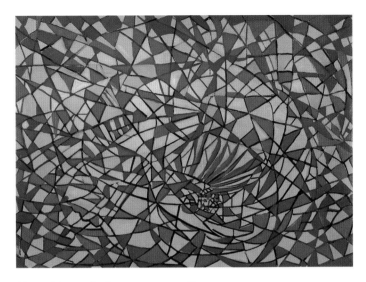

Adam and Eve, 1948, oil on canvas, 131 × 182 cm

Japanese and Arabic calligraphy and Sufi mysticism. She deliberately distanced her art, but not herself nor her upbringing, from such labels by clarifying: 'I have never been a student of Moslem art', and 'I have never been particularly conscious of being an artist in this specifically Turkish tradition. Of course I was brought up in this tradition [...] But I've also been conscious, at all times, of being an artist of the same generally "abstract" school as many of my American, French or English friends and colleagues. I mean a painter of the "École de Paris" rather than of any more specifically nationalist school.' It was in this interview that she said that she found herself as an artist only when she came in Europe in the mid-1940s, quoted at the head of the previous chapter.[12]

Charles Estienne and the Nouvelle École de Paris

Just as important as holding this first solo exhibition in Paris was Fahrelnissa's fateful meeting with Charles Estienne there. It was Colette Allendy herself who had coaxed him to come along. He reportedly had qualms about visiting an exhibition by 'an oriental woman artist, a princess and an ambassador's wife'.[13]

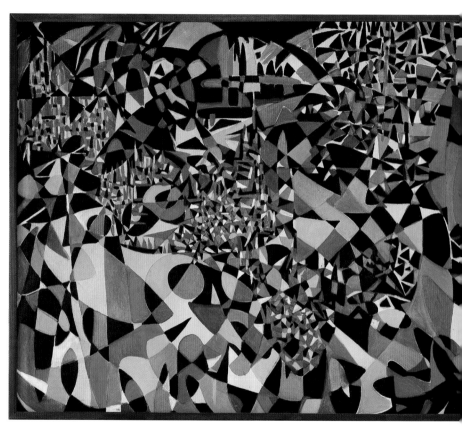

Break of the Atom and Vegetal Life, 1950/1 (originally dated 1962), oil on canvas, 210 × 540 cm

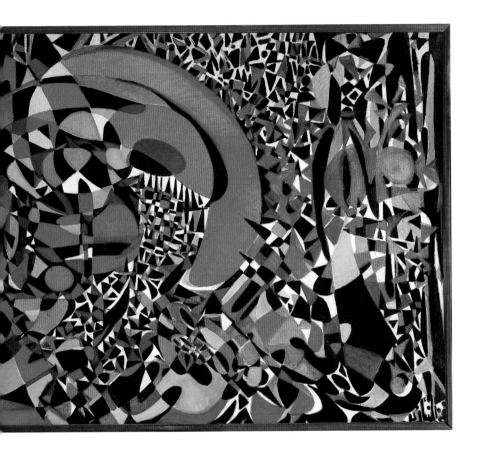

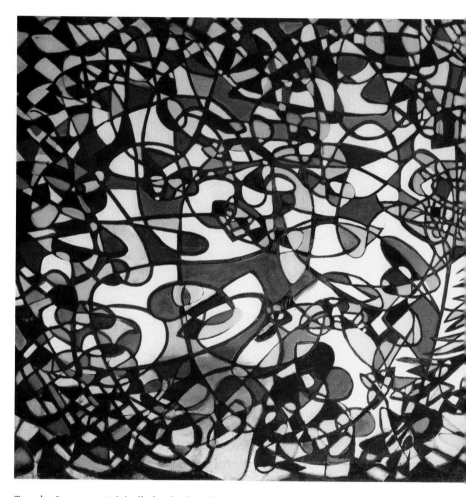

Towards a Storm, 1951 (originally dated 1962), oil on canvas, 210 × 550 cm

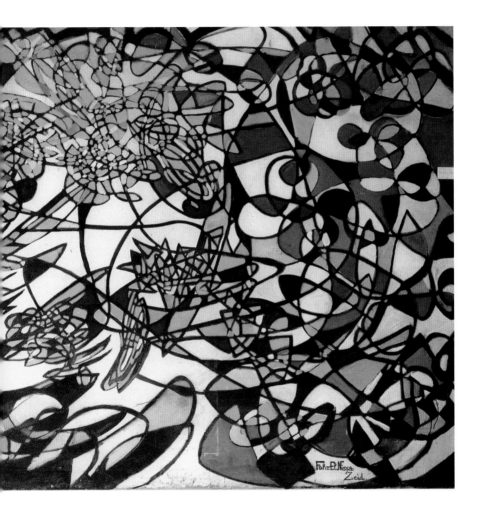

He later said that he had gone there 'like a dog who is whipped' and ended up discovering 'a 1001 night universe'.[14] Fahrelnissa's subsequent Paris career owed a great deal to her friendship with this combative self-taught art critic and exhibition organizer, not to mention her inclusion in the circle of artists that he promoted, which he would formally present as the Nouvelle École de Paris in 1952 with a group exhibition of that title.

The name was an obvious and deliberate reference to the earlier term 'École de Paris', which had descriptively covered a loose group of pre-First World War and interwar artists working in a variety of innovative styles and techniques. After the Second World War, its surviving giants – Picasso, Matisse, and Chagall – would progressively leave Paris for Provençal retreats, leaving the art scene contending for an artistic renaissance. In 1944, after the Liberation of Paris, the French press heralded the arrival of a group of young artists, many of whom had come from overseas to study, at that year's Salon d'Automne, praising their luminous and coloured paintings that relinquished naturalism and perspective.[15] Two years later, art historian Pierre Francastel published a book triumphantly declaring that exhibition as the rebirth of the original École de Paris.[16] Although not yet formally adopted as the movement's name, the idea of a 'nouvelle École de Paris' developed gradually in the postwar years as a self-conscious and prescriptive designation organized and promoted by gallerists and critics. It was welcomed amidst post-liberation euphoria, and was conceptualized as a synthesis of expressive, gestural, and lyrical abstraction. Its early years would be characterized by quarrels and debates over style, about what form of abstraction should be considered its language: lyrical, informal, tachiste, or nuagiste.

The painting scene in France immediately after the war was still dominated by disciples of the original École de Paris, while abstraction was not yet prevalent and was associated with foreign art. At first, there was a revival of pre-war movements: Socialist Realism, Dadaism, and Surrealism, the latter as a result of the return to France of André Breton, who would go on to explore occultism and relations with the emergent form of figurative painting art brut promoted by Jean Dubuffet. Abstract art was generally ignored by institutions,

and supported only by avant-garde galleries and publications. The dominant trend was a constructivist-geometric-linear abstraction as practised and presented by Abstraction-Création, originally formed in 1931 to counteract Surrealism. In July 1946, an offshoot of this group launched the Salon des Réalités Nouvelles to be exclusively devoted to abstract art. The salon quickly met with success, with exhibiting artists increasing from 89 to 336 between 1946 and 1948.[17] This promotion of abstraction was relayed by new galleries such as Colette Allendy's.

During this key period, Charles Estienne's importance rose with a multi-directional promotion of abstraction via his writings in periodicals, publishing pamphlets and numerous books, curating and organizing salons and exhibitions, and identifying and inventing new art trends and movements. He originally admired the Symbolist Nabis artists, and would be further influenced to promote a spiritualist approach emphasizing the properties of pure colour when, during the wartime occupation of France, he discovered the paintings of Wassily Kandinsky (1866–1944), who had not yet achieved wide recognition. In 1946, with the support of Kandinsky's widow Nina, he co-founded the Kandinsky Prize, which was awarded annually until 1961 to an artist or artists said to have advanced abstract art. Estienne's interest in Symbolism and spirituality attracted him to Kandinsky's conception of abstraction as expression of individual emotion, whereby painting is not only a practice but also a meditation on the world and a search for fusion with the universe. Estienne also adopted Kandinsky's notion of painting as an 'internal necessity'.[18] These two notions would be found almost verbatim in interviews conducted with Fahrelnissa in 1951 and 1959.[19] Decades later, she would also recommend to her students in Amman that they read Kandinsky's book *Concerning the Spiritual in Art*.[20]

The Nouvelle École de Paris very quickly became the leading force in postwar French art in legitimizing and expanding both easel painting and modernism. Lyrical abstraction emerged gradually in 1947 from a series of Paris exhibitions, supported by the critics' accounts, and Estienne would go on to discover and champion several young lyrical-abstract painters, such as Jean René Bazaine, Nicolas de Staël, Jean Degottex, Jean-Jacques Deyrolle,

Fahrelnissa with Charles Estienne in Versailles, 1951

Marcelle Loubchansky, Alfred Manessier, Nejad, Serge Poliakoff, and Pierre Soulages. After abstraction took hold as a dominant modernist art form, a new quarrel emerged in the nascent group, that of the struggle between the cold and the hot types of abstraction. Fahrelnissa was part of the 'hot' or lyrical-gestural-abstract camp, which Estienne defended in a 1950 pamphlet entitled *Is Abstract Art an Academicism?* He directed this short text against 'cold' geometric abstraction, which dominated the Salon des Réalités Nouvelles and was taught in an important Paris atelier.[21] The abstraction that Estienne espoused privileged a liberation from formalism and a rejection of structure, and favoured spontaneity, gesturality, colour, and light. Fahrelnissa's practice fitted with the direction of the NEDP that Estienne was shaping, and she became an important participant in its principal manifestations.

Her next activity in Paris would be her first collaboration with Charles Estienne: a second solo exhibition, consisting of oils and works on paper at the Galerie de Beaune in June 1951. No images remain of the installation. The opening of the exhibition was also the occasion for the launch by Estienne of a new translation of Kandinsky's *Concerning the Spiritual in Art* with a postface by him.[22] This connection serves to date Fahrelnissa's introduction to Kandinsky's work and the influence of his philosophy of art on her.

To coincide with the show, Estienne also published a limited edition of 150 numbered and signed copies of a book about Fahrelnissa's work, featuring four lithographs by her and accompanied by a lengthy prose poem by him entitled *Midi Nocturne* (Nocturnal noon). In his role as critic, he saw himself as both a 'mentor' to artists and a guide for the public.[23] He believed that abstraction posed a unique problem in not referring to a concrete exterior reality, hence it required his guiding the public by writing a 'poetic critique' that communicated its structure and content.[24] This translated into a style that reached its most florid in his writing for and about Fahrelnissa, which not only framed contemporary viewers' and critics' perception of her art, but also influenced later writers who would write about her after Estienne's death in 1966, such as André Parinaud and René Barotte:

> And the light came from the Orient. And now the night is waking
> up again [...] that living and breathing night that is not the absence
> of day but its other side, its warmth and place of origin, present
> in the high noon ... the brilliant and funereal kingdom where the
> mother goddesses of the East and the black virgins of the West keep
> watch, immobile, exchanging only their sceptres. [...] the nomadic
> castles of Fahrelnissa Zeid [...] the painting of Fahrelnissa seems

The invitation card for the opening of Fahrelnissa's Galerie de Beaune exhibition and the book launch of the new edition of Kandinsky's *Concerning the Spiritual in Art*, 1 June 1951

to do a pastoral enumeration of strange populations in perpetual
nomadism. But they also depict, in a no less strange light verging
towards a purplish violet, reds and blues circled by violent blacks,
heavy like the lead coils of stained glass. And this light is the
same, fabulous – Orientally fabulous – of Gothic stained glasses
[...] that the wall, not opaque and impenetrable, but translucent
and mysteriously mobile of the Western stained glass forms the
boundless frontier, free from interdictions, where the art of Islam
brings one of its more latest messages to the art of l'Île de France,
speaks volumes about the brotherhood, no longer mystical,
no longer legendary, but concrete and lived [brotherhood] that
unites to each other the most alien art forms.[25]

This fantastically lyrical text amplifies Maurois's earlier orientalist approach
to Fahrelnissa's work, and is in line with Estienne's objective of undertaking
a 'poetic critique' when writing about abstract painting, but it goes far beyond
any such critique. Given that he wrote this at the time of his republication of
Kandinsky's book, he could have made connections with the Russian's paint-
ings, but it was perhaps more appealing to present a new international artist on
the scene who was the representative of such a radically alien culture.

The exhibition at Galerie de Beaune garnered an important non-
conformist review by the influential art critic Julien Alvard, published in the
short-lived journal Art d'Aujourd'hui, which championed geometric abstrac-
tion in the early 1950s. Like Denys Chevalier, Alvard dispensed with cultural
extrapolation and considered instead Fahrelnissa's compositional style. He
deemed her work 'the most astonishing that one can see for some time' and
characterized her style as 'prolix, lively' and having an 'anarchic' line, which is
'melodic in the infinitely small, and symphonic on vast surfaces'. Her formula
has nothing to do with an 'oriental déjà vu', he claimed.[26] That year, she also
participated in her first Salon des Réalités Nouvelles, showing her monumental
My Hell, with its galloping colours and flood of black kaleidoscopic shards, to
the acclaim of critics.[27]

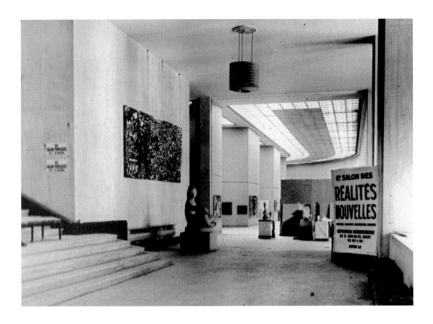

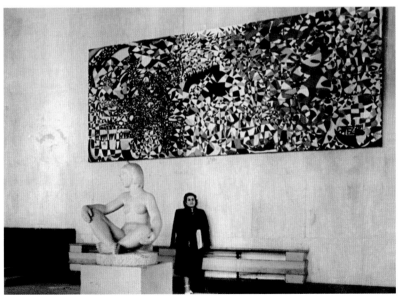

The 1951 Salon des Réalités Nouvelles at the Palais des Beaux-Arts in Paris, where Fahrelnissa exhibited her five-and-a-half-metre canvas *My Hell* of 1951

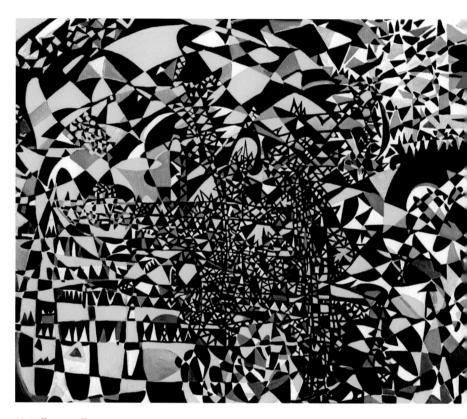

My Hell, 1951, oil on canvas, 220 × 550 cm

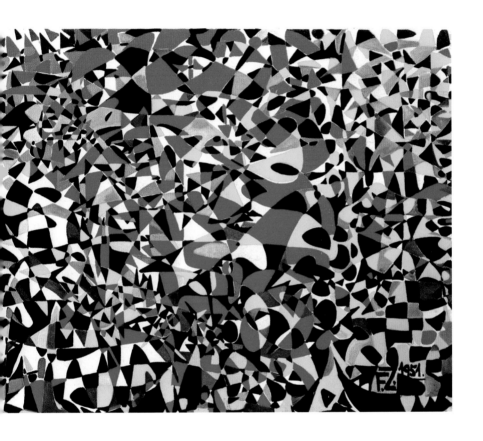

Galerie de Babylone
38, *Boulevard Raspail*
PARIS - 7*

Matisse, ni Picasso, ni... Une autre génération a conquis ses grades, tantôt plus mûre dans le style, tantôt plus jeune dans l'expérience ; mais les eux groupes de peintres que nous vous présentons participent néanmoins de la même et aventureuse certitude. Et si l'avenir est sur les genoux des dieux, la moisson, déjà, est pour nous.

Ch. ESTIENNE.

Peintres
de la
Nouvelle École
de Paris

DEUXIEME GROUPE
VERNISSAGE

Arnal	Lapoujade
Atlan	Marcelle Loubchansky
Calmettes	Messagier
Chapoval	Nejad
Denise Chesnay	James Pichette
Degottex	Pons
Dias	Quentin
Dmitrienko	Resvani
Duvillier	Fahr-el-Nissa Zeid
Roberta Gonzalez	

The invitation to the opening of the second 'Peintres de la Nouvelle École de Paris' in February 1952, featuring Fahrelnissa and her son Nejad

'A force in action'

Estienne formalized his support for lyrical abstraction and his ambition to grow a new generation of postwar lyrical-abstract artists when he organized in January 1952 the self-consciously founding exhibition of the group, held at the Galerie de Babylone on Boulevard Raspail, which he called 'Peintres de la Nouvelle École de Paris', thereby explicitly naming the movement for the first time. A second set of artists and works was presented at the same venue the following month. Fahrelnissa and Nejad were among the eighteen painters in this second show.[28] These were all abstract artists working in Paris at the time, and were of many nationalities.[29] Estienne proclaimed Paris as the new centre of international art, and the NEDP as a redemptive endeavour of the city's universalist leadership role, even as he conceded that the time of national schools was no more. He insisted that the NEDP had been born between 1940 and 1950 and was free from the heritage of its elders. What mattered was the 'plastic fact' – in other words, formal concerns – in a synthesis of Surrealism with 'the most free in abstraction. Art does not imitate nature, it is its meaning.' Estienne would try to reconcile the two trends in the coming years, but the term 'free' here alludes to his future insistence on lyrical and gestural abstraction.[30] It is not known

what Fahrelnissa showed in this exhibition, beyond 'scintillating, patterned works', so presumably they were new, less angular, and more lyrical works than those she had shown in the previous three years.[31]

Estienne's second initiative in 1952 was his launch of a rival to the Salon des Réalités Nouvelles, the Salon d'Octobre, with a virulent manifesto written by Nejad.[32] In April 1953, Fahrelnissa participated in a smaller group show that Estienne organized at the Galerie Craven. This was a seven-person exhibition further focusing on a spontaneous 'lyrical fact', or, as he put it, the paintings affirmed that 'life is beautiful and worthy of being lived, that there is a new way to render life beautiful'. Again, we do not know which works by Fahrelnissa were included.[33] In the same year, she participated once more in the Salon des Réalités Nouvelles, showing another monumental work, *Towards a Sky*, a titanic vertical work combining gestural amplitude in a lyrical mix of minute shapes and whirls and undertows of colour.[34] The painting dwarfed every other work displayed next to it.[35]

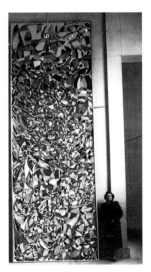
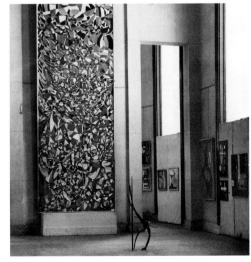

The installation of *Towards a Sky* at the Salon des Réalités Nouvelles, 1953

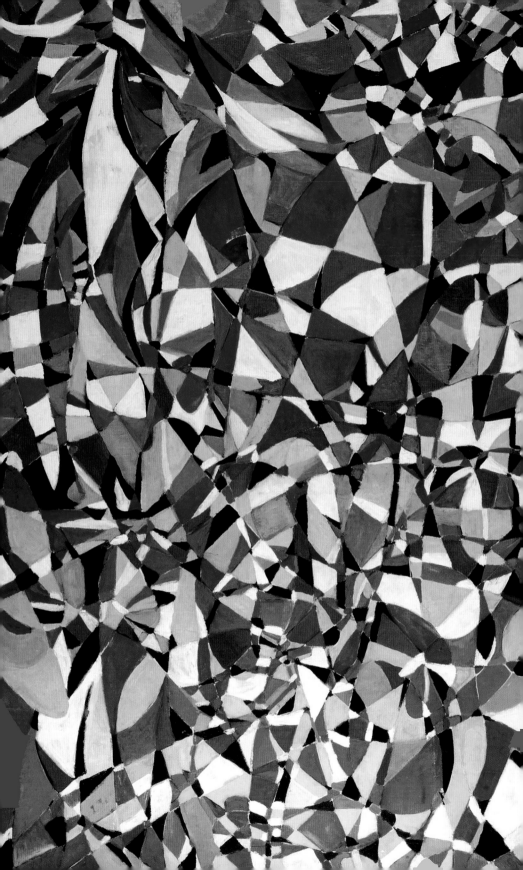

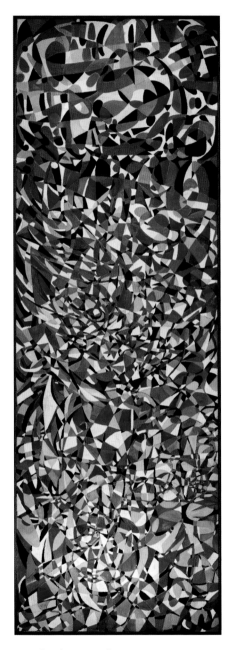

Towards a Sky, 1953, oil on canvas, 593 × 201 cm

The poster for the
1953 exhibition at
Galerie Dina Vierny

Fahrelnissa's next solo exhibition would be at the Galerie Dina Vierny
in December 1953. Vierny (1919–2009) was a Moldovan refugee who had been
a model and muse to Henri Matisse, Aristide Maillol, and Pierre Bonnard.[36]
Matisse supported her in 1947 when she opened her Paris gallery, where she
would exhibit Poliakoff, the CoBrA group, and, later, Ilya Kabakov and Erik
Bulatov. It remains in business to this day, at the same address on rue Jacob in
the Latin Quarter. Estienne, who prefaced the catalogue of her Poliakoff exhi-
bition in 1951, introduced Vierny to Fahrelnissa.[37] The two women would forge
a lifelong close friendship and successful working relationship.[38] In her first
exhibition with Vierny, Fahrelnissa showed eleven paintings and twenty-three
inks. Except for *My Hell*, the canvases were all new, sunny, vitalist works of
monumental proportions in a lyrical vein with dappled undulating colours
anchored by an imperceptible meshing evoking the seabed. The exhibition cata-
logue was a sumptuous limited edition of 950 copies reproducing many of the
large oils on triple folded pages. This was one of Fahrelnissa's strongest shows
to date, and Vierny seems to have been aware of the importance and unicity
of this new phase of her work, as the exhibition is described in the catalogue
as showing the 'fullness of her talent'.[39] The texts in the publication bypass

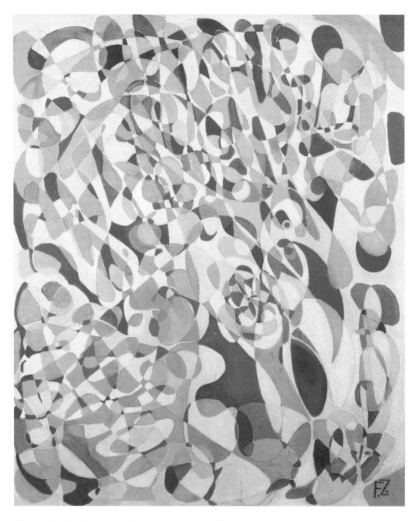

Abstract Composition, 1950s, oil on canvas 225 × 187 cm

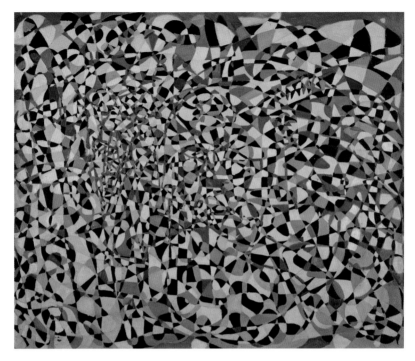

Untitled, 1950s, oil on canvas, 182 × 222 cm

the works' 'plastic fact', however, by harking back to an imaginary antique mythology and to culturalist exegesis. The problem with this sort of framing is that it attracts attention to the writing rather than the works, and distracts from the individuality and contemporaneity of Fahrelnissa's practice. The catalogue opens with a short text by Fahrelnissa in which she dramatically described her first vision of the Bedouin women in 1938, entitled 'Birth of an idea'. This is followed by a long text by Estienne entitled 'Les pierres de la mer' (The stones of the sea). Since most of the large oils in the exhibition had maritime titles, Estienne's evocative text translated the paintings into a sort of abstract décor for the telling of a legend of a sea voyage featuring the Lily prince-priest of the celebrated Minoan fresco, probably in reference to Fahrelnissa's Cretan family background. The tale aimed to provide an imaginary narrative to the

abstract shapes and colours of the paintings. The third text in the book was a return to culturalist form, by the prolific art critic and museum curator Jacques Lassaigne (1911–83), who had penned an orientalist text about Nejad in 1951. He referenced the Koran, compared her paintings with Muslim depictions of paradise with 'rivers of milk, rivers of wine and rivers of honey', and concluded that her unclassifiable art was 'a search of distant parentage: Persian miniatures, Byzantine mosaics, Arabian stained glass. The painting of Fahrelnissa Zeid is a force in action, in a perpetual becoming.'[40]

There are no existing reviews of the 1953 Vierny exhibition except for a small piece in a French daily about 'a princess from the orient' who had taken her place 'among the painters of the avant-garde'.[41] (Similar reviews had followed her Zurich exhibition the year before;[42] and in Brussels four years later, veteran critic Roger van der Gindertael would reprise the words of the Estienne's *Midi Nocturne* poem.[43]) This type of critique is contextualized by the nature of the Nouvelle École de Paris and Fahrelnissa's place within it as a foreign artist. Other art scenes in Europe and in New York were largely national schools. The NEDP, on the other hand, expressed a paradoxical

Gisèle Freund's portrait
of Fahrelnissa painting
a *pierres ravivée*, Paris,
March 1952

redemptive enterprise following the French defeat to the Nazis in 1940, as a buttress of French national pride, wherein a unified community of artists, both foreign and national, would reconcile the anti-fascist ideal of internationalism with a fundamentally national culture. The first-generation École de Paris had replaced the notion of a French school of painting, and most of its stars were foreigners who would in due course become French. Thanks to these immigrants, Paris had been the heart of international artistic life. Promoting international artists working in the city after the war, then, could only feed into a wounded yet resurgent French nationalism. Thus, the internationalist vocation of Paris was affirmed with the emergence of the Nouvelle École de Paris, as it was with the 1946 UNESCO exhibition in which Fahrelnissa participated, where foreign artists were either displayed in national schools or separately presented as foreigners living in Paris.

Soon after, a great number of foreign artists started pouring into Paris. Some had studied in Paris before the war; others were coming for the first time; and a third group were children of refugees and were growing up French or were in the process of acquiring French citizenship. Many of them were east European, Scandinavian, and South American, even if this time the artists were passing through Paris rather than seeking naturalization given competition from other cities.[44] It was recognized that this influx would also have an impact on the city's art scene. Indeed, the art historian René Huyghe observed in 1945 that: 'The École française is becoming the École de Paris: the cosmopolitanism of the metropolis is again creating that sense of uprootedness ... favourable to abstract art.'[45]

Of the small group supported by Charles Estienne, the majority were French born, followed by new immigrants and/or naturalized French citizens. A few were foreigners, and fewer still were women – among them was Fahrelnissa. The star of the Nouvelle École de Paris was the soon-to-be-naturalized Serge Poliakoff, who until the 1940s was similarly the object of culturalist critique and interpretation, making his work the reflection of Russian icons and Russian folklore. Estienne, for example, presented his paintings in 1946 as resembling Bokhara and Samarkand carpets.[46] Such features of cultural

difference could only enrich Estienne's 'poetic critique' vocabulary, and could be useful in increasing the international appeal of the NEDP. This was also a time before the inflection and widening of critical debate by academic perspectives and theory, leaving critics such as Estienne all-powerful to invent personas and build reputations.

This was the paradox of Fahrelnissa's membership of the Nouvelle École de Paris in its heyday: she was more welcome in it because of her familiarity with French culture, and because of the room given to foreigners by this self-consciously pan-nationalist art enterprise. At the same time, she might have been too alien – in gender, national origin, and social status – to win the Kandinsky Prize, to represent France at the Venice Biennale, or to obtain a career retrospective in a national museum, as many of her colleagues did, and as she sought in the 1960s.

Beyond the Nouvelle École de Paris

Estienne continued his initiatives, and in 1954 he launched annual summer retreats in Brittany, where he would host a number of his artists and tried to organize them into an abstract landscape movement (*paysagistes abstraits*).[47] Many of them returned from these retreats changed people, and produced works marked by their spiritualist impressions of the sea.[48] Also in 1954, however, Estienne's newest initiative was ridiculed by critics for his invention of a synthesis between Surrealism and lyrical abstraction called *tachisme*. He could not find a venue for the next Salon d'Octobre and began to withdraw from his omnipresent public activism.[49] His views, which started as a quest for the renewal of the postwar art scene via a new progressive way of seeing and painting, began to be considered outmoded by other critics, who now favoured the new terms *art informel* and *art autre*.[50]

Estienne continued to organize various group shows for his stable of artists, and Fahrelnissa regularly took part. Persisting in his synthesis with Surrealism, he curated in 1955 an exhibition of eleven artists entitled 'Alice in Wonderland', at the Galerie Kléber. Fahrelnissa painted a 'portrait of Alice', a primitivist tangle of lines that recall the doodles that she made on her pebbles,

as well as a menacing large oil painting. Estienne's text in the catalogue is a whimsical imagined dialogue between Alice and the hare about painting being a play with forms, squares, paintings, and likening it to the hare's jump.[51]

Fahrelnissa's last solo exhibition in Paris during this period would be in 1955 at the prestigious artist bookstore, publishing house, and gallery La Hune. It is located in the heart of Saint-Germain-des-Prés, and is an important part of the literary and artistic history of twentieth-century Paris. It was a meeting point for Surrealists, artists and writers, such as Breton, Henri Michaux, Tzara, Dubuffet, and Picabia. Under its founder, Bernard Gheerbrant, La Hune published art books by artists they also exhibited, among them Robert Doisneau, Brassaï, and William Klein. Gheerbrant and his son Alain would become long-time friends of Fahrelnissa's and supporters of her work through to the 1980s. In the 1955 exhibition, she showed gouaches and lithographs recently printed by them, of which no clearly attributable copies remain.

Later that year, she took part in another Estienne-organized exhibition at Galerie Dina Vierny, with the star of the Nouvelle École de Paris Serge Poliakoff (1900–69) and art informel painter James Pichette (1920–96). No information about her work is available from that exhibition either, save that her paintings were described by one reviewer as 'seductive'.[52]

Her last group collaboration would be her participation in 1956 in a seven-person show that included Chagall at the Galerie Kléber entitled 'L'Île de l'Homme errant' (The island of the wandering man), in reference to the legend of Melmoth the Wanderer. This was another attempt by Estienne to generate a group of abstract landscapists, as his exhibition's brochure text was about a man adrift on the ocean, filled with psychedelic descriptions of riotous colours. Most likely Fahrelnissa showed there an uncharacteristic and rarely seen bi-chromatic medium-sized painting entitled Melmoth de Maturin, which depicts this character like a tapered black line on a saturated red background.

Fahrelnissa may not have participated in that year's Salon des Réalités Nouvelles, which had begun to show all schools and genres of abstract art – geometric and constructivist as well as gestural and lyrical – by European and American artists. In addition, it included architecture and three-dimensional

art.[53] Eventually, and despite its success, the SDRN and through it the NEDP became synonymous with a sclerotic abstraction as it refused to accept a coherent stylistic line and progressively rejected new trends, such as demateri-alized art, and artists who began to develop outside the salons, like Yves Klein.[54]

This did not mark the end of Fahrelnissa's membership of the Nouvelle École de Paris, however, nor her collaboration with Estienne. He remained her principal supporter, influenced her vision of art, and wrote in all her main exhi-bition catalogues. He included her in some but not all his group shows, as he was also a prolific curator, convening numerous exhibitions annually in Paris and elsewhere, in which he included permutations of NEDP artists.

In the end, Fahrelnissa's reputation in Paris may have been circum-scribed both by her association with Estienne's polarizing personality and by her own social position.[55] She may also have struggled to be seen fully as an artist. Her characteristic lack of compartmentalization and plain speaking probably did not help. She presented herself exactly as what she was: a princess and the wife of an ambassador. She also entertained critics and artists in grand

Alongside her flourishing career as an artist, Fahrelnissa had the duties of the ambassador's wife until July 1958. Here she is on 14 June 1957 launching Iraqi steam tug *Hashim*, built at the Glasgow shipbuilders Scott and Sons Ltd. Behind her is the assistant cultural attaché of the Iraqi embassy in London, Ala-Uddin Hammoudi.

style in her studio, and spent her own money on promotional material for her exhibitions.[56] In a letter she received prior to her 1955 exhibition at La Hune, Philip Granville alluded to a conversation he had had with its owner Bernard Gheerbrant, and advised her that she should be seen only as an artist: 'You must be solely and entirely considered as a professional artist. To hell with issues of social rank when one deals with art. Only the merits of your work matter.'[57] The same Gheerbrant would aver in the mid-1980s that the Paris art scene had had a hard time accepting Fahrelnissa because of her status, explaining that it was easier to accept that an artist like Poliakoff could go from rags to riches and buy a Rolls-Royce than for a rising artist to be already wealthy.[58] In this, she might have encountered the compounded prejudice – compounded because gendered and cultural – that Theodor Adorno identified about Marcel Proust:

> [A person of means who trespasses onto the territory of artists] will have a particularly difficult time with [his] [...] colleagues [...] his independence is envied, the seriousness of his intentions mistrusted [...] But the real resistances lie elsewhere. The occupation with things of the mind has by now itself become 'practical', a business [...] the man of independent means who chooses it [...] is punished. He is not a 'professional', is ranked in the competitive hierarchy as a dilettante no matter how well he knows his subject, and must, if he wants a career, show himself even more resolutely blinkered than the most inveterate specialist.

Fahrelnissa indeed was resolutely blinkered and determined, and this led her to survive and thrive in the Nouvelle École de Paris despite the odds.[59]

A rapid evolution of a style

Fahrelnissa's artistic style developed remarkably in the time leading up to and during her association with the Nouvelle École de Paris, maturing and evolving over a decade that witnessed an even more remarkable level of productivity. So extensive was her output and so diverse were her stylistic changes in this

period that it is hard to identify and date all the paintings that she completed with any confidence. She did not exhibit everything she painted; many of the paintings have similar names; while others have been misdated. However, thanks to some anchor works that can be reliably identified and dated, the rest of her production may be reconstructed. The changes that her work went through in these ten years could characterize an entire artist's career. But she was always a swift worker, deploying so much energy that she was able to produce works requiring considerable energy in great volume, then grow out of a style and explore new inflections and directions in quick succession and even concurrently. Despite her many evolutions of style, Fahrelnissa maintained a consistently baroque 'abstract expressionist' approach, not abandoning her expressionistic sensibilities when she moved to abstraction. In everything she did, she always expressed the turmoil of her internal experiences with unexpected and exaggerated contrast of colour and form, jarring motifs, vigorous gestures, and expressive brushwork, in a world of whimsy and fantasy communicated via the paintings' titles, all on a monumental scale. She did so in five broad overlapping phases.

The first of these five phases revolved around paintings known to have been shown at the Hugo Gallery in New York in January 1950, as well as a few others made in the same style. Confirming the dating of these works is that Fahrelnissa's sketchbooks of 1949 feature coloured studies for some of them. Whereas the sketches show a free and bold command of line, the paintings are more tentative. A few extant large abstract works are most probably mistakenly dated to 1947 and 1948, when Fahrelnissa's command of her abstract medium was not yet developed. Compared with her future works, those from 1949–50 show little dynamism, except for the monumental *Voyage of the Man Moon* (pp. 104–5). A few canvases that we know from black-and-white photographs of the Hugo Gallery exhibition show a combination of gridding crossed by arched lines. Movement is imparted by the contrast of joyous colours. In *Abstraction* (p. 119), wrongly dated to *c.* 1947, the brushwork is almost scholastic in application, as if she were learning the technique for the first time. This geometric meshing appears to be a clear progression and projection of the smaller-scale

gridding begun in 1948 with the deconstructed figurative landscapes of *Loch Lomond* and *Tents, Scotland* (pp. 115, 116). However, the gesture here is one of deliberate delineation of niches of colour rather than the barring of colour planes with black lines. The meshing that girds the composition is pink. We know already that Fahrelnissa was at the time under the spell of the aerial views she witnessed on her first aeroplane trip, as well as the shock of the attendant speedy change of scale and perspective. As she would explain years later, abstraction was about seeing things as they really are from above. Here she produces ad infinitum, in a Brueghelian all-over, a meticulous reproduction of the exhilarating sight of plots of land from high up in the sky. Placid countryside and suburban tracts of land are transformed into a tangle of lozenges, triangles, and hollowed rectangles anchored by a pattern of white triangles.

With *Voyage of the Moon Man*, Fahrelnissa began a decades' long fascination with all things astral. She appears to have extended the horizon of *Loch Lomond*. The canvas is a distended perspective of diagonal black lines haphazardly carving out alveoli coloured in a limited palette. A vertical white mist of mesh descends the canvas on the left, perhaps signalling a cloud seen from an aeroplane window. The painting is dizzying with its lack of regularity, obvious centre, or orderly patterning; it appears like a hallucinatory optical illusion, but its stasis limits its impact. Nevertheless, works of this period already command a power to envelop, baffle, and perhaps smother the first-time viewer. They are unique in appearance, and clearly show the hand of an ambitious and bold artist making her first steps in abstraction.

If in 1949 she were representing the aerial views that she had recently seen when flying to the United States, within months Fahrelnissa would transform those views into kinetic forms detached from all representation. The kaleidoscopic vortexes show a maturing and a command of the brush and of the canvas. Despite the clearly gestural compositions, she did not improvise the paintings, but drew them first with a pencil. She drew the grand arches and the minute honeycombs directly onto the canvas and then filled them up or drew them again with paint. She painted tens of works in this style. Some of them are well known, such as *Break of the Atom and Vegetal Life* (misdated to 1962,

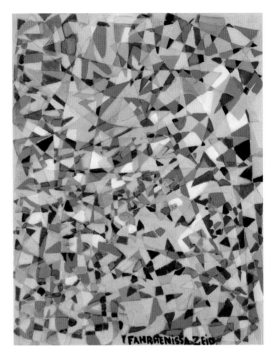

Abstract Composition, 1954, oil on canvas, 90 × 70 cm

when it should be 1950 or 1951; pp. 148–9), the Istanbul Modern's two versions of *Abstract Composition* from 1953 and 1954, and *Arena of the Sun* of 1954 (p. 193).[60] Others appear from time to time at auction, before disappearing into private or corporate collections. These are among Fahrelnissa's most accomplished works, showing her at her utmost command of her medium and demonstrating unclouded self-assurance. The prime example of this phase of apparent optimism is *Towards a Sky* from 1953 (pp. 161–3). She would recount with pride that it took seven workers to install the six-by-two-metre canvas in the east wing of the Palais des Beaux-Arts (which today houses the Musée d'Art Moderne de la Ville de Paris) when it was shown in that year's Salon des Réalités Nouvelles. It was too large for her exhibition at the ICA the following year, where only two-thirds of it were shown, and it would be finally seen unfurled again three

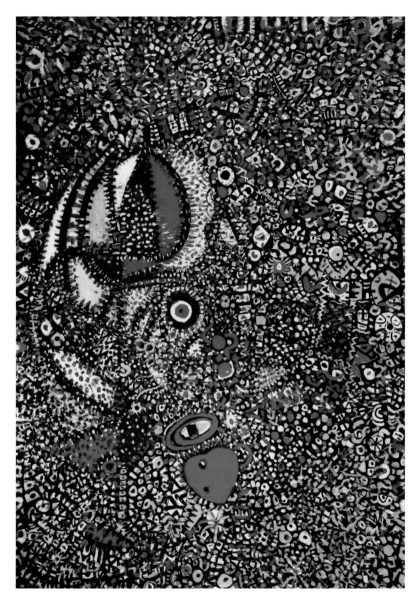

Basel Carnival, 1953, oil on canvas, 280 × 200 cm

years later in the garden of the Lord's Gallery.[61] With this set of paintings, she was illustrating two of Kandinsky's twin prescriptions about abstraction. The first was the coexistence of various subdivisions that stand in antagonistic relation to each other, yet still maintain the harmony of the whole composition: 'singly they will have little meaning, being of importance only in so far as they help the general effect'.[62] The second was his concern for the non-constructivist harmony of compositions that appealed 'less to the eye and more to the soul'. The harmony demanded by abstraction for Kandinsky must be a 'concealed construction', arising from 'an apparently fortuitous selection of forms on the canvas. Their external lack of cohesion is their internal harmony.'[63] This body of work creates precisely that effect by having an odd assortment of radially moving eddies acting independently of one another, compositional tension coming from juxtaposed ensembles of colour against form: the angular offensive of yellows and greys shaded in black against a red mercury spill in *My Hell* (pp. 158–9), for instance; the jagged triangles advancing against the giant red lobe enveloping them in *Break of the Atom*; or the inflated yellow white sails soaring towards a sky of azure cut glass in *Towards a Sky*.

The calmer maritime works that she painted during 1952 and 1953 – notably *Intermittence ... Water ... Sun (Riviera)*, *Sargasso Sea*, and the stones of *Octopus of Triton, Riviera*, all dating from 1953 – contrast with the previous dizzying ensemble. Though not a maritime subject, *Basel Carnival* from the same year might also be considered part of this new phase with its undulating vein.[64] In 1952, Fahrelnissa was able to spend long periods in the Mediterranean for the first time after the illness and death of Queen Aliya, with occasional stays at British resorts. She spent the summer and winter of 1952 and the following summer in the south of France, and she began to paint there. She was so seized with a renewed impulse to work that she even infected her husband, who would paint alongside her back in the London studio.[65] These large canvases testify to these seaside experiences more than to Estienne's text of mythological sea voyages. They reprise the contradictory compositional pattern of the previous periods, but the angular shards have given way to orbiting small suns, to dappled seabeds, and to colourful fireworks. In fact, *Intermittence ... Water ...*

Sargasso Sea, 1953, oil on canvas, 200 × 280 cm

Sun (Riviera) appears as an illustration of the vision that Fahrelnissa had when swimming in 1943:

> I saw all of clear clear depth of the sea through the bracelets of light
> that the sun flung [...] the sun is in me. I closed my eyes and the sun
> intoxicated all the deepest of my depths. All the depth of my brain, of
> my eyes, of my thoughts, I arrived to the extreme limit of the horizon
> to touch to enter in the sun. And the oval eyelids captured full and
> luminous all of the sun.[66]

This period from 1947 to 1954 would, then, see Fahrelnissa work on the geometric compositions that became the most famous of her abstract paintings. She started with tentative grids and progressed onto undulating chromatic eddies. Some of these paintings resemble colour murmurations, where instead of starlings flying in mysterious order, colours whirl on her

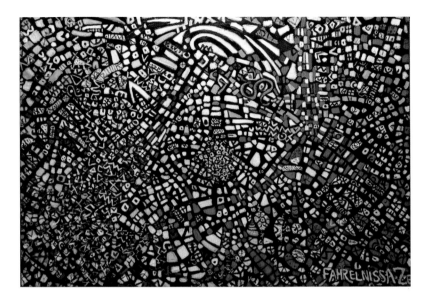

Octopus of Triton, Riviera, 1953, oil on canvas, 190 × 270 cm

monumental canvases. Beyond the structural paradigms of the kaleidoscope, the grid, and the murmuration, another intent may be discernible in these works, that of chromoluminarist divisionism. The technique of painting colour fields by juxtaposing unmixed strokes of pure colour on the canvas is associated with figurative Post-Impressionists, such as the Pointillist Georges Seurat, as well as Paul Signac, Vincent van Gogh, and André Derain. Charles Blanc's writings – which influenced a young Fahrelnissa – and his Colour Wheel were among the theoretical influences on divisionism. Therefore, one can also see Fahrelnissa's abstract canvases with their parcelling and separation of colour patches as a pioneering abstraction of the original divisionist style. It is impossible to tell from her available writings if this was indeed a conceptual influence on her work. However, the clues afforded by her reading and influencing by Blanc's book, and her own Fauvist and Expressionist figurative period may indicate that she deliberately experimented with this technique, leading her to create a unique form of modern chromoluminarist abstraction.

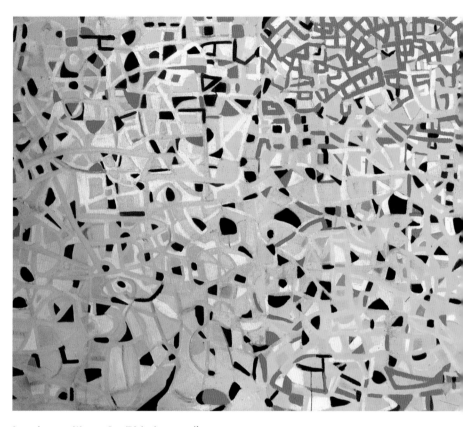

Intermittence ... Water ... Sun (Riviera), 1953, oil on canvas, 190 × 450 cm

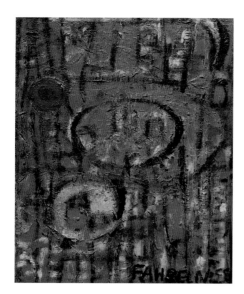

Abstract Composition, 1955,
oil on canvas, 55 × 46 cm

At any rate, Fahrelnissa would then undergo another evolution, also unexplained by her writings and diaries. Between 1954 and 1955, she produced several intriguing primitivist canvases, such as *Réalités Nouvelles* (1954), *Les Gauloises* (1954), *Abstract Composition* (1955), and *Alice in Wonderland* (1955). They have dark backgrounds and feature shapes that resemble menacing orbits, fragments of human organs, long staffs with spikes, a cranium. The series seems to have been made by an entirely different artist. Gone are the commanding confidence of a monumental canvas and the compositional subdivisions. Instead, these are small to medium canvases whose motifs are enmeshed in darkness. *Alice in Wonderland*, which is far from the Disney image we now have, is a dark voyage into recesses of a hellish unknown. Fahrelnissa introduced a textural novelty to these paintings for the first time in her abstract series; she intervened on the surface of the canvas by carving out tracks onto the white lines with a palette knife, making them bleed as they flash and twist. *Les Gauloises* is saturated with red, but the red filaments seep and ooze, while white lines flay about and criss-cross it mysteriously.

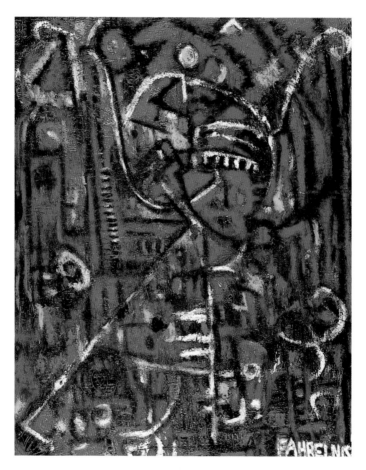

Les Gauloises, 1954, oil on canvas, 100 × 80 cm

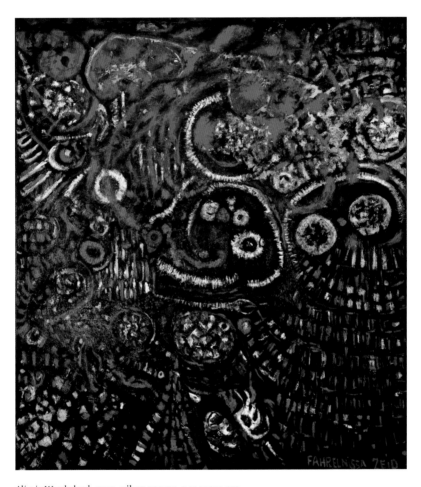

Alice in Wonderland, 1955, oil on canvas, 240 × 215 cm

Indecision, 1956, oil on canvas, 100 × 75 cm

Fahrelnissa ended this ten-year period with yet another change, with smaller works made in 1956 and 1957. Some of these were shown in Brussels in 1956 and were praised by Maurice Collis for being smaller than the forbidding works she had showed at the ICA two years before. He described them as showing 'the convolutions of being, the unfolding of an inchoate consciousness'.[67] Here the canvas is dark, but the lines are straightened and dense. They look less like a Fahrelnissa painting and could have been painted by anyone,

although the intensity of colour remains. These works include *Indecision* (1956), *Melmoth de Maturin* (1956), *Midnight Conversation* (1957), and *Lost Horizon* (1957). The palette is still as sombre and as menacing as in the previous phase, but the busy menacing motifs have gone in favour of large swathes of pure colour distended onto the canvas and bleeding into other darker colours: navy blue into red, red into dark green, dark black, and dark grey. The surface here is also slashed with the palette knife. The most striking examples of this technique are *Lost Horizon* and *Indecision*, which are entirely incised with the knife, in both cases as a compositional counterpoint to the paint. Where the paint creates a vertical direction, the knife superimposes a horizontal grid, and vice versa. Fahrelnissa was fond of this technique and was proud of introducing it to her students in the 1980s.

Lost Horizon, 1957, oil on canvas, 76.5 × 101.5 cm

Midnight Conversation, 1957, oil on canvas, 75 × 183 cm

Throughout these different phases, Fahrelnissa showed a contingent process of composing. She had a rare command of both miniaturist fragmentation and the monumental gestural sweep. Perhaps the compositional subdivisions in her paintings until 1955 owe to an inner turmoil, an incapacity to choose one overall compositional scheme. In 1959, Édouard Roditi described her inner emotional and intellectual turmoil as manifest in her being 'overwhelmingly articulate ... she is aware of a great emotional or spiritual turmoil within herself as she works.... She is content to remain an instrument of this

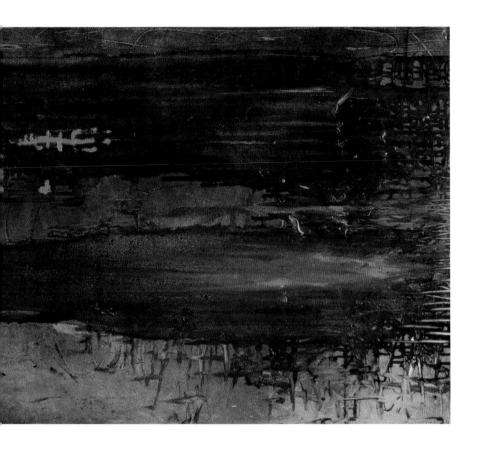

turmoil.'[68] Fahrelnissa would write as much in her diary in the same year: 'It is difficult when from one second to the other I am taken by a thousand different states of mind.'[69]

One cannot describe the minute compositional subdivisions of her paintings as patterns in the strictest sense as they do not repeat and unfold in a predictable or set fashion. Each subdivision is animated by its own speed and character, even in the dappled maritime paintings and the 1956–7 effaced paintings: paint and form go in opposite directions, and confuse the gaze.

What remains, then, to unify these paintings of the period? A forbidding intensity of scale and density of colour? A dramatic relationship between foreground and background, line and colour? What all her works from the period have in common is that each one recreates the sublime, not as natural or divine but as a psychic experience. As Robert Rosenblum wrote in 1961 about American Abstract Expressionism, 'during the Romantic era, the sublimities of nature gave proof of the divine; today, such supernatural experiences are conveyed through the abstract medium of paint alone.'[70] It is ironic that Fahrelnissa, who was told that success in New York was barred to her because of the rise of the Abstract Expressionists, would produce works that evoked a sense of the sublime that was also present in theirs. Before her paintings, the viewing subject cannot establish itself in relation to a coherent and recognizable visual experience. Instead, one is confronted with a teeming multiplicity moving in diverging directions without reason or goal, a maximalist chaos. But Fahrelnissa's sublime was not simply an artistic choice; it was a projection of her own exaltation during the painting process. Her episodes of boundless energy, her rapidity of execution, her all-absorption and loss of self in the act also end up engulfing the viewer. Her work is a recognition of the possibility of otherworldly experiences that can be felt by the human psyche in episodes of transfiguration and surpassement. She experienced it before her canvas when she worked, just as she did decades earlier at the Piazzale Michelangelo in Florence and standing in front of Rubens's *The Great Last Judgment*.

A spiritualist conception of art

An examination of Fahrelnissa's writings and statements in this period indicates a conception of her own art-making as a sort of gnostic quest anchored in a Kandinsky-esque doctrine of spiritual 'internal necessity'. She may also have found in Kandinsky a departure point for an articulation of her own state of mind when working. She described her vision most clearly in a 1951 interview for the book *Témoignages pour l'Art abstrait*, which was conducted after the relaunch of *Concerning the Spiritual in Art*. She referred to herself in proto-postmodern terms as a 'decentred subject effect', unaware of self, which emerges only as a conduit

for universal vibrations. She went further than Kandinsky's text when she wrote of painting as a path to salvation. She did not say a salvation from what, but she may have meant from the depressive episodes of despair that she was still experiencing. As she explained:

> Individual expression is found in a work of art; but [...] there is also a
> boundless infinity outside of human awareness, and thereby a creative
> reality and way of salvation for the artist who finds therein his essence,
> his expression and his explanation. [...]
>
> I do not believe that the personality of an artist [...] has any
> exclusive significance. I have a feeling that I simply do not count at all.
> I am a means to an end. I transpose the cosmic, magnetic vibrations
> that rule us. Supposing that I have [...] the necessary perceptive
> capacities [...] I am not a pole, a centre, a myself, a somebody. I act as a
> channel for that which should and can be transposed by me [...]
>
> I am with Spinoza on this point. The point of departure of
> philosophical speculation, far from being the individual, is, to the
> contrary, the infinite spiritual and wholly impersonal substance.
> 'Individuality [...] is nothing more than negation, an illusion, its
> human moral consisting of flight in an effort to rejoin infinite
> being' [...] painting is for me, flow, movement, speed, encounters,
> departures, enlargement that knows no limits.[71]

A few years later, she would sharpen her sense of self as an artist in another interview for a book. She described a vision of herself painting to Roditi as if standing at the top of a tree of life, tapping into the currents that traverse her:

> My paintings [...] surge within me from depths that lie far beyond
> peculiarities of sex, race or religion. [...] When I paint, I feel as if the
> sap were rising from the very roots of [...] [a] Tree of Life to one of
> its topmost branches, where I happen or try to be, and then surging
> through me to transform itself into forms and colours on my canvas.

> It is as if I were but a kind of medium, capturing or transmitting the
> vibration of all that is, or that is not, in the world.[72]

These views echo Kandinsky's view of art as one of the 'mightiest elements' of 'spiritual life', where the life of the spirit is not static, but is moved 'forward and upwards' by human lived experience.[73] He compared the life of the spirit to a triangle moving imperceptibly forwards and upwards. Each segment represents a time, an epoch, and a human experience. Artists stand at every segment of this pyramid according to their degree of authenticity, but the most authentic and often-misunderstood artist stands at the top of this triangle. The artist then 'helps the advance of the obstinate whole'.[74] Artists are the ones who usher in future realities. Therefore, an authentic artist's eyes must be directed to his inner life, and his ears must be constantly attuned to the voice of inner necessity. Fahrelnissa further echoed this 'ex-timate' introversion in her description of the act of painting, which she called an impersonal act: 'When I am painting, [I] am always aware of a kind of communion with all living things. I mean with the universe as the sum total of the infinitely varied manifestations of being.'[75]

This connection with Kandinsky appears to have been very much internalized and sought by her. In the dark aftermath of the 1958 massacre of the Iraqi royal family, perhaps to cheer herself up, Fahrelnissa wrote in the opening pages of a new diary a few sentences that appear to be words of praise that she must have overheard during her exhibitions. Among them were these lines: 'With Kandinsky it is prepared; with her it is natural'; 'She is what Kandinsky wanted to do'; and 'She has such mastery of her art that she is conscious of her unconsciousness.'[76]

The coming year would bring an earthquake in Fahrelnissa's family life that would constitute a test also of her capacity to sustain an artistic career. In the end, she came out of the next decade with a profound renewal of her practice and vision.

Arena of the Sun, 1954, oil on canvas, 200 × 270 cm (detail)

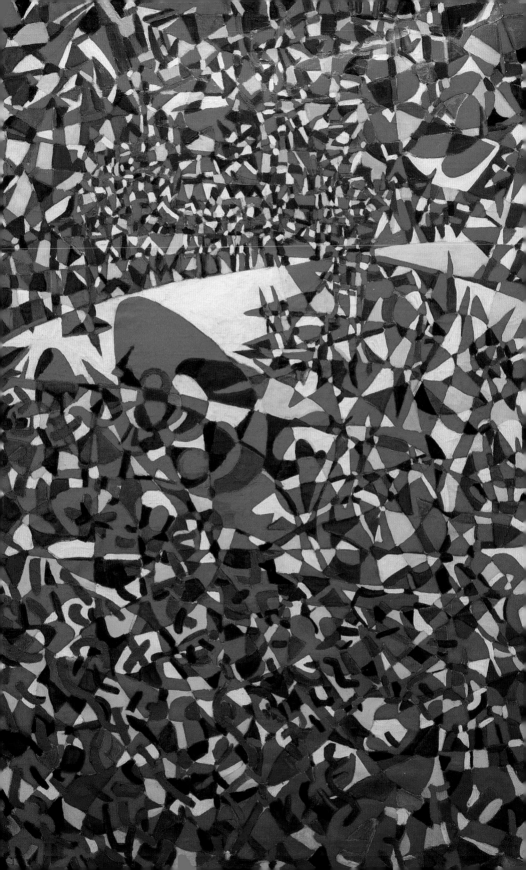

VI

Personal Tragedy and its Aftermath
1958–61

The events of July 1958 transformed Fahrelnissa's life for ever. That month the twenty-three-year-old King Faisal II, Prince Zeid's great-nephew, and several members of the Iraqi royal family were brutally murdered during a military takeover of the country. The coup was the latest in a series, but this one succeeded in overthrowing the monarchy for good. On the morning of 14 July, the officer leading the revolutionary assault on the royal palace ordered Faisal, his relatives, and some servants to line up in the palace grounds, where they were then machine-gunned down: the king, his uncle and the power behind the throne Crown Prince Abdul Ilah, the latter's mother Queen Nefissa, king Faisal's maternal aunt Princess Abdiyah and an orphan boy she had adopted, and a number of their retinue all perished. Princess Hiyam, Abdul Ilah's wife, survived her wounds at the hospital and, unrecognized by the crowds, was able to flee Iraq. Princess Badia, a maternal aunt of the king, also survived, because she lived outside the palace and escaped the massacre. She sought refuge at the Saudi embassy for weeks before being allowed to leave the country. Iraq's strong man, long-serving Prime Minister Nouri Al Said, was killed separately the following day, caught while attempting to flee disguised as a woman. Both his and Abdul Ilah's corpses were mutilated and dragged by crowds through the streets of Baghdad.

In the hours immediately after the killings, Colonel Abdul Salam Arif, one of the leaders of the revolution, proclaimed the new Republic of Iraq,

Fahrelnissa, some time in the early 1960s

bringing an end to the country's Hashemite monarchy. It was a profound blow for Prince Zeid. In one day, he had lost his family, his position, and his country, and in the most violent manner. But he was also lucky to escape the horror. He usually spent each summer in Baghdad as the acting regent in the absence of the king and crown prince. But this year, he had remained in Europe. He owed his life to Fahrelnissa's insistence that they spend the summer together at the house they had just purchased on the Italian island of Ischia.[1] It was there that the new republic's ambassador to Rome gave him notice to return to London at once and empty the ambassadorial residence of personal belongings. He flew back and spent the bulk of the time clearing Fahrelnissa's studio of its contents. The tragedy also had an immense personal effect upon her. Her son Prince Raad was close to his second cousin King Faisal, and she had recently begun to see the king and royal family much more frequently and had got close to several of them. In July 1957, she had hosted them in Istanbul, where they summered usually, and where King Faisal became engaged. His fiancée, Ottoman princess Fazila, was at the time enrolled at a British finishing school, and a few months later the king and she visited London to celebrate his birthday, a celebration organized and hosted by Fahrelnissa at the embassy with a reception for seven hundred guests.[2]

Following the revolution, Fahrelnissa returned to London in the autumn to live with Zeid in a flat in Oakwood Court near Holland Park that he had rented. It was to be their home until 1968.[3] Prince Raad was enrolled at Cambridge. This dramatic upheaval meant that Fahrelnissa the working painter lost the comfort, support, and distraction of being a member of a reigning royal family living in a palatial diplomatic residence. Outwardly at least, she adapted to her new circumstances and never complained; but she was haunted by thoughts of the massacre of those she called her nieces and nephews.[4] Prince Zeid was broken. The massacre's suddenness, scope, and violence hit him the hardest.[5] Fahrelnissa would often say that he would tell her that he had lost his life's purpose and that he wished he had died along with his family. He would ask her where he would be buried at his death? Fahrelnissa decided to devote herself to him and to quit painting. She considered that she had 'done her duty' as an

artist and had accomplished a great deal.[6] She explained that anyway she could 'no longer work as in the past'.[7]

Emerging back into the light
In this pitch darkness, Fahrelnissa somehow mustered the courage in February 1959 to bounce back. In an extraordinary document written in long hand on five double-sided sheets of A2 drawing paper over St Valentine's weekend, she wrote of her sorrow and dismay at the tragedy, and of her resolution to be happy, despite her deep depression. She even gave a title to the entry: 'I have decided to build – my happiness.'[8] She began it:

> Today at 6am I decided to build my happiness [...] no idea, no event, makes me morose or disagreeable. I wanted to be a lamentation rolling through myself through my nerves' raised claws. Now I have no claws and feel no need to slide through [...] I want to build my twenty-four joys, my twenty-four hours of happiness. I want to build [...] but [...] Flies, sadnesses cover me like bats. And [yet] how to build one's happiness when one is continuously submerged. As soon as I get my head out from under the profound sheets of water, I receive a blow anew and I find myself at the bottom of the deep. Gesticulating and trying to breathe, in the end succeeding in breathing to live [...] I must build my happiness second by second. I must stand, rise and breathe far from the heights. All around me silence [...] how I have arrived at this stage, me who only swore by these words 'courage – audacity – freedom'? I am only repeating I am afraid, afraid, afraid, and afraid, misery and company [...] I must sleep and chase the black ideas that anew surround me and hound me despite everything.'[9]

Two things appear to have eventually rescued Fahrelnissa from her gloom. Her work, which imperceptibly reappeared in her life as soon as December 1958, and the home in Ischia, which provided a safety net that helped her and Prince Zeid surmount the tragedy as a family, and even helped

Fahrelnissa develop a new style. She had discovered the island accidentally in the summer of 1957 when seeking to take her daughter Shirin away from Istanbul and her crumbling second marriage.[10] They went to Ischia upon the advice of Fahrelnissa's brother Suat. The island, with its turquoise bays, oleander-lined cobblestone streets and horse carriages, reminded her of Buyukada. In the spring of 1958, she purchased a home on Via Provinciale Panza, which she named Villa Fahrelnissa. Over the next decade, the house would provide her with respite after the dark winters she and Zeid spent in London. The house had views of the sea and the moon rising behind the mountain, and she would entertain visitors there, from her grandchildren to celebrated artists and writers from Paris. She would spend the summers swimming for hours and exploring the different villages, bays, and caves of the island.[11]

In London, even though she had decided to devote herself to her husband and to stop painting, the impulse to work returned to her. She recounted many times in interviews and to friends how the inspiration came to her prosaically, even mechanically, from her new life experience as a home-maker who must cook for herself and her family, rather than from a deliberate search for artistic self-expression. The Christmas season in London was normally a busy and festive period for her and Zeid, as they would be invited to numerous parties and dinners. In 1958, however, they were to spend the time alone, so Fahrelnissa decided to cheer up her husband by having Christmas lunch at home, which meant she had to cook turkey for the first time in her life. A week later, when the turkey had been consumed at last, she noticed while handling its carcass that the shapes of some of its bones reminded her of a human head, and another of an aeroplane. She began to keep the remains of poultry meals. Fahrelnissa would stress that she was merely amusing herself, as she had given up being an artist. As time went by, she became more intrigued by the bones she handled, their different shapes and sizes, and she started to clean, polish, and collect them. One day, she picked up a brush and painted one and then another with china ink.[12] This would not have been an odd gesture for Fahrelnissa, who was a constant sketcher and who had already painted and exhibited beach pebbles. However, at this stage, it remained only a pastime;

unlike her pebbles, she did not exhibit any poultry bones at her 1961 and 1964 exhibitions. However, these 'artist's toys', as she would later call them, were the origin of a unique new artistic practice that she would develop in the second half of the 1960s.

It appears, however, that Fahrelnissa was also painting at this time, perhaps after she took the decision to 'build her happiness'. For in the same month – February 1959 – her diaries show that she ordered eight canvases made to measure from Winsor & Newton, her usual art supplies source, and was apparently also in the process of painting a portrait of a little girl.[13] This is an intriguing discovery because Fahrelnissa stopped painting portraits in the mid-1940s, and because there are no surviving portraits from this period. Adding to the intrigue are two paintings that Fahrelnissa herself dated to 1958, and which deal with the tragedy, *After the Tragedy* and *The Search*.[14] Did she paint these works in Ischia while Prince Zeid was in London, before deciding to abandon art altogether when the couple were reunited in the autumn and she was faced with his despair and the sadness of their new situation?

Fahrelnissa would not exhibit in London again, even though over the next decade she continued to paint there portraits of friends and visiting family members and abstract works. She remained in contact with her two gallerists Lea Jaray and Philip Granville. However, probably aware of her former identity as a royal ambassador's wife, she may not have wanted to subject herself or her husband to the gaze of the public at an exhibition opening with their new changed status; or perhaps she preferred to keep a low profile in England and avoid coming to the attention of the new Iraqi authorities. At any rate, eventually Prince Zeid encouraged Fahrelnissa to return to Paris. Ultimately, Dina Vierny encouraged her to hold another exhibition.[15]

The comeback exhibition

Fahrelnissa returned to Vierny's gallery, and in 1961 held there her first exhibition after the coup.[16] She showed eighteen oil paintings made before and after the Revolution, and some pebbles. The oils have evocative titles like *The Revenants* (1961) – also exhibited in 1968 as *Resurrection* – *Fatality* and *Ghost Ship*.

It appears that the exhibition was a success and that she sold works, including a stone to the famous singer Léo Ferré. Her exhibition was also used as a setting for a film.[17] As with many works exhibited by Fahrelnissa, few images survive of the paintings, either because they were sold at the time or because Fahrelnissa renamed them and showed them at later exhibitions. The 1984 book devoted to her work and the images of paintings held by her estate remain the most reliable way to both identify and date them – after making a few adjustments based on brushwork and compositional concordances.

If the exhibition was successful commercially, the presentation and reception of Fahrelnissa's new work was another matter. The exhibition's catalogue text was again by Charles Estienne. There was no new framing of her work in it. He did single her out as 'one of the most authentic representatives of lyrical abstraction', but then, as in his text for the 1953 exhibition, he focused on Fahrelnissa's Cretan heritage and presented her as the incarnation of a peregrination that originated there. He also likened her to Dante seizing the gift of Virgil's golden bough, her bough on her journey being the seven-coloured rainbow. Estienne also referenced Ulysses, Marco Polo, and Sinbad for her gift of lyrical narration. Eventually culturalist references appear, with his statement that Fahrelnissa's art, 'having as one of its roots an Islamic root, found itself when needed, abstract by vocation more than by stylistic necessity'. He further likens her art to the pillar of fire guiding wanderers in the desert after God forbade idolatry and graven images.[18] Estienne wrote this from his Brittany home, for by 1961, he had already withdrawn from active involvement in the art scene and was focusing more on writing poetry, novels, plays, song lyrics, and the occasional preface to an exhibition catalogue.[19] All these literary concerns may account for the character of his text.

The only available review of the exhibition is a piece of faint praise that further linked Fahrelnissa to Estienne's reputation and bypassed her works, substantiating André Parinaud's observation that her ultimate consecration may have been held back by her association with Estienne.[20] The reviewer Michel Courtois wrote that the show was a throwback to the 'heroic' period when Estienne was revealing the 'poetic and plastic gushing vitality of this Iranian

[sic] princess'. He also noted that her works' new tone, finesse, and delicacy have anachronistic accents in these times when 'Abstract Expressionism and *tachiste* virulence' dominate the art scene.[21]

Transitional deskilling

Notwithstanding Estienne's text and Courtois's review, Fahrelnissa's strongest works in this exhibition and outside of it were full of emotion. In a small 1980s notebook, she sketched a number of her most significant paintings and scribbled a few words about the circumstances of their creation. This is what she wrote about works she painted in the aftermath of the tragedy:

> There was the great drama that was our great misfortune, pain. I was
> ashamed to paint, especially bright tones [like] red, gold, blue. Black,
> black and more black I [illegible] made *The Murderous Bullet* and then
> *The Tragic Mist, Lustred with Black* ['Nacré de noir'] and others that I gave
> to friends.[22]

This proves that Fahrelnissa did work after the coup, probably in Ischia while Zeid was in London organizing the apartment and their new status, and she only decided to stop painting after she was reunited with him and felt the extent of his pain. This same notebook also provides a timeline for works painted after the coup: *The Bullet, Tragic Mist, Lustred with Black*, and its compositional and chromatic pendant *Angel Foot*, followed by *Éclatement* and *Nightmare*. Outside the exhibition proper, some of the works reliably attributable to that period are *London* from 1959 and probably a series of similar works entitled *Soleil de Byzance, Byzantine Fog, Byzantine Red*, and *Purple Fog*, which must have been painted at the same period in London. There is also a similar work, chromatically and texturally, called *The Search*.

All these works made over this three-to-four-year period share the same texture, begun in 1956–7, of incising the surface of the paint with a palette knife. In the earlier paintings, Fahrelnissa used the knife with restraint as a finishing motif. In these post-coup paintings, the artfulness of the aerial-view

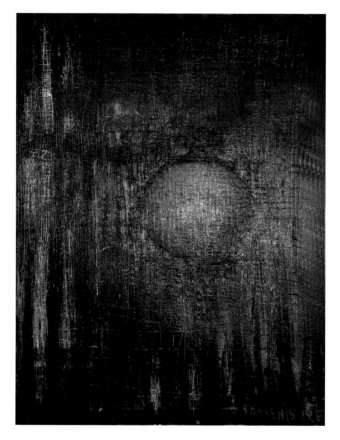

The Bullet, 1958, oil on canvas, 127 × 102 cm

experiments of 1949–50, of the chromoluminarist all-over, of the maritime paintings, of the primitivist opacity of 1956–7 has gone. The Fahrelnissa battling her mood episodes and transposing the sublime onto her monumental paintings has been defeated by the tragedy of July 1958 and by the anguish and uncertainty of what was to come. Before her canvases, she is suddenly deskilled, left wielding her palette knife as a grief-stricken woman rather than an artist. The Bullet is such an artless and deskilled work: its canvas is a mesh of thick

vertical blurred black bars, with a golden sphere surging through; the signature on the canvas is red. The motif and effects of this painting are continued in the more elaborate *Éclatement*. It retains the relatively rare spherical compositional element of *The Bullet*. Here the bullet has shifted to the right of the canvas and is contoured in red. The black signature has returned and all over the canvas appear and reappear faint blurred smothered reddish and blackish shapes. The entire colour is the golden ochre of the Baghdad desert sunrises of Fahrelnissa's Bedouin visions. The canvas is hatched over repeatedly with the palette knife in short jets, vertically and horizontally.

As for *The Tragic Mist*, it appears to have disappeared after the two 1964 exhibitions in Turkey. *After the Tragedy* is a long horizontal ochre canvas, traversed by a black hatched horizontal Y, with splotches of blurred and hatched

Éclatement, 1958, oil on canvas, 74 × 97 cm

After the Tragedy, 1958, oil on canvas, 70 × 183 cm

spots of red on the right-hand side. It is covered with repeated incisions into the paint. No dimensions are available for *The Tragic Mist*, but it resembles *The Search*. More telling and overt in sentiment, the latter is a striking work as compositionally it represents two clouds of colour confronting each other or bleeding into each other: red and black with flashes of yellow, green, and white. This chromatic battle is offset by the whirl of the palette knife on the canvas. In another departure, Fahrelnissa leaves behind her meticulous repeated hatchings for a toing and froing tangle. Here and there, patterns appear but the vortex takes over in long furrows.

This series of four works appears to be an implicit *tombeau* for Fahrelnissa's nieces and nephews – a painterly 'tombstone' for a family that was summarily herded together and instantly shot dead in the forecourt of their home, the Palace of Roses.[23] The series is a deskilled blur of sand, blood, and smoke. The hand of the artist is shown in the blending of colours, in the introduction of the palette knife, but its handling is emotionally raw rather than artful. The composition is almost absent; colours are distended into shapelessness, interspersed with blotches and flashes of colour, as if the artist's mind is elsewhere rather than on her art.

The Search, 1958, oil on canvas, 88.5 × 129 cm

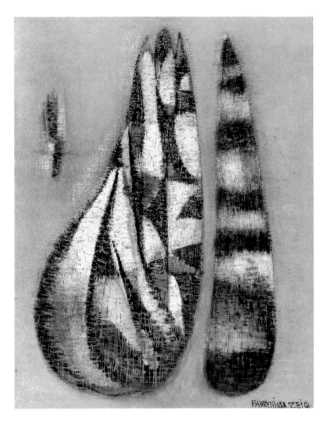

Angel Foot, 1958, oil on canvas, 127 × 102 cm

Angel Foot and Lustred with Black are oddities for this period, in that they show more compositional effort than the tombeau. In both works, black, yellow, and white dominate; in Angel Foot, blue is also introduced. Both paintings feature abstract biomorphic patches. In Lustred with Black, it is an overall oval shape trans-pierced with static vestiges from her kaleidoscopic vortexes: small black and white triangles and squares make out a grid, crossed out with a palette knife, while a black spindly star seems to claw at them from the bottom of the canvas. Angel Foot appears like a more thought-out piece compositionally.

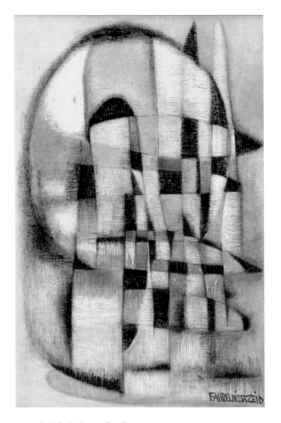

Lustred with Black, 1958, oil on canvas, 152 × 102 cm

Two large teardrops float vertically side by side against a grey background. Both are filled with the same geometric shapes and colour palette. These two works appear to be exercises in painting where Fahrelnissa tries to reconstruct her compositional and painterly edifice, but the divisionist shards and the biomorphic shapes are now static rather than swirling. As for *Nightmare*, which was also included in the 1961 Dina Vierny exhibition, it is an illustrative piece, a throwback to the 1956–7 paintings, with the distended lustred colours sliding on the canvas; here the two colours come from three red horizontal flames

emerging from blackness. The entire canvas is covered with coarse grooves from the palette knife, and the signature is reduced to her two initials in red.

This is an elegiac series, a tragic context ignored by Estienne. While the works in the show lacked the earlier plastic 'virulence', that was the result of genuine pain and anguish. Those works were an artistic grieving process, a transitional body of work where her earlier painterly syntax distended and slowed. And, as with all Fahrelnissa's works, what must be considered is not only a given painting, but also the gesture made, the artist standing before the canvas, wielding the brush or the palette knife, and the nature and force of that gesture, its sense and motivation. The knife became her most important instrument, which she now used instead of colour to give movement to her works. This exhibition was an act of will, a manifestation of Fahrelnissa's decision to 'build her happiness', even if what she had to show at this early stage were the deskilled mournful pieces of her grieving process. Perhaps a need to show her Paris acquaintances that she was still a working painter who had not been swallowed up by the coup and its aftermath motivated her to have the exhibition so soon.

At the same time as she was making these works, however, she was also producing a series of paintings that appear to show the London cityscape that she now had all the protracted London winter to observe. These works are all similar paintings of a blurred and hatched horizon line of a city with tall buildings. Fahrelnissa worked on this series, which she would continue on and off through the 1960s, in the vein of an abstract landscape painter. However, with the return of her spirits and her skill, she transfigured the grey wintry vistas with her use of colour combinations: green and red in *Byzantine Fog*; red and green in *Byzantine Red*; and an improbably blurring of bright orange, yellow, and blue in a tangle of buildings in *London*. These last works were not shown at the Vierny exhibition, but they point the way out for Fahrelnissa from her mourning period, when time slowed down and colours blurred. Fahrelnissa would also build on the work that she had experimented with in her kitchen to forge new paths in the coming few years.

Nightmare, 1958, oil on canvas, 102 × 76 cm

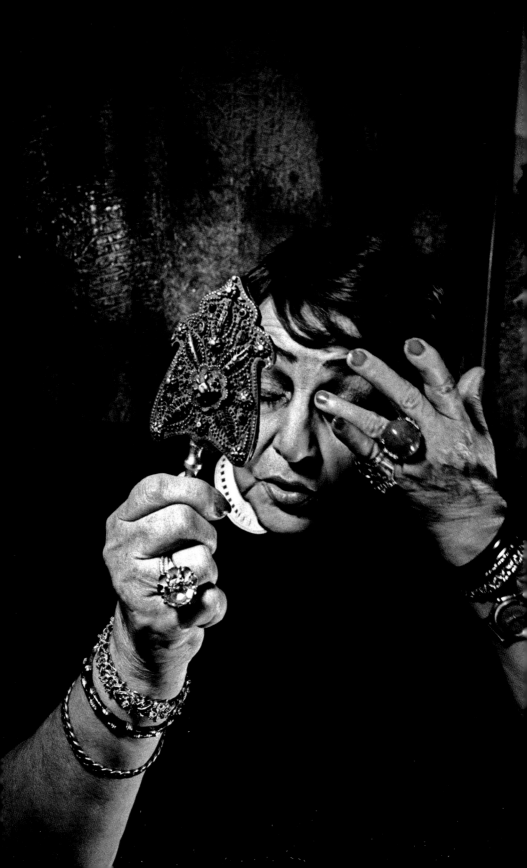

VII

Enter Light, Sea, and Space
1962–9

After the trauma of the Iraqi royal family's massacre and their own subsequent exile, it took several years for Fahrelnissa and Prince Zeid to fully adjust to the new situation. They spent winters in London and summers in Ischia, with Fahrelnissa making occasional trips to Paris. Following the shock of the coup, her mental and physical health continued with its 'ups and downs', and she kept in touch with her Baghdad physician, Dr Hoff.[1] A highlight in the family's life was their son Prince Raad's marriage in 1963 to a Swedish fellow student, Margaretha Lind – who became known as Princess Majda – and the couple's move to Amman, where King Hussein granted them Jordanian citizenship.[2]

Artistically, Fahrelnissa's output continued unabated, and the 1960s would turn out to be a decade of intense renewal and creativity in her practice. Her painting evolved as she started to work more frequently in Ischia, and she produced works that were completely different in colouring and composition than everything that had come before. Moreover, taking her fascination with light and colour away from the confines of the canvas, she invented new forms of expression born out of her personal tragedy. But this creative innovation coincided with the next phase in Fahrelnissa's life, for now she entered a period of increased retrospection. There was a feeling that the apogee of her career was behind her and that it was a time for reflecting on all her artistic achievements to date.

Ara Güler, *Fahrelnissa Zeid, Istanbul*, 1968

The 1964 exhibition at
the Istanbul Academy
of Fine Arts, with
My Hell (1951) installed
on scaffolding

This sense of looking back took its most obvious physical form in 1964 when her daughter Shirin organized two major retrospective exhibitions of her work in Turkey. She had proposed the idea after she noticed that her mother was going through a period of loneliness and depression and had once again started to take to her bed in her London flat. Fahrelnissa had not visited Turkey in several years, but more importantly, she had not exhibited there for two decades. Even if the Turkish press occasionally covered her exhibitions in London and Paris, she was unknown to the new generation working there. Shirin had extensive contacts thanks to her work in Turkish theatre, and she chose two prestigious locations: the Istanbul Academy of Fine Arts and Ankara's Hittite Museum of Anatolian Civilizations. It would be the first time the Turkish government had given the museum over entirely for a one-person show. Shirin not only organized locating and getting all the works for the exhibitions, she was also responsible for their design, calling upon technicians from the stage to accommodate Fahrelnissa's unconventional canvases. The monumental *My Hell* and *Intermittences* were placed on a special scaffolding that dominated

the long, narrow, marble terrace of the Academy so that visitors could see them through the glass doors against the blue water of the Bosphorus.[3]

The Istanbul opening was a huge social and cultural event. It was thronged with members of the public, as well as by artists, the Shakir and Zeid clans, various luminaries, and William Saroyan, the American writer with Turkish-Armenian roots whose portrait Fahrelnissa would sketch. The show featured ninety works from 1951 to 1964, including forty-five oils, gouache-on-paper works, and lithographs. Shirin considered the display at the Hittite Museum the best of all Fahrelnissa's exhibitions.[4]

The retrospectives were a return home in many ways, as the exhibition catalogue placed Fahrelnissa in her Turkish context. The opening text listed all her illustrious ancestors and relatives, along with her membership of the D Group. The publication also featured selected excerpts from international reviews that stressed her oriental and Byzantine heritage. These included one critique by the prominent Turkish writer, journalist, and one-time prime minister of Turkey, Mustafa Bülent Ecevit, a reprint of his review for the Turkish arts and literary magazine *Sadirvan* of her 1948 Gimpel Fils exhibition.[5] His text praised Fahrelnissa's energy and artisanship, and her handling of light and colour in her depiction of local scenes, and alluded to her optimism and positivity despite a painful inner life and torments. He argued that her use of

The last day of the exhibition, May 1964, photographed outside the Academy of Fine Arts and beside the Bosphorus, in front of *Basel Carnival* (1953). On the far right is her niece the famed ceramicist Fureya Koral.

mosaic-like patterns was spontaneous and not premeditated, and that she combined content and abstract form in a mystical harmony, infused by the same spirit that inspired mystic poets in Anatolia through the ages.[6]

The exhibitions were widely covered in the Turkish press, and Fahrelnissa arranged for an article to appear in Paris.[7] Nurullah Berk, her erstwhile fellow D Group member, wrote a laudatory review, singling out her 'overpowering quality' as she was moved not by her intellect, but by 'instinct, under the influence of her lyrical and excessively emotional nature'.[8] A more representative example of the response to the show was artist and art historian Cemil Eren's review placing Fahrelnissa's oeuvre in the context of her nostalgia for Turkey, leading her to recreate authentic Anatolian atmospheres without using any of its recognizable motifs.[9]

A promising offer from Paris

Fahrelnissa was overwhelmed by her reception in Turkey, and it led her to return frequently over the coming years for family visits. The survey exhibitions also spurred her to work, while another event occurred a few months later also encouraged her to increase her productivity. In November 1964, King Hussein of Jordan visited Paris on a state visit. He invited his great-uncle Prince Zeid and Fahrelnissa to come from London for the reciprocal dinner he was giving for General Charles de Gaulle and the French government. Fahrelnissa was seated next to the new and powerful cultural affairs minister, writer and adventurer André Malraux (1901–76). Fascinated with all things oriental since his 1920s travels in Cambodia, and prone to pithy and grandiose statements, Malraux apparently knew who Fahrelnissa was. He greeted her by saying that art originally came from the East, and that the future of art would come from the East also. They met soon after in his palatial offices in the rue de Valois. Fahrelnissa related that he suggested that the ministry organize an exhibition of her works. Malraux was then extending the remit of the state as a comprehensive sponsor of the arts, to eclipse the cultural influence of the Communist Party at home and extend France's grandeur and influence abroad. To this end, he founded the Paris art biennale in 1959, commissioned Marc Chagall to paint

the ceiling of the Paris Opéra in 1963, and sponsored a large Picasso survey exhibition in 1966. According to Fahrelnissa, Malraux asked her to choose one of two options: either a joint exhibition with Chagall or a group exhibition with a number of Russian artists. She opted for the first idea.[10]

Fahrelnissa must have wanted this recognition now that the art scene had moved on from the hothouse of lyrical abstraction of the Nouvelle École de Paris. It had been supplanted in pre-eminence by the experiments of *art informel* of Pierre Soulages and Georges Mathieu and by the *art brut* of Jean Dubuffet. Then the art pendulum swung the other way completely in the early 1960s, with avant-garde practices more attuned to the ironies and realities of contemporary life, notably the emergence of the Nouveau Réalisme movement.[11] At the same time, Fahrelnissa's former contemporaries in the Nouvelle École de Paris were obtaining official recognition: in 1962, Alfred Manessier, Jean Messagier, and Serge Poliakoff all represented France in the Venice Biennale, Manessier receiving the coveted international grand prix for painting; Jean René Bazaine had a retrospective at the Musée d'Art Moderne de la Ville de Paris in 1965, with Charles Lapicque receiving the same honour in 1967, and Hans Hartung and Raoul Ubac in 1968. Fahrelnissa was in the unique predicament of being affiliated with three countries with which she now had only tenuous ties – Iraq, Turkey, and Jordan – while not being a citizen of the country where she had developed her practice, France. Like Prince Zeid, in other words, she found herself state-less, at least artistically speaking.

Malraux's joint exhibition did not materialize, however, but Fahrelnissa continued to pursue the project of a large state-sponsored show for a few years. In November 1965, she received a letter from the Jordanian embassy in Paris informing her that they had received a letter from Jacques Jaujard, a senior advisor to Malraux, who had passed on her file to him 'with strong recommendations to pave the way' for her exhibition.[12] The embassy scheduled a meeting between Fahrelnissa and Jaujard for December at her rue de Grenelle studio flat. Jaujard had been the legendary director of the French Musées Nationaux during the Second World War. As such, he had saved the Louvre's collection and thousands of works of art in public and private collections from the Nazis.[13]

In 1959, he became secretary general of the new cultural affairs ministry, and three years later was tasked with the organization of all state-sponsored art exhibitions in France and abroad. It seems that there were unforeseen delays, because Fahrelnissa wrote to him in June 1966, enclosing a list of her proposed works for exhibition.[14] The list featured thirty-seven abstract oil paintings and twelve semi-figurative or symbolist to semi-abstract works that she proposed to bring from London for Jaujard to judge whether to exhibit. She also listed nine portraits and some works on paper.

In the end, the exhibition may not have taken place for dramatic reasons. In April 1967, Jaujard was inexplicably relieved of his functions by Malraux; he died of a heart attack a few weeks later. Still, Fahrelnissa persisted and kept in touch with Malraux, and they corresponded in early 1968.[15] Shortly thereafter, she and Prince Zeid moved to Paris permanently, perhaps with the idea of advancing the exhibition plan in mind. As her husband grew older, she worried about leaving him behind in London for any lengths of time, so he suggested that they live together in her cluttered Paris studio apartment.[16] There, they would socialize with her circle of artist, critic, and gallerist friends, for whom she would throw elegant dinners complete with seating charts and silverware, and stay in touch with visiting family. Almost immediately after they settled in the city, however, the May 1968 revolts would paralyse the country for a year. In consequence, de Gaulle resigned in April 1969, and Malraux followed in June, ending all hopes of Fahrelnissa's long-anticipated retrospective.

The birth of a new art form

Fahrelnissa's 1965 meeting with Malraux may not have to come to anything as far as an exhibition was concerned, but it did lead directly to her developing an entirely new art form. When she went to meet him at the ministry, she had taken with her two examples of her whimsical painted poultry bones, in this case, guinea fowl bones, which she had wrapped in a dark-green mousseline scarf. She told him that she had a gift for him, a specimen of a 'rare palmiped' that looked like a traditional Mexican children's toy. Malraux replied, 'Perhaps, but this is art.'[17] He placed the bones on his desk and later mentioned them in

a radio interview as 'more or less surrealist objects made by a sculptor' who was the 'aunt of the king of Jordan'. A news magazine tracked her down and published a short item about her, along with a photograph of her holding one her 'anti-sculptures'.[18]

Malraux's enthusiastic response spurred her to innovate further. Even as she left his office, Fahrelnissa was determined to have an exhibition focused on these bones.[19] In 1967, she began transforming what had been until then merely her own 'amusement' in her Oakwood Court kitchen into a new artistic medium: sculptures formed by encasing the painted bones in blocks of transparent coloured polyester resin. Fahrelnissa credited family friend Issam El-Said with the technical breakthrough at their origin. El-Said (1938–88) was a grandson of the slain Iraqi prime minister Nouri El-Said. Based in London, he had studied architecture at Cambridge when her son Prince Raad was there.[20] She said to Issam that she did not know how to get rid of the carcasses' grease or to display them to their fullest potential. He told her about a new German-made chemical product used for moulding that he had seen at a trade fair for architects and designers at London's Olympia exhibition centre. She asked him to contact the manufacturer and ended up buying large quantities of the liquid. She described the process as painting the bones, filling moulds with the liquid, adding colouring, inserting the painted bones, and then pouring in a hardening formula. As they hardened, the sculptures would emit a cracking sound through the night.[21] Fahrelnissa made several small and large sculptures in this way, and invented a new name for them: 'paléokrystalos'. At first, they used the moulds in London, but then in the spring of 1968 El-Said came to Paris to help her make the sculptures there, as they were too fragile to carry. As time went by, and as she needed more bones, she would hold special dinner parties at her London and Paris homes, and would also ask neighbours to give her their rabbit and poultry carcasses rather than discard them.

She also devised different ways of displaying them. For the larger sculptures, she had made-to-measure wrought-iron stands produced in Paris. She displayed the smaller and medium-sized ones on revolving stands, with light projectors focused on them or behind them that would change the colour of the

paléokrystalos as they turned, as well as shine their colour on the ceiling and walls.[22] Many journalists and friends commented about the fantastical aspect of her Paris flat, with the whirring sound of the revolving bases and their changing colours running on the walls. The fantastical veered into the tragicomic in the autumn of 1969, as she prepared to exhibit the works for the first time, when one of Fahrelnissa's neighbours mistook the smell of the chemical for a gas leak and called the fire brigade. They arrived with three engines and were about to flood her basement studio with water when they discovered the error. Prince Zeid was quoted as commenting after the incident that, 'everything will be well as long as my wife does not transform her art into an atomic bomb. With her one can expect anything.'[23]

Presenting her 'anti-sculptures'

The paléokrystalos received their public outing in October 1969 when she held her first Paris exhibition in eight years. The venue was Katia Granoff's gallery on the quai de Conti on the Left Bank directly opposite the Louvre. Fahrelnissa had met Granoff (1895–89) in the mid-1960s. She was a former Ukrainian refugee who had managed to become an acclaimed published poet in French, while running three art galleries in her name in Paris, Cannes, and Honfleur. She supported and exhibited varied artists, including Claude Monet, Chagall, and several Nouvelle École de Paris painters.[24] She soon became a long-time friend and supporter of Fahrelnissa, who would paint many portraits of Granoff and members of her family.

El-Said came to Paris to help install the exhibition, arranging for the paléokrystalos – all of which were dated to 1967 – to be displayed on their revolving bases, and for a large painting to be lit with rotating multicolour projectors. The exhibition was important on many levels. It signalled an ending and a rebirth for Fahrelnissa. It was also the first to show her in all her complexity, without orientalist reductionism but with her soaring imagination, crippling creative angst, vulnerability, and artistic impact. She was also

Moon Drops, 1967, resin, bone, and metal, 87 × 83 cm

determined to sell the works, and she drew up a detailed price list outlining the value of the most important ones. It is clear that she had full control of her catalogue this time, as it was a very personal publication that presented her in congruence with her works. It was a small booklet featuring two revealing and intimate personal statements by Fahrelnissa. Her portrait, taken by African American photographer Emil Cadoo, who had moved to Paris earlier in the decade, showed her aging face with a rare wistful and pensive gaze behind a chipped slab of paléokrystalos (reproduced as the title page of this book). The catalogue also featured a handwritten poem by Fahrelnissa that celebrated her whimsical spirit and exalted fortitude:

> Life played me her serenade and I danced all around like a gypsy.
> I overturned the years, passed over and breaking the unhealthy
> constructions of suffering.
> Thirsty, panic-stricken, half-blind, pursued, lamenting,
> I ran to the inferno and the inferno engulfed me
> and this is why I am happy.

The main text was excerpted from the nineteen-page 1956 diary entry in which Fahrelnissa described her tormenting painting process, laid out on the pages like a poem, in stanzas. The publication also featured a quote by André Breton, excerpted from a letter that he had written to her in the 1950s: 'I forever keep in my innermost secret heart the echo of words that have reached me here from you, like a ray emanating from these admirable geodes that are born and extend at will under your fingers and that pierces all darkness.'[25]

Extant reviews of the exhibition appear to have responded to the sincerity of the catalogue and the breadth and originality of the new works. Without the fevered quarrels of the Nouvelle École de Paris, critics were able to appreciate the show as it was. These reviews focused on the artist and on her extraordinary invention of new worlds. Poet Anne-Marie Cazalis called Fahrelnissa in Elle 'a very great painter'.[26] The specialized modern art magazine La Galerie des Arts saluted her 'freedom of inspiration and a rare independence of spirit'.[27]

Another critic hailed her as a reformer of modern art in her 'reconstitution of an imaginary museum of prehistoric art'.[28]

The principal review was by long-time friend and occasional gallerist of Fahrelnissa's, Bernard Gheerbrant. It was the first substantial review to explicitly reject orientalist clichés, while also underlying the influence of Kandinsky. He rejected reducing her art to the Islamic ban on figuration and her persona to a 'Scheherazade' figure. Instead, he wrote of her work in terms that Fahrelnissa herself used, of a struggle with painting, a *'corps à corps'* or hand-to-hand combat. He also linked that struggle to Kandinsky's writings about art as 'improvisations', 'impressions', 'compositions': 'the approach of one who feels in his depth of his being the struggle waged on the canvas shapes of opposed colours and trends … on a cosmic scale where worlds and planets interfere dangerously'. Indeed, Gheerbrant framed her exhibition as 'a discovery of the hidden face of the Moon', as it was held one year after the Apollo 8 mission first orbited the Moon and just a few months after the first Moon landing in July 1969. He also tied her work to Kandinsky's assignation of specific properties to certain colours, and more broadly to modern artists' quest for depth. He compared her, with her paléokrystalos, to a Palaeolithic artist who elaborates a primitive alphabet. Finally, he likened her entire approach in the exhibition to that of a demiurge seized by a cosmic passion in her manipulation of colours, shards of glass and bones to fashion a stellar world where the viewer becomes a 'cosmonaut … projected in a sci-fi universe where speed and light make us encounter the images of the birth of man'.[29] This assessment may be a reflection of Fahrelnissa's new status, eleven years into her European exile. It may also be an instance of her gaining in assurance and experience sufficiently to allow her to put forward her conceptual approach herself, rather than let a critic take the reins in her catalogue and influence the reviewers' and the public's interpretation of the work.

These works with bones manifested the culmination and simplification of Fahrelnissa's lifelong fascination with light and colour, with which she was now able to work directly without the opacity of canvas. With them, colour become translucent and refracted; she appears to have perceived light

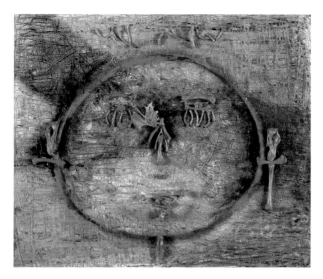

The Solitary of the Cave, 1968, mixed media on canvas, 63 × 76 cm

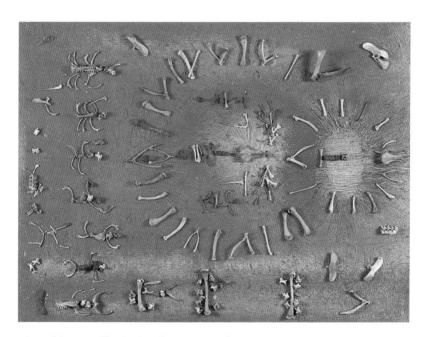

Adorers of the Sun, 1968, mixed media on canvas, 76 × 102 cm

in a fragmentary manner too. This is how she described her fascination: 'Since childhood I was impressed by light. I was attracted by the play of light on bevelled mirrors, by the colours on their edges. I like light decomposed in a thousand facets. It is a strange world of fleeting coloured movements.'[30] Her poultry bones allowed her to recreate even stranger worlds in colour and light.

Most of the works with bones have disappeared; approximately fifty remain. They included five types of work. First, the small unpainted poultry bones that Fahrelnissa placed on the surface of painted canvases furrowed with palette knife tracks, as if she were painting lines on a painting. These include works such as *The Solitary of the Cave*, *The Harvesters*, and *Adorers of the Sun*. They are playful symbolist tableaux of prehistoric or mythological scenes. The bones are arranged like rays of the sun, like arms raised in prayer, like legs, or even like little animals such as cats and seagulls. Sometimes the shape is intrinsic to the bone; at other times, she fashioned recognizable features from tiny bones: eyelashes, ears, and brows. This extraordinary set of works must have been an occasion for playful invention, with Fahrelnissa discovering a fresh pictorial language that allied her newly found bones with her traditional painterly skills.

Then comes the second group, the beginning of the paléokrystalos phase proper, in which she placed larger bones and fragments of carcasses, which she had painted, into blocks of coloured resin. One type is a small-sized circular or cubic-shaped colour block filled with painted bones. These

Untitled paléokrystalo, 1967, resin, bone, and polyester, estimated 11 × 11 cm

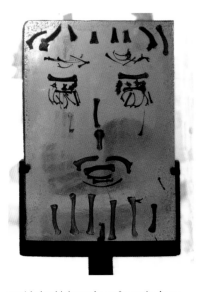

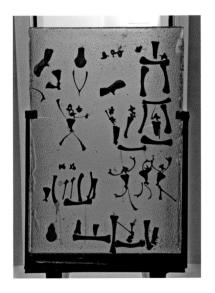

Untitled paléokrystalo, 1967, resin, bone, and metal, 40 × 30 cm

Signs and Symbols, 1967, resin, bone, and metal, 45 × 29 cm

are usually made from more substantial bones like the jawbone. They include *Helios* and *Sea Horse*. Here the outer resin and polyester casting is used only as a framing and exhibition device, while the bones and the figures are the centre and focus of the work. In *Helios*, the small straight bones are shaped like a human face inside a round green slab itself encased in a larger yellow square block. In *Sea Horse*, a curved and crooked bone is painted over to evoke the marine animal, while a wishbone painted red tags behind it.

The next group comprises large flat rectangular slabs of resin filled with small bones arranged in anthropomorphic groupings, figures, and gestures. In these, Fahrelnissa arranged the bones as she did on the paintings, in a vertical or horizontal symbolist-figurative scene, rendered more eerie by its translucent background. They vary in size from the medium (40 × 30 cm) to the larger (80 × 40 cm). As in the paintings and the smaller blocks, they represent either a human face with a tousled mane and beard, rendered with small bones floating in a square sea of cerulean resin, or a scene of celebration or dancing. As

Fahrelnissa put these last works on revolving stands, Prince Zeid likened them to whirling dervishes.[31]

Then there were slabs embedded both with bones but also with chips of broken coloured resin, presumably from other paléokrystalos. This group explores the material properties of the resin more than before, as with the small *Ball of Gold*, *Asiatic*, and *The Man of All Time*, and the large *Moon Drops*. Here, the textural properties of the hardening coloured resin strengthen the impact of the work. *Asiatic*, for example, has in the middle a human face made of small assembled bones, but what catches the attention are the bubbles that fill the cast, giving it a prehistoric fossilized amber quality; the same could be said about *The Man of All Time* and *Moon Drops*. Their coloured resin is ridged with radiating imperceptible stretch marks that give it an otherworldly aspect. *Moon Drops* is the most accomplished piece in this set. Not only is its texture subtly

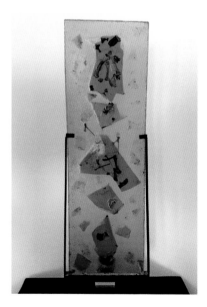

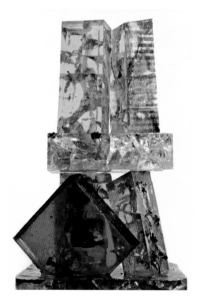

Untitled paléokrystalo, 1967, resin, bone, and metal, 82 × 25 cm

Fairy Palace, 1967, resin and bone, dimensions unknown

uneven like slabs of fogged yellow crystal edging each other out, but also it is filled with scattered small bones and bone fragments, as well as with shards of small multicolour paléokrystalos and larger fragments of broken pale-blue paléokrystalos filled with small bones. This masterpiece appears indeed as an otherworldly artefact, as an exhibit belonging more in a natural history or mineralogy display than in an exhibition of modern art. However, the originality of these works lies in their creation at the hands of an artist. They do not appear as primitivist affectations, but as a genuine attempt to create a contemporary artistic expression. Fahrelnissa used modern chemical colouring solution, and had a Cambridge-educated architect as her studio assistant. The artistic gesture immanent in the works lies in the choice of the material elements, in the creative act, but also in the waiting – waiting for the liquid to harden to give its final shape. The work is born again when it is set upright and backlit, and then it acquires another identity when applied with a coloured filter.

The final group of paléokrystalos, of which she exhibited a few in 1969 that do not seem to have survived, are the logical continuation of this last process. In these works, she focused on arranging slabs of resin and polyester in sculptural assemblages rather than on the bones inside them. These required more work than just removing the dried blocks from their moulds; they also entailed cutting different slabs with a saw and superimposing the pieces on top of one another in a formal composition.

Painting the sea

In the 1969 Katia Granoff exhibition, alongside her innovative paléokrystalos, Fahrelnissa also presented a number of previously unseen oil paintings. Chief among those were works she had begun painting in Ischia. She had already shown one at her 1961 Dina Vierny exhibition, *Ischia: Terra Incognita* (1961), which clashed with the rest of the post-coup paintings because of its bold, almost aggressive forms and vibrant colours.[32] Nevertheless, it belongs with the rest of the paintings shown in 1969. The most spectacular among these was the vast *Fight of the Moon and the Astronaut / Intruder* (1965), but there were equally striking canvases that showed again Fahrelnissa's capacity for renewal

Ischia: Terra Incognita, 1961 (originally dated 1954), oil on canvas, 210 × 205 cm

within the confines of painting, which she seemed to have exhausted with all her successive and sometimes overlapping stylistic changes.

These paintings were painted when she was in full contact with the sun and the sea of Ischia, and while she had the opportunity to bathe there daily. In several in particular, she transposes almost literally the underwater visions and sensations of swimming in the clear waters of the Bay of Naples. The overall painterly style is more sensuous, except for two black-and-white canvases that seem to flow into each other with their bi-chromatic intensity and lunar thematic. The rest of the available works painted in Ischia testify to the intensity of its sun and to the lush blues of its deep sea. Here Fahrelnissa abandoned for a while the busy surfaces of her Abstract Expressionist style for a form of abstraction that is representative of an objective reality that is already

Puncta Imperator, 1963, oil on canvas, 165 × 210 cm

Submarine World, 1962, oil on canvas, 179 × 208 cm

abstract: the depths of the sea, its contents, the glare of the sun, the burst of fireworks. These are not fixed objects that can be seen realistically in all their minute details. Fahrelnissa abstracts them further with her painting. These works retain an Expressionist fantasy. However, there is no need for her to exaggerate forms excessively because the natural tableaux she represents are already otherworldly to her exalted perspective.

The three paintings *Submarine World* (1962), *Puncta Imperator* (1963), and *The Visionaries No. 4* (undated) exhibit the most obvious connections to Ischia. Unlike her maritime canvases of the previous decade, these works show the depth of the sea. Whereas Fahrelnissa's usual seashore experience was to swim by a beach, here she often swam by jumping off from a boat and would

explore not only the open-ended sea, but also inside the grottos of the island. This made for a different sensual and visual experience that she transposed in these works. They are saturated with a lush palette of blues and greens, filled with blurry biomorphic forms and with a quiet and slowness not experienced in other paintings. The surfaces are still in places criss-crossed with a palette knife – a technique that she would retain into the late 1970s – but used in a deliberate manner to punctuate or highlight elements of the composition rather than manifesting frustration or despair.

Linearity also has receded in favour of creating depths via juxtaposition of modulated colours. The dimensions are large but smaller than the monumental works of the 1950s. Nonetheless, the paintings engulf the spectator, who has the sensation of swimming in the paintings. In *Submarine World*, the perspective is mixed; we are at once seeing from above the depth of the sea, but it is also facing us as if we were embedded in the deep. The only distinguishable shape is an odd type of maritime fauna swimming upwards from the left, endowed with a translucent blue skin with a thoracic cage, under which pulse fragments of red, and a head shaped like a human female breast. The rest of the canvas is filled with amorphous shapes.

Puncta Imperator is named for the promontory and lighthouse on the island, and it represents a series of tightly assembled large arched shapes that appear like recesses of an underwater cave, perhaps filled with algae and coloured fauna. In *The Visionaries*, Fahrelnissa shows her dexterous handling of light and colour with a limited palette and a small surface. The two teardrop and collapsed kidney-shaped figures in the centre of the painting are greenish ochre, and differences in depth and space around them are subtly rendered with about five shades and tonalities of blue, from an ultramarine on the left to a light cobalt turquoise on the right, evoking motion and escape.

At Katia Granoff, Fahrelnissa also showed a fiery sunburst painted in Ischia, in a return to representations of the sublime, of the unquantifiable awe inspired by nature. She replaced the quiet of the deep with explosions in the skies, dominated by the expressive use of gradations of yellow. *Ischia* is an exploding maelstrom of ascending snakelike shapes at the centre of the work

The Visionaries No. 4, date unknown, oil on canvas, 101 × 76 cm

with smaller flamelike shapes framing it, consuming yet smaller ensembles of tangled black lines. Linearity has returned here, not to create depth and shape, but to represent unknown entities engulfed by the blaze exploding at the centre of the canvas. The colour scheme is a swirl of lemon yellows and cadmium reds, tinged with cobalt turquoises.

Fahrelnissa did not abandon her earlier style altogether during this period, however, because she returned to the geometric sublime with the two black-and-white works already mentioned. The first one, *Lunar Chiaroscuro* (1965), seems to be a study for the second, *Fight of the Moon and the Astronaut / Intruder*. It is a tangle of black and white lines. Anchored by a central oval shape, the painting is covered with a random tangle of grids, spindly oozes of paint and knife-carved bursts. This largely bi-chromatic composition is overlain with random jets of violet browns, chiselled with the palette knife along its edges. The entire painting looks like it is a nightmarish midnight cityscape of multiplying skyscrapers.

Its probable successor was the final monumental work that Fahrelnissa ever painted. With *Fight of the Moon and the Astronaut*, she returned for one last time to the engulfing exalted and teeming multiplicity moving in diverging directions of her first canvases in London and Paris. With this painting, she returned to the vivid, jarring forms of the early 1950s. Here, however, she distended the compositional subdivisions in the expanse of space. At the bottom of the canvas is a lunar landscape of white folds. The white grid and squares on the right appear like skyscrapers at night, and those on the left look like the protuberances of reptilians' skins. Then from the right, surging down an incline is a tumbling jumble of zigzagging white lines and pointed arrows. The Moon appears as a small crescent followed by three full moons floating in the darkness on the left. Reportedly, she painted it after hearing of the beginning of space exploration and she was dubious of the ability of man to conquer the Moon, which was responsible for so many negative effects on people's characters and moods, 'so she had the idea for this aggressive painting [...] introducing arrows symbolizing the interdiction made to men to penetrate this planet. The squares [...] signified the angers of the threatened satellite. Taking as principle that the cosmos [...] must be black, she renounced the use of colour.'[33] However, she chose to display the painting by projecting colours on it, probably signifying the glow of the other planets.

Not surprisingly, this hallucinatory work was used as the foldable three-page cover of the 1969 catalogue. Yet it is a work that defies comprehension – that is, comprehension of compositional logic, and comprehension of the impulse and gesture of the artist painting such a unique work in her corpus. A few of its visual elements, like the folds and the squares in the grids, had been used before, but not all at once. Fahrelnissa, who was attuned to the vibrations of the cosmos, as she called them, must have been weary of an exploration of space that would bring it into the banal realm of the *terra cognita*.

This work and the rest of the paintings, as well as the paléokrystalos, confirm Fahrelnissa's continued powers of invention and innovation, as well as her skills as a colourist. Her imagination and her energy to implement it are extraordinary for a woman in her seventh decade. The laudatory reviews that

Lunar Chiaroscuro, 1965, oil on canvas, 205 × 164 cm

she received are a tribute to that. The Katia Granoff exhibition was held in 1969, but the paintings shown were all painted by 1965, while the paléokrystalos were made in 1967 and 1968. There had been no gap in Fahrelnissa's practice, however, but a series of new paintings that she had been working on since 1959, which she would exhibit for the first time in her next Paris show in 1972.

Fight of the Moon and Astronaut / Intruder, 1965 (originally dated 1968), oil on canvas, 210 × 535 cm

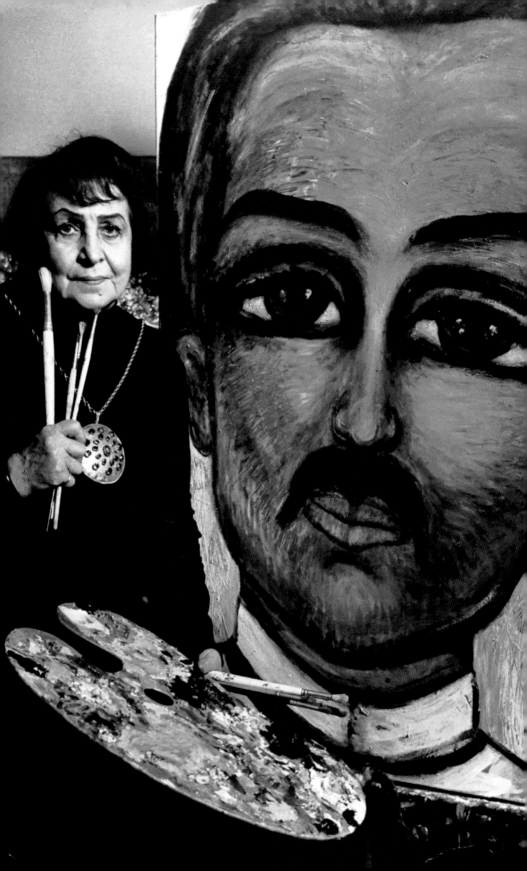

VIII

Renew and Return

1970–4

L iving together for ten years in London after the coup, and without social distractions, then in cramped conditions after moving to Paris, Fahrelnissa and her husband became even more attached to each other. But as the 1960s drew to a close, Prince Zeid was growing progressively ill with age, developing a heart condition. Shuttling between the apartment and long hospitalizations at the Hôpital Cochin in the 14th *arrondissement* for two years, he was further affected by the events of Black September 1970 in Jordan, when forces of the Palestinian Liberation Organization led by Yasser Arafat fought soldiers from the Jordanian army under the command of King Hussein. The conflict resulted in thousands of deaths. Even though his son and family and the Jordanian royal family were unharmed, Prince Zeid himself died a few weeks later, on 18 October. Having years earlier expressed his fears to Fahrelnissa over where he would be buried now that he had no country to call home, he was given a state funeral by Jordan and interred in the Royal Mausoleum in Amman.[1] Fahrelnissa visited his grave in December and was enchanted by its beauty. Over the following years, however, whether in Paris or in Ischia, she would increasingly write of her loneliness and sadness.[2] Writing to friends and in her diary, she would complain of being 'completely broken' by his death.[3] She would write of feeling 'miserable without the company of that so noble, so wonderful man, Emir Zeid whose wife I am proud to be, because in this awful world of intrigues, vulgarity [...] he was the brilliant wonderful

Fahrelnissa painting her portrait of Prince Hassan, 1968

239

noble soul! The light who guided me.'⁴ Fahrelnissa and Zeid's personalities were markedly different – he was as calm and quiet as she was assertive and flamboyant – yet their marriage endured through nearly four decades marked by political turmoil, family tragedies, illnesses, and physical separation, during which Fahrelnissa would remain devoted to him. Above all, Zeid supported his wife's career wholeheartedly, perhaps surprisingly for a man of his background and generation. She would describe him with fascination as self-sufficient and equanimous: 'He has a different character than all characters I have ever met or known. He is a universe that turns always alone [...] he has such a unity, such an ensemble, such a cohesion in the elements that compose him that I am always dazed and charmed [...] he takes everything with calm and striking maturity.'⁵ In fact, their union was such a fusion that Prince Zeid would himself begin to paint and draw in the 1940s, sometimes alongside his wife in her studio.

His death led Fahrelnissa to decrease her intensive work regimen, although she continued to travel between Paris, Ischia, and elsewhere in Europe for group exhibitions and family visits.⁶ In the end, she made time for another last exhibition in 1972 in Paris, where she unveiled the monumental but unseen portraits that she had been painting, quietly, throughout the 1960s. She wrote that despite her fatigue and sadness, she had to go through with the show in order 'to get away from thinking and crying [...] only trying to save myself, to be able to continue'.⁷

That year also brought the remarriage of her daughter Shirin and another trip to visit her in the United States. Two years later, Fahrelnissa's beloved younger sister Aliye passed away in Buyukada. It seems that later that year Fahrelnissa decided to leave Paris for good, as she commissioned the budding film-maker Olivier Lorquin, the son of Dina Vierny, to make a documentary that would sum up her life's work and announce what was to come.

Return to portraiture
There is a perception originating in Shirin Devrim's memoir that Fahrelnissa returned to portraiture because of her loneliness after her widowhood, in 1970.⁸ In fact, she began drawing portraits in her early adolescence and never

abandoned them. Quick, precise, and dramatic ink and pencil portraits and self-portraits fill the sketchbooks and diaries she kept for eight decades. During her figurative phase in the late 1930s and 1940s, she painted and exhibited numerous representations of herself and her family members, domestic servants, friends, and fellow artists. After her switch to abstraction in 1948–9, she did not exhibit any painted portraits – if she painted them at all.

There is documentary evidence that Fahrelnissa rediscovered a knack and interest in portraiture in 1959, accidentally. To please a friend in London, she painted the portrait of her daughter. She mentions in a diary entry in February 1959 that after the little girl's sitting ended, she worked on the portrait for five hours, and in the process, was 'really stupefied' at herself, because she 'saw that I like immensely anew painting a portrait'.[9] This remark poses a wider question about Fahrelnissa's portrait painting. Was she painting portraits of friends all along in the 1950s? Alternatively, did she only have time to do so for the first time after 1958, and rediscovered then her taste for portraiture? If the former, one wonders how many unknown or forgotten portraits by Fahrelnissa there may be in private hands around the world that would provide important insights into her oeuvre. In her June 1966 letter to Jacques Jaujard, which enclosed a list of works for her projected exhibition, she does include portraits. Indeed, she mentions the existence of 'latest portraits', nine that vary in size between 80 and 150 centimetres in height and 100 and 150 centimetres in width.[10] This is the size of most of the portraits that she exhibited at Katia Granoff in 1972, and which she dated in her exhibition catalogues to 1967 and 1968. Further, critic René Barotte mentioned in his text for the exhibition catalogue that these portraits were made a decade ago, placing them at 1962. That means that Fahrelnissa probably spent the better part of the 1960s, beginning in 1959, painting oil portraits alongside the abstracts that she painted in London and Ischia, and while working on the paléokrystalos between 1967 and 1969. This is a testament to her abundant creativity and to her continued energy despite her advanced age.

Fahrelnissa's gradual return to painterly portraiture in the late 1950s was also part of the wider zeitgeist, as a few artists in Paris and London had

begun a revival of the genre (Bernard Buffet, Francis Bacon, and Lucian Freud among them). However, for whatever reason, she chose not to show them in her 1961, 1964, and 1969 exhibitions in Paris and Turkey. The 1960s paintings and paléokrystalos signalled her innovative output, compared with her 1950s geometric abstractions. She separated then between her identity as an abstract painter belonging to the Nouvelle École de Paris, which promoted abstraction, and her private sketching. Perhaps with the waning of the NEDP's ideological sway, and finding satisfaction in portraiture as a social and bonding practice, she felt free to come out with her work. Yet perhaps acknowledging her established identity as an abstract artist, or feeling that abstraction was the legitimate genre and figurative was *passé*, she asserted in her interviews that portraiture was no different from abstraction, or maybe a variation of it. Technically, 'Everything made by the hand of man [was] a manifestation of the spirit.'[11]

Indeed, her implicit belief in the superiority of abstraction is paradoxically manifest in her affirmation that, in fact, portraiture is superior, because it is 'a sort of totality of art' that encompasses 'structure, the colour, forms, the soul'. Further, if in abstraction she was alone with her own psyche before the canvas, in portraiture she had to transpose the sitter's inner life as well onto the painting:

> With abstract painting it was my unconscious side that was looking
> to express itself, to translate my internal exigencies without giving a
> definitive point [...] With the portrait, it is the man you have facing you,
> the human being, with his thought, with his life [...] one must arrive
> to render, in all its intensity, this life facing you, and it is very difficult.
> One must pass through a concentration, to reach ascetics and surpass
> oneself to attain to almost touch the divine, the creator. It is wild, but I
> must tell you, there are moments where one surpasses oneself.[12]

This statement of the difference between the two genres also demonstrates Fahrelnissa's continued spiritualist conception of her work, and of her state of exaltation when working, of loss of self, even with a sitter present in the studio.

She reiterated that when conceptualizing her notion of portraiture, which allied Roger Bissière's old enjoiner against realist figuration with her own spiritualist conception of painting. For her, the portrait was:

> Not the form. It is much stronger and so much beyond that [...] with
> a portrait, you find yourself in a theatre with three characters: there is
> the human being posing – the model. There is the painter and the third
> character that one must create not only by looking at [the face] [...] of
> the model. It is a matter of discovering the anterior life of the model,
> behind these forms, and his expressions, but by reaching so far, you
> also go to the depths of yourself, to arrive at understanding. You forget
> the hour, the day, the present minute. You go on a mysterious voyage.[13]

As for her process, it remained as exalted as ever. She worked very quickly, needing only one or two sittings, and always asked her subjects to sit a few metres away from her. On the other side of the easel, she could experience a psychic episode of exaltation. She described the process in these extraordinary terms:

> I am then subject to this dilemma: I start to paint and ask myself what
> should I eliminate, subtract to release the essential – the portrait [...]
> negation after affirmation, destruction of what are visible 'I', 'you'
> to leave room to other 'I' and other 'you' that await crouched in the
> unknown conscious – invisible. A great break [...] a sudden jet of form,
> of line begins to form! This is when [...] I destroy. I remove what was
> so consciously elaborated. My model has no idea what is going on, he
> is patiently posing. I only bear this avalanche, this cataclysm. Nothing
> any more on the canvas – at this moment it is the spirit alone that
> passes here. At last, I seize it! Now the portrait, the real one, will be
> born. I no longer see my model photographically, but I see his interior
> truth. The character is born and I continue working in it [...] then I see
> my model absent but more present than ever.[14]

The poster for
Fahrelnissa's final show
at a commercial gallery,
in 1972, featuring her
portrait of Rose Larock,
Katia Granoff's sister

The final solo exhibition

In addition to unveiling her portraits, Fahrelnissa included in the Katia Granoff show in 1972, her final solo exhibition in a commercial gallery, old abstract works from the early and late 1960s, perhaps in order to sell them. The opening was a crowded affair and left Fahrelnissa elated.[15] The catalogue showed ten portraits with two old Ischia paintings and three London gouaches. The portraits exhibited were of Granoff and her family members, and of Fahrelnissa's immediate and extended family and art friends, like avant-garde gallerist Iris Clert and Charles Estienne.[16] In the catalogue, the exhibition appeared to be a coda or a tribute to a long career rather than a look into the future. The portraits are not presented like new works but as records of a life. The opening text by Granoff is another fantastically orientalist text about Fahrelnissa being torn between the figurative heritage of antique statuary and Persian and Byzantine painting on one hand, and the abstraction of carpet weavers on the other.

Next followed an extraordinary short poem, handwritten by Fahrelnissa, laid out across from a reproduction of her 1967 portrait of her husband. The text is a mark of her profound literary culture, but also of her acute sensitivity and

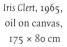

Iris Clert, 1965,
oil on canvas,
175 × 80 cm

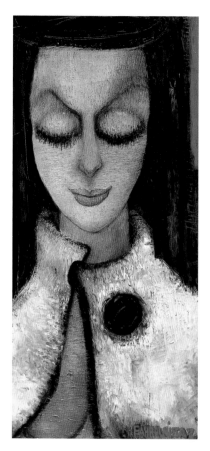

continuing heartbreak two years into her widowhood. She began her poem by writing, 'Inspired by Apollinaire I Say'. Perhaps she meant his sorrowful 1903 poem *The Key*, about a distraught widow mourning her beloved. In it, there is a fusion between her closed eyes and her dead husband's. The woman describes herself as, 'I am a widow with wounded feet.' She beseeches her beloved to:

> Open your eyes since you love me
> Open for me your closed eyes
> [...] I need the key of the eyelids.[17]

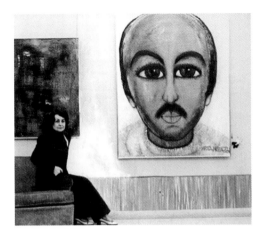

The artist in the Galerie
Katia Granoff exhibition,
beside her 1967 portrait
of Prince Zeid

Fahrelnissa herself writes:

> Do not lower your eyelid any longer ...
>
> Your wounded eyes,
>
> Discs of lost times,
>
> Gaze ...
>
> I sink in the light
>
> Overturned [renversée] to the limit of my soul.[18]

This highly personal and revealing text was followed by the main presentation text, entitled 'The painter who goes beyond beings and things', by art critic René Barotte. He began with an orientalist introduction about Fahrelnissa's storied life, enchanting work, and childhood, and relates little anecdotes about some of her paintings. He then praised her for working against current fashions and painting portraits. He lauds the works for their newness and unexpected psychological take on otherwise well-known figures from the art world. He concluded the text by recounting his own experience of posing for her, and how he was surprised to discover an unknown facet of his personality in the resulting portrait.[19]

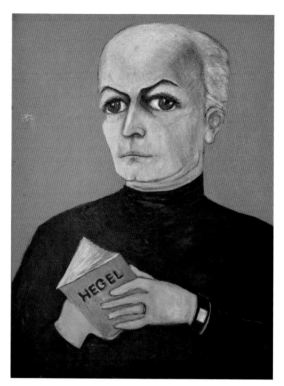

René Barotte, 1970,
oil on canvas,
130 × 97 cm

Abstract portraiture

Fahrelnissa's approach to portraiture generally paid heed to Bissière's injunction against photographic realism. An indication of her aversion to verisimilitude was this note in her diary about the little girl's portrait she painted in 1959: 'the painting is finished except for some details. Am I not going to massacre a work, perhaps a work of art, by looking for resemblance?'[20] Beyond this question, her portraiture went through three distinct stylistic phases: the 1940s portraits of her figurative period; the late 1950s to 1970s portraits painted in Europe; and the 1980s portraits of Amman. In the 1940s, she painted naturalistic portraits with sitters in more-or-less conventional representations and realistic environments. The few known 1940s portraits manifest a tension

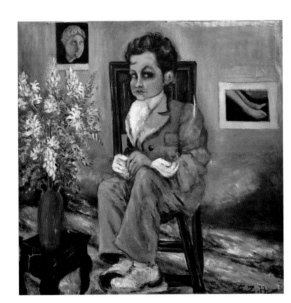

Prince Raad, 1944,
oil on canvas,
100 × 100 cm

between her *beaux-arts* instruction and her Expressionist sensibilities. This is apparent in a 1942 portrait of her son, *Raad*, a 1944 self-portrait, and a portrait of her husband *Emir Zeid* in pilgrim raiment from the same year. These works have a realist workmanship in the transparently rendered flesh of the self-portrait, the proportion of volumes, resemblance to the sitters, their clothing details and the inclusion of background décor. The Expressionist tendency is manifest in the exaggerated expressivity of the three figures, especially in their commanding gaze. Also in 1944, she painted a symbolist portrait. *Yugoslav Dream* is a portrait of Fahrelnissa's maid that resembles more a menacing apparition with her elongated Modigliani features, her sunken dark closed eyelids, her sinuous nose, and the floating, almost flying folds of her white head covering painted with thick, rapid, and short brushstrokes.[21] This painting may have been part of Fahrelnissa's experimentation with symbolist works that she showed in Istanbul in 1945, like her large-scale *Three Ways of Living (War)* and *Three Moments in a Day and a Life.*

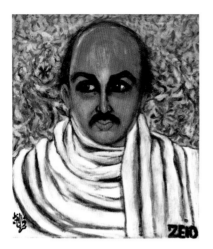

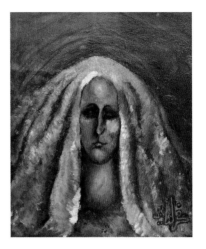

Prince Zeid, 1944, oil on canvas,
70 × 60 cm

Yugoslav Dream, 1941, oil on canvas,
60 × 50 cm

Both her 1940s Istanbul portraits and those she made in the 1980s had an Expressionist quality to them. But for a while, she abandoned the Expressionist figurative style in her portraiture, and after her passage through abstraction emphasized the spiritualist approach instead. She stressed psychological depth with two formal devices: enlarging the eyes and painting full-face planar representations of a few chosen subjects. Surviving portraits from the 1960s share common features: large-scale, simple colour scheme, meditative gazes, enlarged eyes, simplified features, hieratic presence, long brushstrokes, and extensive use of the palette knife to trace furrows in the thick impasto paint. In all these paintings, she perfected a highly stylized and recognizable workmanship where the ageless sitters resemble each other, and their portraits are recognizable Fahrelnissa paintings. Yet they also retain their individual features and basic resemblance to their subject. These portraits were a departure from her otherwise constant interest in motion, light, and colour. They are static, almost statuesque or masklike; she mixed gradations of similar colours

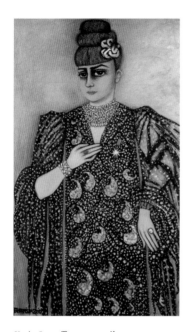 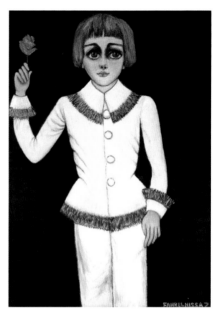

Katia Granoff, c. 1972, oil on canvas, 195 × 114 cm

Marc Larock, c. 1972, oil on canvas, 160 × 112 cm

inside one large colour field at a time, and there is no identifiable source of light. The works from this middle period are so unique in their extensive textural workmanship and monochromatic aspect that they almost look like abstract portraits, where the faces and clothes could be seen as fragments from abstract paintings.

These middle portraits fall into two categories: the bust and half-length social portraits of her gallerists, their families, and her friends; and the close-up full-facial psychological studies of people she was closest to. The former include Olivier Lorquin's 1964 portrait *The Adolescent*, the 1970s portraits of Katia Granoff, and her sister Rose Larock and her son Marc Larock. The latter include the 1964 *Charles Estienne*, and the 1968 portraits of Maurice Collis and Emir Raad. The first type of portraits are very stylized, as in Granoff's improbable pile of blue hair and spangled dress; in Rose Larock's black cape, embroidered with

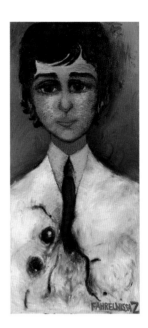

The Adolescent
(Olivier Lorquin), 1964,
oil on canvas,
175 × 80 cm

pearls like a starry night sky, and her carefully rendered two-toned red lips and hooded eyes; and in her son's Gainsborough-esque white pageboy costume, deep-blue eyes, and offering of a red rose. In these portraits, Fahrelnissa seemed to build rapport through painting flattering archetypal tokens of friendship. In Lorquin's remarkable portrait, however, she mixes the two approaches by experimenting with modulating the surface's textures with the palette knife with no concern for flattery. She carves his face with deep horizontal furrows that contrast with the youthful aspect of his large black eyes. His smart new Renoma white suit looks like a soiled and torn artist's rag on which different brushes were wiped clean. Strikingly, the bright cadmium-yellow shirt melds in the middle with the black tie and buttons, and the white shirt merges into an indistinguishable daubing of dirty whites and light greys.

In the second type of portraits, the object of the painting is the planar surface of the sitter's face. Closer and more at ease with these subjects, she

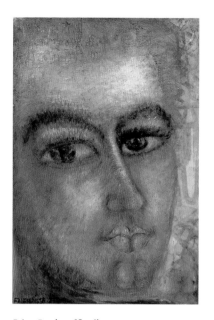

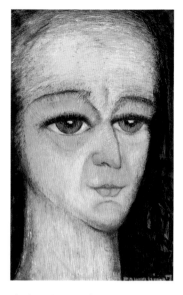

Charles Estienne, 1964, oil on canvas,
139 × 88 cm

Prince Raad, 1968, oil on canvas,
160 × 108 cm

could give free rein to her painterly instincts and gestural habits, and to her exalted psyche. In these portraits, the faces become abstract surfaces vigorously layered with improbable colours of similar and sometimes opposed range, slashed by the palette knife to reveal chromatic palimpsests. It is hard to tell whether they are the barren landscapes of some unknown planet or an abstract experimentation with colour and texture. The masterpieces of the second approach are the 1967 *Emir Zeid*, the 1968 *Emir Hassan*, and the 1972 portrait of her husband *Always Seeing Emir Zeid*. In these works, the eyes are morphed into large pools of black and umber browns. *Emir Hassan* is the least naturalistic with his horizontally distended hooded eyes and remarkably rendered skin tones. His brow and cheeks are an outwardly radiating interplay of long brushstrokes of blue black, pewter, and raw umber. Volume is given with intermixtures of lighter tones of the principal colours. Rendering the portrait eerier is the black-and-indigo mane crowning this improbable face.

Maurice Collis, 1968,
oil on canvas, 90 × 70 cm

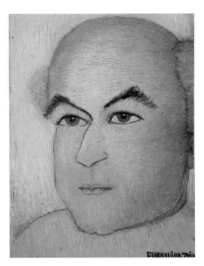

Fahrelnissa's two portraits of Prince Zeid are different testaments of her love. In both of them, his eyes do appear like large dark 'discs of lost times', gazing forward. The 1967 portrait is a seemingly ageless portrait where the flesh is rendered with long horizontal brushstrokes of ochre, sienna, and maroon, and definition is made with shorter vertical black brushstrokes. This is a younger and more feminine portrait than the 1944 *Emir Zeid*, almost idealized. He is dressed casually in a ribbed round-collar sweater. The entire portrait's surface is incised outwardly with short palette knife grooves, giving it a radiating intensity. The 1972 posthumous portrait is a three-quarters capture of the entire face and head, where he now looks away from our gaze. The moustache is thicker, the face paler, and he has acquired the arched curvature of the eyebrows of his wife's self-portraits. His maroon lips are more sensuous and his gaze is intensified with thick black contours. This is more than a portrait; it is a presence, a protective sentinel, his monumental scale imparting presence and permanence.

Ultimately, and regardless of what Fahrelnissa said of her portraits, they may not be captures of their sitters' personalities and interior lives so much

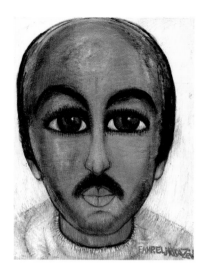 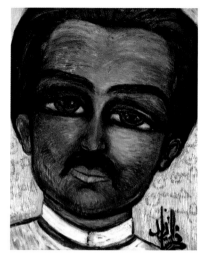

Prince Zeid, 1967, oil on canvas, Prince Hassan, 1968, oil on canvas,
184 × 140 cm 127 × 100 cm

as reflections of her own state of being at a given time. She painted them all in an otherworldly state of suspension between physical presence and inward contemplation. The paintings' formal properties also bear the hallmarks of Fahrelnissa's recognizable handling of the brush in her abstract work: the familiar gestural sweep is in the rendering of the large faces. Her meticulously painted teeming motifs are found in the repeated applications of short brush-strokes of nuanced colours in the shading of the faces and in the application of the palette knife. The Fahrelnissa of the abstract portraits has anchored her familiar gestures around facial features, but her instincts as an abstract painter are intact, and reproduced in the expanses of her sitters' visages.

The 1972 Granoff exhibition garnered a number of positive reviews, in the generalist press and the specialized art press. These reviews praised the monumental originality of the size of the portraits and likened them both to 'Byzantine effigies'[22] and to Persian miniatures.[23] The main review that dealt with the formal aspects of her works was by her long-time friend

Always Seeing Emir Zeid,
1972, oil on canvas,
100 × 81 cm

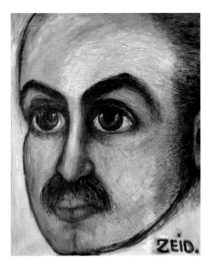

André Parinaud, the major arts publications editor and journalist in Paris in the 1950s and 1960s. He hailed Fahrelnissa's capacity for renewal, and focused as well on her renewal of the portrait genre by 'choosing the monumental' format, a format that managed both to zoom in on the sitter in tight shots, while also capturing a 'new code of this art: the explosion of the spiritual power of a face that irradiates like a brazier through colours, creates a tumult of shadows, gives an acuity to the line and adds to pure painting the energy of presence.'[24] This appears to be more a direct quote from Fahrelnissa rather than his impression of her works. His review had thus the merit of faithfully rendering the artist's process and intent.

By now, however, it was probably too late to make a new reputation for Fahrelnissa in Paris, despite her own painterly renewal. She and her gallerist were both in their seventies, and Granoff specialized in pre-war and Nouvelle École de Paris art, rather than in current avant-garde artists, who at the time were beginning to move towards the conceptual. Fahrelnissa had at any rate made her mark and was ready to move on to her next endeavour. After exhibiting some of the best works in her corpus, Fahrelnissa would enter a new period, ushering in a 'late style', both in painting and with teaching.

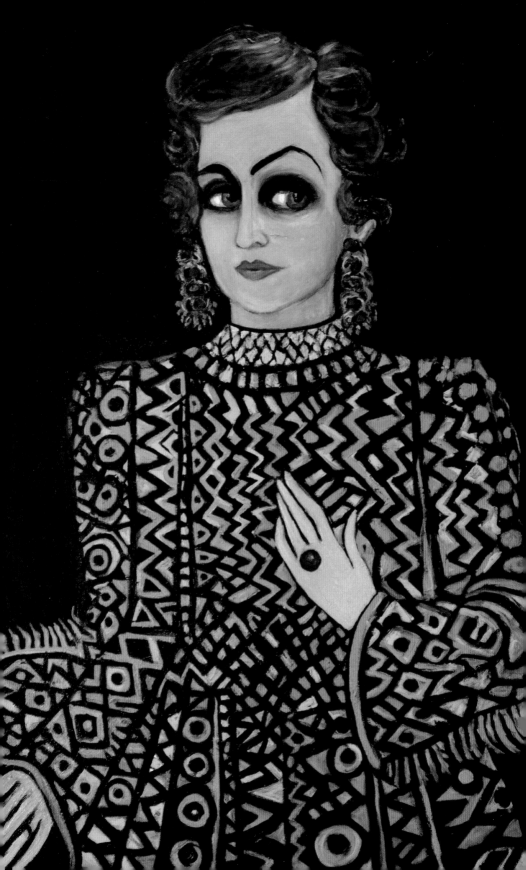

IX

Fahrelnissa's Late Style

1975–91

The last sixteen years of Fahrelnissa's life were a consolidation of her previous work and a projection into the future. True to her powerful personality, this was not a period of quietude but one of renewed vigour, with her teaching, exhibiting, travelling, and painting prolifically until her last days.

In 1975, five years after the passing of her husband in Paris, and within two years of the passing of her siblings Cevat and Aliye in Turkey, Fahrelnissa left Europe for Jordan, where she lived and worked until her death in 1991. She chose Amman for her new home to join her son Prince Raad, who was Chamberlain of the Royal Court there, his wife Princess Majda, and their growing young family. In addition, Fahrelnissa found there members of the extended Hashemite royal family whom she had known over the years in Baghdad, Istanbul, and London.

Amman at that time was a quiet, modern city of fewer than a million inhabitants, hailing from different origins: native Arab and Circassian Jordanians, and Palestinian and Lebanese refugees and exiles. There was no art world to speak of. Most of the politically engaged Palestinian painters had left for Beirut after 1970. Local painters exhibited regularly in hotel lobbies, foreign cultural centres, and community spaces. It was not until 1980 that the art scene expanded rapidly, with the opening of private commercial galleries and a national gallery.

Someone from the Past (Self-portrait), 1980, oil on canvas, 208 × 117 cm

Undaunted by old age and illnesses, Fahrelnissa was busy as soon as she arrived and until her final days. She split her time between teaching and painting, exhibiting in Jordan and Europe, and a full social life. Her students describe her then as a person of exceptional curiosity, a voracious reader of books and newspapers, interested in everything from the philosophy of Nietzsche, art, movies, space, and music. In the first year of her arrival, she opened her house to anyone who wanted to meet her to discuss his or her art practice. She would receive visitors in her customary style of a full menu of *petits fours*, caviar, and smoked salmon. She then organized her time by meeting with her students on Tuesday mornings and gradually added Wednesday mornings for regular receptions of a salon type, to receive the growing number of people who wanted to meet her: artists, diplomats, and family friends. She was partial to French or Turkish speakers, as she did not speak Arabic, and English was the main foreign language in Jordan. In addition, she would occasionally host receptions and birthday parties complete with musicians.[1]

She reproduced in her stone-clad modern house in the Oum Outhaina area of Amman the cluttered aesthetic of her successive studios in Istanbul and Europe. The interiors were a panoramic decorative chronological sedimentation of her life and career. As this was not a small flat or an impersonal diplomatic residence, she was free to cover all the walls and ceilings, including in the bathrooms and kitchen, with her small and large abstract and figurative oils from her diverse periods. Most impressive to visitors were the large abstract works she stuck on the ceilings of her ground-floor sitting room. She also hung her lithographs, gouaches, and exhibition posters, and filled every nook with her painted stones, paléokrystalos, her collection of antique bronze Buddhas, and various Ottoman and Asian *objets d'art*. The upstairs floor had a small sitting room equally full of paintings, bibelots, and family albums, a small studio, and her bedroom, where she spent most of her time and received close friends and family, surrounded by books, records, family photos, her own art, and reproductions of her favourite works by other artists.

A year after her arrival, Fahrelnissa held an open house to show her paintings. She placed them inside and outside the house and even some on the

ground in front of the entrance where visitors stepped on them. She distributed a statement to guests saying that she had made her paintings with 'hard work, dynamism, and the intense concentration of the artist'. She drew their attention to her change of styles over time: 'I rarely repeat myself. As soon as I have attained a new angle in my composition and have exhibited my work ... I struggle to express myself in a new way. Contentment in this new dimension to me signifies advancement.' She explained her process, probably in an echo of her previous statements about working in a trancelike concentration, in terms of working until she had found her 'consciousness' in her 'unconsciousness'.[2]

Besides her social and family life, Fahrelnissa was also active with her work. She was no longer an artist developing and promoting a practice in a busy art centre; instead her work had bifurcated into what Edward Said called a 'late style', a stylistic quality possessed by works created late in an artist's career, after decades of creative productivity. This notion of a late output by artists renewed with youthful energy before impending mortality was Said's amplification and expansion of a notion developed by Theodor Adorno when writing on Beethoven's third-period compositions, which he saw as full of irresolution and eccentricity. These peculiarities of style do not necessarily suggest closure and quiet resolution, but rather 'intransigence, difficulty, and unresolved contradiction ... non-harmonious, nonserene tension'.[3] Said added his analyses of the late careers of Constantine Cavafy, with his refusal to write about the present, Richard Strauss's anachronistic operas of eighteenth-century allusions, and Glenn Gould's abandoning live audience performances.[4] Said defined the notion of timeliness in art and in life as appropriateness to certain stages of life, and lack thereof at other periods. Accordingly, he explains 'lateness' as 'the idea of surviving beyond what is acceptable and normal'. However, this lateness is not an apotheotic transcendental shift, but, as being at the end, fully conscious, full of memory, and also very ... aware of the present'. This late style is in, but oddly *apart* from, the present.[5] Above all, any absences and silences in late style may not be explained away by weaknesses of old age.

Fahrelnissa's late style is far from Beethoven's late-style alienation and obscurity, or Adorno's ir-reconciliation with administered society. It is not so

much that her painterly practice exhibits late style. Rather, her artistic outlook itself exhibits late-style characteristics as it diverges into bifurcated and anachronistic directions. Since the 1940s, Fahrelnissa had single-mindedly focused on developing, promoting, and renewing her art work. In Jordan, she broke up the notion of 'art work' into two main paths: painting and teaching. She had already decided before leaving Paris that she would devote the next period of her career to teaching art. As soon as she arrived in Amman, she began giving classes in Prince Raad's house to a few isolated students, and after moving into her own home, she gathered a growing number of amateur artists around her and met with them periodically. She held regular classes with a core group of students whom she chose early on according to their personalities. After 1981, the school was legally incorporated as the Fahrelnissa Zeid Royal Fine Arts Institute. It remained based in her home, teaching was tuition free, and existing students would introduce additional students over the years.

Teaching to unlearn

In her teaching, Fahrelnissa was also both *in* and *apart* from the present. She did not introduce her new students to contemporary art of the day, and she stood apart from the regional developments. She chose, rather, to impart her conception of art as self-expression: abstract painting. There was no formal art school in Jordan at that time. Artists were trained in Baghdad, Egypt, or Europe. A few gave drawing and painting lessons for art amateurs in Amman. Fahrelnissa's former students stress that her teaching was unique and ahead of its time, as much as she set aside academic pedagogies to foster rigorous self-expression and introspection.

Fahrelnissa always spoke of her debt to Roger Bissière, and she may have been influenced in her own teaching by his approach. As he explained it, 'I believed neither in education nor in experience, but in the most primitive instinct [...]. The only thing that ought to be transmitted [...] is what is intransmissible and that resides in the innermost of man and that no one but he can capture.'[6] Fahrelnissa's former student Suha Shoman said as much, stating that she often quoted Bissière's injunction from the late 1920s to her: 'You must

Fahrelnissa with some of her students, late 1980s: (*back row, from left to right*) Hind Nasser, Ufemia Rizk, Jeanette Joumblatt, Princess Alia, Princess Majda, Suha Shoman; (*front row*) Alia Zubyan, art writer Meg Abu Hamdan, Rabab Mango

have a story to tell, a song to sing, and otherwise you will only be a painter not a creator.' She added that Fahrelnissa based her teaching on three principles: not to copy nature; mastering painting as a skill 'to make the hand like a machine'; and producing what one is.[7] Her constant reminder to her students was, therefore, to unlearn: 'You must forget what you know because what you know is what you have learned, but what you do not know is what you really are.'[8]

Fahrelnissa started the first group that met and worked collectively at her home studio until 1984 by challenging them to paint either her portrait or an abstract work. They would then meet weekly to work in her studio, complete their paintings in their homes, and then return for a group critique and discussion of the works. As the number of students grew, Fahrelnissa could no longer accommodate them in her small studio, so they would paint at home and bring their works individually for review. She focused on explaining and teaching composition, volume, and perspective, and how to curate an exhibition.[9] She insisted that her students keep their hand busy and always sketch and learn to sketch quickly.[10] She also stressed that they liberate their instincts, strengthen their imaginary, and see beyond material forms to attain abstract purity. In fact, some of her advice to them echoed her own 1950s statements about her inspiration in all things cosmic. Some former students describe her as 'obsessed with the cosmos', telling them that their paintings should be animated by balance and movement, echo 'cosmic movement' and 'the rotation' of the 'universe'.[11]

Fahrelnissa introduces
the 1981 exhibition
of works by herself
and her students in
Amman, 1981

She stressed that movement was not 'in straight line but in orbits'. The students
had to forget what they had learned and access that movement of the universe
through 'their inner self and unconscious'.[12]

Punctuating her teaching was an extraordinary group exhibition that
Fahrelnissa held with twelve of her students in 1981. The show was unprec-
edented in Jordan and even regionally. Its premise was simple but unique
– a teacher exhibiting with her students – and the scale and character of the
works shown in it had never been seen before. The exhibition included many
of Fahrelnissa's monumental paintings. No hall could accommodate the
canvases, so the largest local auditorium was converted into a gallery space.
The exhibition was extended, received wide coverage in the press, and was
noted by local critics for clashing with the art normally seen in Jordan at that
time. For *bon ton* society, however, as well as for some established local artists,
it was a 'shock and an irritant', baffling for its content-less abstraction and its
all-female, non-academically trained artists.[13] In reaction, four of them went
on to supplement their training with Fahrelnissa by taking lessons in drawing
techniques with painter Aziz Amoura, and in life drawing with a Lebanese artist
for more than a year. Ultimately, one of the effects of the show was to normalize
abstraction as an art practice in the country. Fahrelnissa then encouraged her

students to develop their careers and exhibit independently, which a few of them did, both at home and abroad in the following decades.

All Fahrelnissa's students prized their relationship with her, giving them an experience they had never had previously. It must have been a mutually nourishing relationship. Fahrelnissa told one student that she was continuing to paint abstract works through them. She also experimented briefly in the late 1980s with a new practice at the intersection of teaching and painting. She was seized with enthusiasm in 1986 to learn along with her students, stained-glass painting, a practice that Bissière and many of her contemporaries in the Nouvelle École de Paris had taken up in the form of large public commissions. Fahrelnissa invited a stained-glass artist to come to Amman and teach her and her students. Varuni Pieris-Hunt (1909–2001) was a Sri Lankan-British sculptor and painter. A contemporary of Fahrelnissa, she had designed a number of windows in churches and universities in England and Japan. She came to Amman in 1987 for a few weeks at Fahrelnissa's request, and gave lessons in the techniques of transferring drawings to opaque glass, bonding colours with acid, resin, and heat, and then separating them with black molten lead. Pieris-Hunt described the process as working directly with light and colour, which must have appealed to Fahrelnissa, who had done the same thing two decades

King Hussein of Jordan congratulates Fahrelnissa on the 1981 exhibition

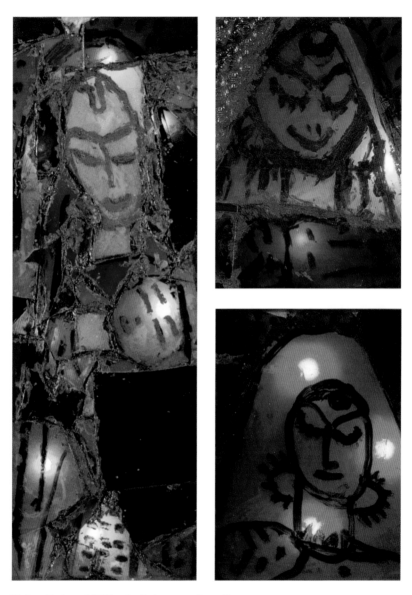

Various *Mother and Child* stained-glass portraits, 1987,
glass, resin, and lead, dimensions unknown

earlier with her paléokrystalos.[14] Fahrelnissa exhibited her resultant works – highly stylized portraits painted on pieces of coloured glass – the following year. She and her students could not continue the practice, however, given the difficulty and expense of sourcing the necessary materials from Europe.

Many of her former students describe their experience with her as life-changing. They greatly valued her generosity with her time, advice, and painting techniques. She gave them courage and self-confidence to become artists, and drove them to keep evolving their practice. Working with her was not only about learning the rudiments of art but also an intellectual experience.[15] She gave 'everything she had'.[16] These students were (in alphabetical order): Princess Alia, Jeanette Joumblatt, Adila Laïdi (that is, myself), Princess Majda, Rabab Mango, Hind Nasser, Nawal Qattan, Leila Rizk, Ufemia Rizk, Janset Shami, Suha Shoman, Rula Shukairy, and Alia Zubyan. Most of them subsequently pursued careers in culture, arts, and design. Hind Nasser, Ufemia Rizk, Suha Shoman, and Rula Shukairy continued their careers and achieved recognition locally and internationally as artists and painters. Two of them also pursued Fahrelnissa's educational and outreach work: Nasser went on to found Gallery 14, an important Amman gallery, and Shoman founded the Darat al Funun home for the arts, the first non-governmental modern art foundation in the Arab world.[17]

Fahrelnissa's 'late style' was thus reflected not only in a bifurcation of her artistic energies. She also projected herself with great urgency into the future by teaching, and mainly chose to mentor adults who had never painted before. While her teaching focused on abstraction, her own practice at the time now focused on portraiture. Her late portraits are 'full of memory' of her 1940s and 1960s portraits, yet constitute a departure from them. Her own artistic practice was an irregular combination of circular return and purification: she returned to the portraiture with which she started drawing as an adolescent, modified by a simplified expressionism. Painting now became an exercise for its own sake, for her own sake. Fahrelnissa thus manifested lateness as being out of her time, being both in the future and in a revisited past: 'unfashionable', 'in, but oddly *apart* from, the present'.[18]

Late portraiture

After she arrived in Amman, Fahrelnissa again focused on the portraiture that she had started in London and continued in Paris. She once more selected sitters from her circle of friends, family, and students. The Amman portraits however, reveal a purgation, an exercise in pure painting in simplified Fauvist-Expressionist chromatic juxtapositions. Focusing her innovative and intellectual energies on her teaching, portraiture became for her a pure exercise of painting *'for itself'*.

Fahrelnissa continued painting the first type of portraits that she developed in the late 1960s – that is, bust and half-length social portraits of her gallerists, family members, and casual friends. In these portraits, she seemed to build rapport through painting immobile flattering archetypal portraits. The late-style works share a recognizable 1980s Fahrelnissa workmanship: static compositions, highly stylized ageless sitters, and enlarged eyes amid generic facial features. Many of these portraits recall pared-down paintings by Kees van Dongen. Rather than commissioned fashionable *portraits mondains*, hers were tokens of sustaining relationships, painted at her initiative and for no charge.[19] Compared with her 1960s portraits, these new works reflected a few changes that Fahrelnissa had introduced: she abandoned the nuanced flesh tones and the vigorous palette-knife incising; and she compensated for the flatness of the portraits by introducing Expressionist *cloisonnisme*, shaping colour fields with a black outline, in accordance with her modernist disregard for three-dimensionality and visual continuity. She relieved the masklike stillness of her sitters' visages by distending the eyes, which acquire a menacingly hypnotic quality. Another characteristic of these portraits was their systematic featuring of a small error in perspective, volume, or finishing, underscoring her belief that portraiture ought to be free from reproducing physical appearance and should instead 'give life'.[20] Fahrelnissa painted tens of these portraits, many of them unaccounted for.

What Fahrelnissa gave up in textural layering in these portraits, she made up for in the stark chromatic contrasts. She eliminated three-dimensional spaces and linearity for a predominance of colour in the picture plane, achieving

Suha, 1983,
oil on canvas,
98.5 × 89 cm

a sense of solidity with strong juxtapositions of highly saturated planes of colour in the clothing, hair, and background of her subjects. Many of these bust portraits appear almost like colour studies rather than portraits. The simplified tendency appears, for example, in the bust portraits of Suha Shoman, of her husband Khalid, and of their friend the collector Mamdouh Bisharat. They exhibit various traits of late style non-harmonious, non-serene tension.

Suha (1983) was painted impulsively when Fahrelnissa saw Shoman enter her house wearing a new shawl; she was struck by its shape and colour, and decided to paint her there and then. In doing so, she transformed Shoman's casual entrance into an archetypal three-colour composition, intensified by the strong continuous black outlines of the shawl's folds, contrasted with her pensive gaze. The rapid realization of the painting is visible in the short brushstrokes of the depthless background. Shoman's closeness to Fahrelnissa accounts perhaps for the subtle colouring and finished brushwork of the hair and face. This impulsive minimalist work reflects a late-style practice of portraiture as a response to emotional and visual stimuli, and as realization of Fahrelnissa's innate desire to paint.

Khalid Shoman, 1984,
oil on canvas,
180 × 112 cm

Her portrait of Suha's husband Khalid Shoman from a year later is
a three-quarter-length work that was similarly finished in one sitting, but it
deploys a number of contrasting effects. The subject has a mature grey mane,
youthful attire, and intense gaze. The vivid yellow background contrasts in
the modulated rendering of the white jumper, with gradations of low-satura-
tion colours to create shading. The carefully rendered brow bone and eyelid
folds frame an intense gaze, contrasting with the smooth subtle blending and

shading of the face. The details of the face and sweater draw the viewer away from the background. This makes for a casually intimate portrait manifesting the close relationship between the artist and her subject.

Departing from the minimalist rendering of these two paintings, the portrait of Mamdouh Bisharat is an Expressionist riot of vivid colours and lines. The undated 1980s bust portrait is a contrast of complementary and antagonistic colour planes: a popping hot-pink background, an Indian yellow jacket, a textured cadmium-yellow fur collar, a wide deep-green tie with fuchsia motifs, a red-and-white striped shirt collar. Bisharat's hair is painted in a flat, heavy black, framing a face roughly finished with short brushstrokes, with arched black eyebrows and deep black eyes. His introspective quizzical gaze contrasts with the chromatic riot surrounding it. The portrait is a mark of Fahrelnissa's close relation with the subject and a mark of his *bon vivant* aesthete personality. This portrait and others from the period also manifest 'lateness' as a survival 'beyond what is acceptable and normal', as much as they hark back to Fauvist portraiture's artificial and generalized representations of the human figure with saturated colours, a style that Fahrelnissa must have absorbed in her travels and training in late 1920s Paris.

She also painted a small number of very different works in the late 1970s and early 1980s: large-scale three-quarter-length portraits that look like hybrids of Old Master royal portraiture and regional mythologies. These works featured highly stylized costumes and culturally specific detailing. Fahrelnissa painted these tokens of friendships as her contemporary take on traditional portraits of royalty and nobility, via mythological storytelling, and archetypal presence – a reflection perhaps of her great interest in Carl Jung's writings. These works include her self-portrait, portraits of Hind Nasser, Suha Shoman, Queen Alia, Princess Alia, and Princess Majda. *Someone from the Past* (p. 256) represents Fahrelnissa as a hieratic goddess, her ageless face defying resemblance but her imposing gaze imparting that it can only be a self-portrait. Standing out from the black background is the long-sleeve dress with Fahrelnissa's familiar and distinctive teeming motifs. These gold markings recall her mid-1950s primitivist style, painted like radiating asters about to orbit out of the composition,

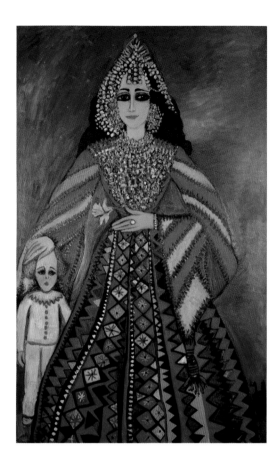

Divine Protection, 1981,
oil on canvas,
206 × 130 cm

giving the costume an abstract quality. The self-portrait balances Fahrelnissa's different stylistic epochs: the eschewing of realistic detailing, simplified portraiture, busy motifs, and Expressionist chromatic vividness.

In the three-quarter-length works *Hind* and *Divine Protection* (both 1981), the subjects are represented standing, more like protective pagan deities than flesh-and-blood women with exaggerated anatomical features, highly stylized regional costumes and folk dresses, and allusions to events in their lives. The highly artificial hieratic portraits manifest late-style contradictions: juxtaposing the memory of Fahrelnissa's Fauvist and Expressionist painterly

practices with her awareness of present relationships, and her desire to create in modern Amman a tradition of archetypally regal portraiture.

The Amman portraits received limited public exposure and a mixed critical reception. They were the object of elision or facile dismissal rather than engaged evaluation and scholarship. For example, one critic considered that the production manifested 'aesthetic barrenness' and 'aesthetic de-skilling'.[21] Another considered that Fahrelnissa had turned her 'back' during her Amman years 'on the West', and that those portraits 'have practically no foundation in the art history that is familiar to us and that leads us to representations of Egyptian sarcophagi and passing by Persian portraits'.[22] Such arguments constitute yet another link in the long chain of reductive othering evaluations of Fahrelnissa. There is no indication in her writings and papers, or in her statements to her sitters and students, that she was under the stylistic influence of a culturalist atavism. In fact, the naturalism of Fayyoum Egyptian sarcophagi paintings and the controlled precision of Persian miniatures are far removed from the Expressionist exaggeration and Fauvist chromatic abandon of the Amman portraits. In her late style, therefore, Fahrelnissa recalled other artists' late styles, in as much as 'each ... makes of lateness or untimeliness, and a vulnerable maturity, a platform for alternative and unregimented modes of subjectivity, at the same time that each ... has a lifetime of technical effort and preparation, [...] even though they are egregiously self-conscious and supreme technicians. It is as if having achieved age, they want none of its supposed serenity or maturity.'[23]

Preparation for posterity

Projecting herself into the future with her teaching, Fahrelnissa also worked during this period on shaping her future legacy. She was already aware of that in 1974, when she commissioned Olivier Lorquin to make a one-hour documentary about her life and work, which was never broadcast, but would serve as an important primary archive into her life, career, and thinking. It features interviews with her and with André Parinaud, Dina Vierny, and Shirin Devrim. The film shows her cluttered apartment packed with her dazzling large abstracts, her equally monumental portraits, and an incalculable number of

paléokrystalos. The film shows her intently painting the portrait of a shirtless Issam El-Said, and speaking of her idiosyncratic vision of art, of her love for colour, of the paléokrystalos, and of abstraction and portraiture. The soundtrack is her favourite Romantic music: Wagner and Dvorak's cello concerto, probably the Casals recording she listened to on a loop in Baghdad in 1938. Devrim describes in the film her mother's paintings as her brothers and sisters, and Parinaud and Vierny talk about her in magically orientalist terms.

In Jordan, this concern for the preservation of her legacy continued, first with her two Amman exhibitions in 1981 and 1983, and with her participation in a number of exhibitions abroad, alone and with her students. She did not sever her relations with France and Turkey. Fahrelnissa arranged for a French arts magazine to cover the 1981 exhibition, and she participated in two large group exhibitions in France in 1981 and 1986.[24] Notably, Fahrelnissa arranged for Jordan to be the invited nation at the 1981 Salon d'Automne, and she exhibited there with a number of her students. She then travelled to Paris in 1984 for a Charles Estienne program of tributes. Her niece Fureya also organized a few exhibitions in Turkey of her works.

Fahrelnissa tried for many years to have a book published about her. Finally, in 1983, she and her students started to work on the publication of a book about her career, which was published the following year. André Parinaud came to Amman to edit with two of Fahrelnissa's students the various Estienne texts into one critical introductory text. The rest of the bilingual French and English book featured excerpts from a number of reviews and interviews, as well as images of most of her major art works. Fahrelnissa dated the works herself (often incorrectly) and devised the book's layout. Three of her students funded the book in recognition of her mentorship to them, which had been conducted without compensation. The book was instrumental in consolidating the fragmentary iconography and documentary traces of Fahrelnissa's career, thereby serving to introduce her to various international art-world gatekeepers.

As a result, two major retrospectives were held a year before her death. The first was a solo show at the Peter Ludwig Museum in Aachen, organized on the initiative of the German ambassador in Jordan. In return, Fahrelnissa

donated to the museum her 1953 painting *Basel Carnival*. The exhibition featured all her major paintings, and the catalogue included a series of summary texts about her career. Suha Shoman initiated her Paris exhibition, held at the newly opened Institut du Monde Arabe. The exhibition was an inexplicable joint exhibition that grouped Fahrelnissa with two naive artists: Baya Mahieddine and Chaibia. Her works were shown in the larger spaces, however, and the catalogue featured extensive texts about her work and interviews. Fahrelnissa was elated to have had such considerable exhibitions in two countries that had shaped her work and to meet a new generation of curators and critics.

It was a happy sixteen years for Fahrelnissa after she moved from Paris to Amman, for she was close to her five grandchildren and was receiving adulation and official recognition. Two of her exhibitions in Amman in 1981 and 1983 were inaugurated by King Hussein, who decorated her with the order of the Star of Jordan for her contribution to art. In 1985, the French government also made her a Commandeur de l'Ordre des Arts et des Lettres, one of the highest honours the state can bestow, for her 'significant contribution to the enrichment of the French cultural inheritance'. And she was fulfilled teaching and continuing to work. But at the same time, she became progressively ill, suffering from diabetes and heart trouble, while her psychic episodes reduced to transitory periods of fatigue and depression. Fahrelnissa passed away three months before her ninetieth birthday on 5 September 1991. She received an official state funeral and was buried next to Prince Zeid in the Royal Mausoleum in Amman.

Within a decade of her death, revisionist expansions of the history of modernism led to the reconsideration of the trajectories of female and non-European modern art pioneers. This, along with the accelerated development of the Turkish art market and the emergence of a Middle Eastern art market, increased interest in Fahrelnissa's life and work. She would have been delighted with this rediscovery. Still, her work was its own reward. As she wrote to her guests at her 1976 open house, her paintings were 'the results of forty solitary years of dynamic work … a long struggle – but I would not have had it in any other way'.[25]

Chronology

1901 Fahrinnisa Shakir Kabaaghacli born on Buyukada Island, Ottoman Empire.

1910?–14 Attends Lycée Notre Dame de Sion, Istanbul.

1914–18 Studies at Pension Braggiotti, Istanbul; obtains *brevet supérieur* diploma; reads Balzac, Dumas, Machiavelli, Hugo, Voltaire, La Rochefoucauld, Zola.

1919–20 Attends the School of Fine Arts for Girls, Istanbul.

1920 Marries Izzet Melih Devrim.

1921–2 Birth of son Faruk Devrim.

1922 Trip to France with Izzet.

1923 Birth of son Nejad Devrim; death of Faruk; establishment of Turkish Republic.

1926 Birth of daughter Shirin Devrim; Devrims travel to Madrid, the Netherlands, Paris, and Florence; extensive visits to museums.

1928 Meets Atatürk and attends Dolmabahce language conference; reads Kierkegaard, Lautréamont; Devrims travel to Paris; Fahrelnissa enrols at the Académie Ranson; Devrims travel to Munich and visit the Alte Pinakothek.

1929–30 Fahrelnissa studies at Academy of Fine Arts in Istanbul.

1933 Obtains divorce from Devrim and marries Emir (Prince) Zeid al Hussein in Athens; takes title of Princess Fakhr El Nissa Zeid.

1934 Both return to live in Istanbul.

1935 Prince Zeid named Iraqi ambassador to Germany; Zeids move to Berlin.

1936 Birth of son Prince Raad bin Zeid; two-month stay at Carlsbad Spa-Sanatorium near Dresden (now Karlovy Vary in the Czech Republic); travels to Paris; summers in Istanbul and Ankara.

1937 Fahrelnissa takes private painting classes with small group in Berlin; reads Rilke, Nietzsche, a biography of Bach; three-month stay at Carlsbad; travels to Paris.

1938 Prince Zeid recalled to Baghdad; Fahrelnissa stays at Carlsbad and travels on to Istanbul; first trip to Baghdad; visits Karbala, Babylon, and Nineveh; first illness in Baghdad; hospitalized at the American Hospital in Paris.

1939 Travels between Baghdad, Paris, and Istanbul.

1940 Treated for four months at Budapest's St Gellért Hotel sanatorium; spring and summer in Istanbul; autumn and winter, lives in apartment in Budapest; treated by various doctors at St Gellért; paints daily in her studio; consults local artists about progress of her work; hospitalized at Siesta Sanatorium; suicide attempt; returns to Istanbul; fifteen of her paintings of mainly Budapest cityscapes are stolen at Sofia train station; in Istanbul, repaints the stolen paintings

1941 In Istanbul, critic Fikret Adil sees her work and introduces her to D Group; Fahrelnissa's first exhibition when she takes part in ninth D Group show, Istanbul.

1942–3 Fahrelnissa paints, sketches, and exhibits with D Group; reads Kierkegaard, Rimbaud, and Jung.

1944 Goes to Baghdad; second illness; June: returns to Istanbul.

1945 16–31 March: takes part in twelfth D Group exhibition, at Ismail Oygar Gallery, Istanbul; 14–28 April: first solo exhibition in her Ralli apartment in Istanbul, showing figurative oils gouaches and watercolours; May: illustrates published poetry collection *Lamalif* by poet Asaf Halet Calabi; solo exhibition in Izmir.

1946 Takes part in fourteenth D Group exhibition, at the Academy of Fine Arts, Istanbul; 11–31 May: second solo exhibition in Istanbul apartment; solo exhibition in House of the People, Izmir; autumn: travels to Europe; Prince Zeid is appointed the ambassador to London; 18 November–28 December: participates in exhibition organized

by UNESCO, 'Exposition Internationale d'Art Moderne'; Musée d'Art Moderne, Palais des Beaux-Arts, Paris; 30 November–December: participates in exhibition 'Peintures turques d'aujourd'hui, Turquie d'autrefois' at the Musée Cernuschi, Paris.

1947 Participates in group exhibition 'Contemporary Turkish Painting' organized by the Arts Council of Great Britain in the United Kingdom.

1948 5–28 February: 'Fahrunnisa Zeid: Paintings, watercolours and drawings' solo exhibition, St George's Gallery, London, shows mainly Istanbul works; May: 'Fahrelnissa Zeid' solo exhibition, Gimpel Fils, London, shows abstract and semi-abstract geometric kaleidoscopic oils and gouaches; 28 June: enters an abstract painting in the summer exhibition group show at the St George's Gallery, London.

1949 4 January: solo show at Gimpel Fils, London; buys apartment in Paris; March–April: first trip by aeroplane and to the United States; stays in Eastbourne and Brighton; May: Fahrelnissa inaugurates (along with young King Faisal) an exhibition of contemporary Iraqi artists at Walton House, London; 2 December: first solo show in Paris, 'Fahr-El-Nissa Zeid' at Galerie Colette Allendy.

1950 2 January: first solo show in the United States, 'Fahrelnissa Zeid', Hugo Gallery, New York, shows abstract geometric kaleidoscopic works; March: Takes part in group show of Women's International Art Club at the Royal Society of British Artists Gallery, London; March: receives signed book from Fernand Léger; 18 May: inaugurates (accompanied by King Faisal) 'An Exhibition of Middle East and Arab Paintings' organized by the Anglo-Arab Association in Eaton Place, London, including two works by the king; 1 August: participates in the summer exhibition group show at Gimpel Fils, London. The show includes works by Degas, Picasso, Renoir ,and Hartung; illness and death of Queen Aliya in London; Summer and Winter 1951 issues of *Poetry London* magazine bear one of her lithographs on its covers; June 1: solo exhibition 'Fahr-El-Nissa Zeid Peintures-

Gouaches-Lithographies', Galerie de Beaune, Paris; publication of the limited-edition book *Midi Nocturne* by the Éditions de Beaune. The book features four numbered lithographs by Fahrelnissa and a text by Charles Estienne; 8 June 8–16 July: participates in sixth Salon des Réalités Nouvelles, Palais des Beaux Arts, Paris, in which she shows *My Hell*; Salon also includes Hilla Rebay, Saloua Raouda, Jamil Hamoudi, Man Ray, Ellsworth Kelly, Nejad, Poliakoff, Fureya Koral, Fikret Mualla, and others; 5–14 July: participates in group show of Paris artists in Bar of Artists, Florence.

1952 Fahrelnissa is among thirty-five artists interviewed in the book *Témoignages pour l'Art Abstrait* by Julien Alvard and R. V. Gindertael (Paris: Éditions d'Art d'Aujourd'hui); January: meets with Matisse for two hours; possible participation in seventh Salon des Réalités Nouvelles; 12 February: participates in second Nouvelle École de Paris group show along with eighteen other artists, Galerie de Babylone, Théâtre de Babylone, Paris; 8 March: solo show 'Gouaches et Encres de Chine Orient Occident' in Gallery 16, Zurich; March: sits for photographer Gisèle Freund in Paris; travels to Zurich, Saint-Paul de Vence, Nice, and Cannes.

1953 10–23 April: participates in a group exhibition curated by Charles Estienne along with six other artists at the Galerie Craven, Paris; 10 July–9 August: participates in eighth Salon des Réalités Nouvelles, showing *Towards a Sky*; Salon includes Vasarely, Léger, Nejad, Poliakoff, Hilla Rebay, and others; 4 December–7 January: solo exhibition 'Peintures' at Galerie Dina Vierny, Paris; travels between London, Paris, and Cannes.

1954 Possible participation in ninth Salon des Réalités Nouvelles, Paris; 8–31 July: solo exhibition 'Recent Paintings by Fahr-el-nissa Zeid' at the ICA, London; September: participates in group show of the Women's International Art Club exhibition at the Royal Society of British Artists Gallery, London.

1955 1–22 March: participates in group show curated by Charles Estienne 'Alice in Wonderland' at Galerie Kléber, Paris;

29 October–15 November: joint exhibition with James Pichette and Serge Poliakoff at Galerie Dina Vierny, Paris; 8 November: solo exhibition of paper works' Gouaches et Lithographies d'Ailleurs' at Galerie La Hune, Paris; 13 December: sells painting entitled *Composition* to the French state collections via Galerie Dina Vierny; travels to Brighton.

1956 13 March–15 April: participates in a seven-artist group show curated by Charles Estienne that includes Chagall, 'L'Île de l'Homme Errant', Galerie Kléber, Paris; October: first issue of the magazine *Le Surréalisme, même* features a full page of black-and-white pictures with four of Fahrelnissa's coloured stones – André Breton is the 'editor-directeur' – published by Jean-Jacques Pauvert; 10–28 November: solo exhibition 'Peintures et Statuettes' at Galerie Aujourd'hui, Brussels; also exhibits lithographs at the following group exhibitions in the United States: Fourth Biennial, Cincinnati Art Museum; American Federation of Arts touring group show; and the Contemporary Graphic Arts Centre, New York.

1957 5 June–5 July: solo show 'Inaugural Exhibition of Paintings, Coloured Indian Inks, Painted Stones' at the Lord's Gallery, London; summer: participates in touring group exhibition 'Modern Turkish Painting' at the Edinburgh Festival; 10 May: exhibits a paper work at the All Iraqi Artists Exhibition organized by the Society of Fine Arts in Baghdad; August: first trip to Ischia with Shirin; 28 November: participates in touring group exhibition 'Modern Turkish Painting' at the Matthiesen Gallery, London; 14 November: inaugurates stained-glass exhibition of Varuni Pieris-Hunt at the Leighton House gallery in London.

1958 Spring: buys house in Ischia; 14 July: Iraqi Revolution and massacre of the royal family in Baghdad; autumn: Fahrelnissa and Prince Zeid move out of Iraqi embassy in London to apartment in Oakwood Court, Holland Park, London.

1959–60 Begins painting portraits; experiments with painting on poultry bones;

interviewed by Édouard Roditi for his book of artists' interviews *Dialogues on Art* (London: Secker & Warburg, 1960); travels between Paris, Ischia, and Filippo spa.

1961 19 May–13 June: solo exhibition at the Galerie Dina Vierny, Paris.

1962–3 Paints portraits; lives and travels between London, Paris, Ischia, and Venice.

1963 Summer: hosts in Ischia Charles Estienne and his wife Marie-Hélène, André Breton's daughter Aube and her husband the writer Yves Elléouët, and artist Jean Messagier and his wife.

1964 15 April: retrospective exhibition 'Fahrünnisa Zeid 1951–1961' at the Hittite Museum, Ankara; 26 May: retrospective exhibition at the Academy of Fine Arts, Istanbul; meets André Malraux in Paris.

1965–6 Lives in London, Paris, and Ischia; lengthy contacts with Malraux and Ministry of Culture over its sponsorship of a survey exhibition.

1967 Creates most of her paléokrystalos in London; paints portraits.

1968 Moves to Paris permanently; correspondence with Malraux.

1969 22 October–15 November 15: solo exhibition 'Peintures et paléokrystalos' at the Galerie Katia Granoff, Paris; shows new works painted in London after the revolution, in Ischia, and paléokrystalos for the first time; Prince Zeid illness, on and off hospitalization.

1970 Death of Prince Zeid.

1971 Travels and lives in Paris, Amman, and Ischia.

1972 30 May–24 June: solo exhibition 'Portraits et peintures abstraites' at the Galerie Katia Granoff, Paris; shows her 1960s portraits for the first time; solo exhibition at Galerie Katia Granoff, Honfleur; participates in 18th group exhibition of the Federazione internazionale culturale femminile di Parigi at the Palazzo delle Esposizioni, Rome; travels and lives between Paris, Istanbul, Amman, Rome, Ischia, and Milwaukee.

1973 31 October: participates in group exhibition '50th Anniversary of the Turkish Republic' at the Society of Contemporary Art Gallery, Rawalpindi, Pakistan.

1974 Commissions documentary film from Olivier Lorquin about her life and art;

death of sister Aliye Berger
on Buyukuda.

1975 Moves to Amman permanently.

1976 13 November: holds open house at her home to introduce her work to the Amman public; establishes the Royal Fahrelnissa Fine Arts Institute to teach art.

1977–80 Teaches a core group of students.

1981 5–12 February: 'Fahrelnissa Zeid and Her Institute' group exhibition at the Palace of Culture, Amman; decorated with the Star of Jordan by King Hussein; November: exhibits with a number of her students in the 'Peintres de Jordanie' exhibition within the Salon d'Automne at the Grand Palais, Paris.

1982 Teaches a core group of students.

1983 5 November–5 December: '1915–1983' retrospective exhibition, Royal Cultural Centre, Amman.

1984 July: participates in group show at the Festival do Labirinto at the Gulbenkian Foundation, Lisbon; 21 June–2 September: participates in group show 'Charles Estienne et l'Art: 1945–66' organized by the Centre National des Arts Plastiques at the Fondation Nationale des Arts Graphiques et Plastiques in Paris; 26 June–5 July: participates in group show 'Au Souvenir de Charles Estienne' at Galerie La Hune, Paris; is filmed in the documentary 'Charles Estienne à l'Horizon du Vent' by Michel Moy; publication of the book that surveys her life and career in two different French and English editions, *Fahr El Nissa Zeid*, edited by Suha Shoman and Meg Abu Hamdan (Amman: Royal National Jordanian Institute Fahrelnissa Zeid of Fine Arts).

1985 Made Commander of the French Arts and Letters

1986 26 November–25 January: participates in the group show 'La Voie Royale: 9000 ans d'art au Royaume de Jordanie' at the Musée du Luxembourg, Paris.

1987 Learns stained-glass painting and cutting with Varuni Pieris-Hunt in Amman.

1988 28 May–5 June. Amman: 'Kaleidoscopes' solo exhibition of her stained-glass works at the Royal Cultural Centre, Amman; 19 December–6 January: solo exhibition of works in the Fureya Koral Collection at the Atatürk Cultural Centre, Istanbul; solo show at the Macka Sanat Galerisi, Istanbul.

1989 Teaches and paints.

1990 23 March: 'Fahr El Nissa Zeid Entre l'Orient et l'Occident: Peintures et Dessins' retrospective exhibition at the Neue Gallery-Sammlung Ludwig, Aachen; 6 June–26 August: joint exhibition 'Trois Femmes Peintres' at the Institut du Monde Arabe, Paris.

1991 Dies in Amman.

1993–4 December–January: 'Fahrelnissa Zeid' retrospective curated by Suha Shoman at Darat al Funun, Amman.

1994 7 February: represented at the 'Forces of Change: Women Artists of the Arab World' touring group exhibition curated by Salwa Mikdadi-Nashashibi at the National Museum of Women in the Arts, Washington, D.C.; 6–30 November: retrospective exhibition at the Cemal Resit Rey Exhibition Salon, organized by the Erol Kerim Aksoy Foundation, Istanbul; publication by Shirin Devrim of her family memoir *A Turkish Tapestry: The Shakirs of Istanbul* (London: Quartet Books, 1994; paperback 1996).

1998 28 July: inauguration of the Fahrelnissa Gallery at the Jordanian Ministry of Culture in presence of Prince Raad, Amman.

2001 Joint exhibition of works by Fahrelnissa, Fureya Koral, and Aliye Berger at the Yapi Kredi Bank Art Gallery in Beyoglu, Istanbul.

2001–2 6 December–21 February: 'The Centenary of Fahrelnissa Zeid' retrospective curated by Suha Shoman at Darat al Funun, Amman

2006 18 May–1 October: 'Fahrelnissa and Nejad: Two Generations of the Rainbow' joint exhibition curated by Haldun Dostoğlu, Istanbul Modern, Istanbul.

2011 13 July–7 November: represented at the retrospective group exhibition 'L'Aventure de l'Art Abstrait: Charles Estienne, critique d'art des années 50' at the Musée des Beaux-Arts de Brest.

2015 Retrospective exhibition within the Sharjah Biennial 12; 15 March: award of a posthumous Sharjah Biennial Award.

2017 13 June–8 October: retrospective at Tate Modern, London.

2017–18 20 October–25 March: retrospective at Deutsche Bank Kunsthalle, Berlin.

2018 Retrospective at Sursok Museum, Beirut.

Notes to the text

All quotations from Fahrelnissa Zeid's diary are taken from personal diaries held in the Fahrelnissa Zeid Archive, Amman, Jordan (here cited as FZA) and are my translations from the original French. All quotations from Fahrelnissa Zeid's press conference in 1984 are my translations from the original French of a tape recording held in the Fahrelnissa Zeid Archive.

Introduction

1 Handwritten by Fahrelnissa Zeid on p. 18 of a copy held by Hind Nasser of Suha Shoman and Meg Abu Hamdan (eds), *Fahr El Nissa Zeid* (Amman: Royal National Jordanian Institute Fahrelnissa Zeid of Fine Arts, 1984) (in French, my translation).

2 Quoted in André Parinaud, 'Le goût du portrait', *La Galerie*, No. 115, April 1972, p. 72 (in French, my translation).

3 Fahrelnissa underlined this quote by André Gide in 1951 on the last page of her copy of a book by fellow Nouvelle École de Paris painter Jean Bazaine, *Notes sur la Peinture d'aujourd'hui* (Paris: Floury, 1948) (in French, my translation). From Fahrelnissa's private library, conserved in Darat al Funun, Amman, Jordan.

4 'Fahrelnissa Zeid: À Paris 1949–1975', unbroadcast documentary directed by Olivier Lorquin, 1975.

Chapter I

1 This book uses the English spelling for Turkish proper names and place names, instead of the current Turkish: Shirin for Şirin, Kabaaghacli for Kabaağaçli, and Buyukada for Büyükada, etc.

2 Shirin Devrim, *A Turkish Tapestry: The Shakirs of Istanbul* (London: Quartet Books, 1996), pp. 70–1.

3 According to Arab naming practices, a female commoner marrying into a royal family replaces her own family name with her husband's first name. It is another reason for referring in this book to Fahrelnissa Zeid by her first name, rather than her last, Zeid, in order to avoid confusing her with her husband, Prince Zeid.

4 Devrim, op. cit., pp. 6, 9.

5 Ibid., pp. 47, 49.

6 Press conference, 1984.

7 Quoted in Karlheinz Barck and Anthony Reynolds, 'Walter Benjamin and Erich Auerbach: fragments of a correspondence', *Diacritics*, Vol. 22, No. 3/4 (Autumn–Winter 1992), pp. 81–3.

8 Necmi Sönmez, 'Nejad Devrim', E-Skop, <http://www.e-skop.com/skopbulten/turk-modernistler-nejad-devrim/1928> (accessed 2 January 2017).

9 Devrim, op. cit., p. 231.

10 Ibid., pp. 37–8.

11 Sonia Nigolian, 'Rencontres à Paris: La Princesse Fahr-El Nissa Zeid', *Revue du Liban*, 22 April 1972, No. 695.

12 Wendy M. K. Shaw, 'Where did the women go? Female artists from the Ottoman Empire to the early years of the Turkish Republic', *Journal of Women's History*, Vol. 23, No. 1, 2011, pp. 21.

13 Ibid., p. 24.

14 Press conference, 1984.

15 Ibid.

16 Devrim, op. cit., pp. 43–4.

17 Ibid., p. 49.

18 Ibid., p. 44.

19 Ibid., p. 67.

20 Ibid.

21 Ibid., pp. 45, 68.

22 Ibid., pp. 78–9.

23 Falconetti would achieve iconic status among cinephiles for her tortured 1928 performance in Carl Theodor Dreyer's silent film *The Passion of Joan of Arc*.

24 Devrim, op. cit., p. 67.

25 Diary, 5 September 1926, p. 2.

26 Diary, 7 September 1926, p. 3.

27 Diary, 5 September 1926, p. 1.

28 Diary, 15 September 1926.

29 Diary, 10 November 1928.

30 Ibid.

31 Sophie de Juvigny and Alexandra Charvier (eds), *Montparnasse Années 30: Éclosions à l'Académie Ranson – Bissière, Le Moal, Manessier, Etienne-Martin, Stahly* (Gand: Snoeck, 2010), p. 5.

32 Devrim, op. cit., p. 71.

33 Press conference, 1984.

34 Quoted in André Parinaud, 'Présentation', in Shoman and Abu Hamdan (eds), op. cit., pp. 28, 37 (in French, my translation).

35 Ibid., p. 37.

36 Press conference, 1984.

37 Quoted in Parinaud, op. cit., p. 37 (in French, my translation).

38 Katharina Elisabeth Russell, 'Prinzessin Fahr-el-Nissa Zeid – Malerin der moslemischen Welt', *Die Zeit*, 1961.

Chapter II

1 Devrim, op. cit., pp. 179, 182.

2 Ibid., p. 80.

3 Olivier Lorquin, personal interview with the author, 7 December 2016.

4 Devrim, op. cit., p. 111.

5 Diary, 28 September 1943.

6 Diary, 11 April 1948.

7 Diary, 21 July 1928.

8 Devrim, op. cit., pp. 56, 82.

9 T. E. Lawrence, *Seven Pillars of Wisdom* (Radford, VA: Wilder Publications, 2011), pp. 32, 62.

10 Devrim, op. cit., p. 80.

11 Ibid., p. 92.

12 Ibid., p. 93.

13 Diary, 11 February and 30 April 1937.

14 Devrim, op. cit., p. 108.

15 Ibid., p. 92.

16 'Princess from the East', *Prager Montagsblatt*, No. 33, 16 Aug 1937 (English translation of German original). FZA.

17 Devrim, op. cit., p. 101.

18 Diary, October 1936, various entries.

19 Quoted in André Parinaud, 'Présentation', in Shoman and Abu Hamdan (eds), op. cit., p. 39 (in French, my translation).

20 Quoted in 'Fahrelnissa Zeid', 1969, undated and unattributed fragment of French-language magazine feature (in French, my translation). FZA.

21 Devrim, op. cit., p. 105.

22 Ibid., p. 109.

23 Ibid., p. 115.

24 Ibid., p. 126.

25 Ibid., pp. 120–1.

26 Ibid., pp. 124–5.

27 Diary, 1 January 1939.

28 She had a few episodes of suffering from what she called 'neurasthenia' and suicidal angst in the autumn of 1936 and in the following spring, but these appear to be short-lived.

29 Diary, 27 April 1937.

30 Devrim, op. cit., p. 130.

31 Devrim, op. cit., pp. 73, 75.

32 Imam Hussein (AD 626–80) was a grandson of Prophet Muhammad. His shrine stands near the place where he was martyred. Karbala is a major Shia Muslim pilgrimage destination.

33 Devrim, op. cit., pp. 131, 133–4.
34 Attending sanatoriums and water spas was still a relatively common activity in the first half of the twentieth century, a remnant of pre-antibiotics medicine when a stay at a mountain resort or thermal spa with cleaner environments than cities was a common prescription for physical and psychosomatic illnesses. Fahrelnissa had originally stayed at spa for a slimming cure following the birth of Prince Raad.
35 Diary, 5 May 1940.
36 Diary, 21 June and 21 August 1940.
37 Diary, 9 and 13 June 1940, recopied in 1988 diary.
38 Diary, 10 December 1940.
39 Devrim, op. cit., p. 144.
40 Quoted in 'Fahrelnissa Zeid', 1969, undated and unattributed fragment of French magazine feature (in French, my translation). FZA.
41 One-page undated typewritten letter (in French, my translation). FZA.
42 This date is probably an error. Fahrelnissa herself incorrectly dated these works in the 1984 book devoted to her, perhaps because of her advancing age. The dates given to some of the paintings there contradict evidence from earlier exhibition catalogues and photographs.

Chapter III

1 Devrim, op. cit., p. 147.
2 Ibid., p. 149.
3 Ibid., p. 150.
4 Clifford Endres, 'Edouard Roditi and the Istanbul Avant-Garde', Texas Studies in Literature and Language, Vol. 54, No. 4, Winter 2012, p. 488, n. 3.
5 Duygu Köksal, 'Domesticating the avant-garde in a nationalist era: aesthetic modernism in 1930s Turkey', New Perspectives on Turkey, Vol. 52, May 2015, pp. 40, 49.
6 Ibid., pp. 42–3.
7 Ibid., pp. 50–1.
8 Fikret Adil, 'À propos de l'Exposition du groupe "D"', undated press clipping. FZA.
9 Endres, op. cit., p. 477.
10 Quoted in Édouard Roditi, 'Fahr-el-Nissa Zeid', Dialogues on Art (London: Secker & Warburg, 1960) p. 196.
11 Shaw, op. cit., p. 20.
12 Ibid., pp. 22–3.
13 Roditi, op. cit., p. 196.
14 Devrim, op. cit., p. 163.
15 Derek Patmore, 'Preface', Modern Turkish Painting, 1957, pp. 2, 3.
16 G. M. Butcher, 'Turkey comes to London', Art News and Review, undated press clipping. FZA.
17 Quoted in Sonia Nigolian,

'Rencontres à Paris: la princesse Fahr-El Nissa-Zeid', Revue du Liban, No. 695, 22 April 1972.
18 This entry takes the form of a seven-page diary entry written at 3am of 22 August 1940, without attribution or citation. However, I was able to trace the passages to Blanc's book. His treatise was taught from 1872 in French high schools, where artists like Georges Seurat read it. The manual celebrated idealism and classicism. Its aim was to propose a universal grammar of beauty in art, via explaining rules of proportions and of colours' interactions in painting, drawing, sculpture, architecture, etc. Blanc privileged the expressive vocation of art as an expression of the human spirit rather than the imitative.
19 Diary, 22 August 1940 (2:45am).
20 Devrim, op. cit., pp. 150–1.
21 Diary, 15 and 23 July and 8 August 1942; 28 September and December 1943; and 1 June 1946.
22 Ibid., August 1942.
23 Devrim, op. cit., p. 161.
24 Ibid., p. 154.
25 Diary, 26, 27, and 28 February; 7 and 20 June; and 25 October 1944.
26 Such as high blood pressure and diabetes.
27 Devrim, op. cit., pp. 131–2, 140, 143, 177.
28 Press conference, 1984.
29 Quoted in 'Nouvelles mondiales: Turquie', Réalité Magazine, No. 153, May 1945, p. 25.
30 Fahrelnissa Zeid, draft of letter to Maurice Collis, 14 February 1948. FZA.
31 Fahrelnissa Zeid, draft of letter to Louis le Brocquy, 1949. FZA.
32 Ibid.
33 Devrim, op. cit., pp. 91, 96.
34 Ibid., p. 183.
35 Ibid., p. 167.
36 Quoted in 'Nouvelles mondiales: Turquie', Réalité Magazine, No. 153, May 1945, p. 25.
37 Quoted in Roditi, op. cit., pp. 193, 194.
38 Devrim, op. cit., pp. 161–2.
39 Fahrelnissa Zeid, handwritten note on the back of a 1945 photograph (in French, my translation). FZA.
40 Quoted in Nigolian, op. cit.
41 Asaf Halet Celebi, Lâmelif (Istanbul, 1945).
42 These works are Bergama Festival; Three Ways of Living (War); Third Class Passengers, all from 1943; and Three Moments in a Day and a Life from 1944.
43 Paul Tabori, 'Princesse et Peintre', Images, 13 January 1946, Cairo (in French).
44 J. O., 'Deux manifestations artistiques: I. – Au Halkevi de

Beyoğlu; II. – Chez Fah-runissa Zeid', 18 April 1945 (in French). FZA.
45 R. A. 'L'exposition de Fahrunissa Zeid', 25 April 1945 (in French). FZA.
46 V. Mumtaz, 'La vie artistique à Istanbul : L'exposition de la Princesse Fahrunisa Zeid', La République, 15 May 1946 (in French).
47 Fikret Adil, 'Fahrünnusa Zeid'in resim sergisi münasebetiyle' [On the occasion of FZ painting exhibition], Halki Sesi, 24 May 1945 (in Turkish, translated).
48 Jean Guichard-Meili, Temps Présent, 6 December 1946. Quoted in Devrim, op. cit., p. 167.
49 There was also another painting in a similar Symbolist-Surrealist vein: the saturated-with-despair Three Moments in a Day and a Life of 1944.
50 Devrim, op. cit., p. 164.
51 Fahrelnissa Zeid, draft of letter to Maurice Collis, 14 February 1948. FZA.
52 Diary, November 1946.

Chapter IV

1 Quoted in Roditi, op. cit., p. 196.
2 Anonymous, 'Roses', Evening Standard, 18 July 1956.
3 Maurice Collis, 'Topolski, Korda, Astor and the Princess Zeid', The Journey Up: Reminiscences, 1934–68 (London: Faber & Faber, 1970), p. 106.
4 Diary, 27 February 1948.
5 Devrim, op. cit., p. 175.
6 Collis, op. cit., pp. 102–5.
7 The Diplomatist, Vol. III, No. 5, May 1949.
8 'Middle East pictures', Daily Telegraph, 19 May 1950.
9 King Faisal II, letter to Fahrelnissa Zeid, 8 August 1954. FZA.
10 Mahmud Sabri, letters to Fahrelnissa Zeid, 15 April 1957, 10 May 1957, 14 May 1957. FZA.
11 Jamil Hamoudi, 'Al-ameerah al-iraqiyya fakhr-al-nissa' Zeid ta'ridh fannaha fy Paris' [Iraqi princess Fahrelnissa Zeid exhibits her art in Paris], Al-adeeb, Vol. XVII, No. 3, March 1950, pp. 9–12. I am grateful to Dr Amin Alsaden for allowing me to share this article, which he unearthed in the course of his academic research into the history of Iraqi modernism.
12 Devrim, op. cit., p. 167.
13 Collis, op. cit., p. 101.
14 Judith H. Dobrzynski, 'The zealous collector: a special report – a singular passion for amassing art, one way or the other', New York Times, 12 December 1997.
15 Lea Jaray, letter to HRH Princess Fahrunnissa Zeid el Hussein, 9 March 1948. FZA.

16 Maurice Collis, 'Chagall, Fahrunnissa Zeid, Fred Mayor and others', *Time & Tide*, 4 February 1948.

17 Only the visitors' book of the exhibition exists in the Fahrelnissa Zeid archive.

18 'Nejad Devrim to lead Sotheby's London sale of contemporary Turkish art this April' <http://artdaily.com/news/54155/Nejad-Devrim-to-lead-Sothebys-London-sale-of-Contemporary-Turkish-art-this-April#.WROVhVPysUE> (accessed 2 January 2017).

19 Devrim, op. cit., p. 183.

20 Kim Levin, '"Alexander the Great: The Iolas Gallery 1955–1987" at Paul Kasmin', 30 July 2014 <http://www.artnews.com/2014/07/30/alexander-the-great-the-iolas-gallery-1955-1987/> (accessed 2 January 2017).

21 André Maurois, 'The Oriental painter Fahr-El Nissa-Zeid' (New York: Hugo Gallery, 1950).

22 Alexander Iolas, letter to SAR La Princesse Zeid, 15 May 1950 (in French, my translation). FZA.

23 Serge Guilbaut, *How New York Stole the Idea of Modern Art* (Chicago: University of Chicago Press, 1985), p. 185.

24 Ibid., pp. 197, 204.

25 *Towards a Sky* (1953) was for three decades in the corporate collection of Michigan-based Steelcase Inc. The work was then sold by Sotheby's in London in April 2017 for £992,750.

26 Even if there are no surviving available images for that exhibition, the catalogue mentions that Loch Lomond was exhibited, a semi-abstract work already shown at Gimpel Fils in 1948. The only known work listed in the Galerie Colette Allendy exhibition catalogue is an abstract work. The texts in the catalogue and subsequent reviews also appear to denote that all the works shown were indeed abstracts.

27 Shoman and Abu Hamdan (eds), op. cit.

28 Necmi Sönmez, 'Nejad Devrim', op. cit.

29 <http://www.roger-bissiere.fr> (accessed 2 January 2017).

30 The Bedouin women were a common sight at dawn in Iraq in the spring and summer seasons. They were women from the countryside called ma'eediyyats, who sell fresh homemade gaimar, a clotted cream made from water buffalo milk. This was a popular breakfast staple in Iraq. As in Fahrelnissa's paintings, they carry the cream with its measuring and serving pots inside closed round metal containers or palm baskets, piled on their heads like a column.

31 Prince Raad, personal interview with the author, 10 October 2016.

32 Quoted in Shoman and Abu Hamdan (eds), op. cit., p.38.

33 Handwritten note by Fahrelnissa Zeid on p. 70 of Hind Nasser's copy of Shoman and Abu Hamdan (eds), op. cit. (in French, my translation).

34 Handwritten note by Fahrelnissa Zeid on pp. 72–3 of Hind Nasser's copy of Shoman and Abu Hamdan (eds), op. cit. (in French, my translation).

35 Quoted in Shoman and Abu Hamdan (eds), op. cit., p.38.

36 Press conference, 1984.

37 This 1912 book is one of the most important documents in the history of modern art. In it, Wassily Kandinsky (1866–1944) explained his theory of painting, and of art as the expression of the spiritual atmosphere of a given period in the history of humanity. The book was retranslated and republished in French in 1949, and again in 1951 with an afterword by Charles Estienne. In December 1949, Fahrelnissa met Estienne for the first time and he introduced her to, among others, Kandinsky's widow Nina, who managed his estate and became a friend of Fahrelnissa's. The text must have come to the attention of Fahrelnissa after 1951.

38 Diary, 2 December 1949. This text appears as a twelve-page handwritten diary entry. Either it was a preparation for an upcoming radio interview or an a posteriori account of the interview.

39 'Complete ICA Exhibitions List 1948', <https://www.ica.art/sites/default/files/downloads/ICA%20Exhibitions%20List%201948%20-%20Present.pdf> (accessed 2 March 2017).

40 Roland Penrose, 'Opening of the exhibition of paintings of HRH Princess Fahr-el-Nissa Zeid by Mr Roland Penrose, Chairman of the Institute of Contemporary Arts at the Institute of Contemporary Art', ICA Press Release, 8 July 1954. FZA.

41 'Princess's Pictures', *Manchester Guardian*, 13 July 1954.

42 Terence Mullaly, 'The princess paints', *Art News and Review*, Vol. VI, No. 13, 24 July 1954.

43 'Philip Granville (biographical details)', < http://www.britishmuseum.org/research/search_the_collection_database/term_details.aspx?bioId=39452> (accessed 2 January 2017).

44 Philip Granville, letter to Fahr-el-Nissa, 19 July 1955. FZA. (in French, my translation).

45 Philip Granville, 'Inaugural exhibition of paintings, coloured Indian inks, painted stones by Fahr-El-Nissa', exhibition brochure, Lord's Gallery, June 1957. FZA.

46 Terence Mullaly, 'Five outstanding paintings: Lord's Gallery Exhibition', *Daily Telegraph and Morning Post*, 24 March 1958. FZA.

47 George Butcher, 'Fahr-El-Nissa', *Middle East Forum*, December 1957, pp. 19–20.

48 Diary, 4 September 1983. FZA. This diary entry is a ten-page draft of a letter that Fahrelnissa sent or was planning to send to the well-known cognitive scientist Douglas Hofstader after she read an article entitled 'Exploring the labyrinth of the mind' in the *Herald Tribune* that mentioned her work with artificial intelligence.

49 The work she was working on was an abstract canvas measuring 240 × 220 cm. Fahrelnissa included a sketch of it with the diary entry, but it is not possible to identify it. She later said that the text – which she reprinted in part in the catalogue for her 1969 exhibition at the Katia Granoff Gallery, Paris – was about her *Alice in Wonderland* painting, which she painted in 1955 for the group exhibition of the same name. Its measurements are similar to this one: 237 × 211 cm. However, she signed and dated this text by her hand in 1956.

50 Diary, 24 January 1956. Fahrelnissa was so pleased with this text that she would rewrite a shortened version and reproduce it in her 1969 exhibition Katia Granoff Gallery catalogue.

Chapter V

1 Sönmez, op. cit.

2 Devrim, op. cit., p. 169.

3 Alice B. Toklas, letter to Princess Zeid, 16 March 1948. FZA.

4 Fahrelnissa was friends with Breton and corresponded with him. One of her painted stones figures was in his famous 'Wall'. Fahrelnissa always insisted that she was not a Surrealist as her vision was larger and universal. Surrealism at any rate dispels illusions of transcendence via knowing desublimation of the hidden and the occluded, while Fahrelnissa lived fully in a transcendent emotional and psychic universe when she painted. Still, Breton praised her work, notably her *The Reverse* (1964), which was painted on the reverse side of the

canvas. He also included images of her stones in the first issue of his magazine Le Surrealism, même.

5 Julien Alvard and R. V. Gindertael, *Témoignages pour l'Art Abstrait* (Paris: Éditions d'Art d'Aujourd'hui, 1952).

6 Hans Hartung, Wols, Francis Picabia, François Stahly, Georges Mathieu, Michel Tapié, and Camille Bryen.

7 'Galerie Colette Allendy', <http://www.imec-archives.com/fonds/galerie-colette-allendy/> (accessed 2 January 2017).

8 'Fahr-El-Nissa Zeid', *Fahr-El-Nissa Zeid* (Paris: Galerie Colette Allendy, 1949) (in French, my translation).

9 See, for example, *Art News and Review*, Vol. VI, No. 14, 7 August 1954.

10 Dora Ouvaliev, 'Triumph of abstract art', *Art News and Review*, 1949.

11 Hamoudi, op. cit., pp. 9–10.

12 Quoted in Roditi, op. cit., p. 196.

13 Press conference, 1984.

14 René Barotte, 'La princesse Fahrelnissa Zeid, peintre des Mille et Une Nuits', unknown publication, 21 October 1969.

15 Natalie Adamson, *Painting, Politics and the Struggle for the École de Paris, 1944–1964* (London: Routledge, 2009), p. 17.

16 Adamson, op. cit., pp. 20–1.

17 Domitille d'Orgeval, 'Le Salon des Réalités nouvelles: pour et contre l'art concret', <http://www.folmer.net/wp-content/uploads/2012/01/salondesrealitesnouvelles.pdf> (accessed 2 January 2017).

18 'L'Aventure de l'art abstrait: Charles Estienne, critique d'art des années 50', <https://www.musee-brest.com/les-services/publics/expositions-temporaires/> (accessed 2 January 2017), p. 7.

19 Alvard and Gindertael, op. cit. (1951) and Roditi, op. cit. (1959).

20 Suha Shoman, personal interview with the author, 11 October 2016.

21 'L'Aventure de l'art abstrait', op. cit., p. 20.

22 Ibid., p. 4.

23 Nathalie Reymond, 'Charles Estienne, critique d'Art', in Pierre Charreton (ed.), *Travaux XIV: Geste, Image, Parole* (St Etienne: CIEREC-université de St Etienne, 1976), p. 40.

24 Ibid., p. 47.

25 Charles Estienne, *Midi Nocturne* (Paris: Editions de Beaune, 1951) (in French, my translation).

26 Julien Alvard, 'Fahr El Nissa Zeid', *Art d'Aujourd'hui* (Paris: Galerie de Beaune, 1951).

27 Other artists in that salon were Hilla Rebay, Man Ray, Ellsworth Kelly, Serge Poliakoff, as well as the Lebanese abstract sculptor Saloua Raouda, Nejad, and Fikret Mualla, who had returned to live in

Paris. Also showing, most probably thanks to her help, were her niece the ceramicist Fureya Koral and Iraqi artist Jamil Hamoudi.

28 Estienne organized the artists he included in his vision of the NEDP in two groups, shown successively. The first one on 15 January included: Bazaine, Berçot, Deyrolle, Estève, Hartung, Hilaireau, Lanskoy, Lapicque, Le Moal, Manessier, Mortensen, Piaubert, Pignon, Poliakoff, Marie Raymond, Schneider, Singier, Soulages, de Staël, Tal-Coat, Ubac, Vasarély, and Vieira da Silva. Fahrelnissa was included with Nejad in the second group of 12 February: Arnal, Atlan, Calmettes, Chapoval, Denise Chesnay, Degottex, Cicero Dias, Dmitrienko, Duvillier, Roberta Gonzalez, Lapoujade, Loubchansky, Messagier, Pichette, Pons, Quentin, and Rezvani.

29 Laurence Bertrand-Dorléac, 'De la France aux Magiciens de la terre: Les artistes étrangers à Paris depuis 1945', in Antoine Marès and Pierre Milza (eds), *Le Paris des étrangers depuis 1945* (Paris: Publications de la Sorbonne, 1994), p. 414.

30 Charles Estienne, 'Peintres de la Nouvelle école de Paris', *Galerie de Babylone*, 12 February 1952 (in French, my translation). FZA.

31 Adamson, op. cit., p. 189.

32 Adamson, op. cit., pp. 192–4.

33 Charles Estienne, 'Du 10 au 23 Avril 53 Vernissage: Vendredi 10 Avril à 17h.', Galerie Craven (in French, my translation). FZA.

34 Also exhibiting that year were Rebay, Vasarely, Fernand Léger, Nejad, and Turkish artist Orhon Mübin.

35 Fahrelnissa may also have exhibited at the SDRN twice more, in 1952 and 1954, but no records were accessible. However, images of her paintings were included in a publication issued by the Salon from 1951 to 1954, the *Cahiers du Salon des Réalités Nouvelles*, which were separate from the SDRN's exhibitions catalogues. I am grateful to Dr Domitille d'Orgeval-Azzi for this discovery, and for generously providing me with this information and iconography.

36 Vierny was the model for Maillol's statues of the seasons and the elements exhibited at the Tuileries Garden in Paris, as well as at the Metropolitan Opera in New York, at the J. Paul Getty Museum, etc. She was also the founder of the Maillol Museum in Paris.

37 Olivier Lorquin, email to author, 6 February 2017.

38 Fahrelnissa always sold some paintings at her exhibitions, from her very first Istanbul show, but Dina Vierny also managed to have the French state purchase one of her paintings, a major achievement for the artist. The work was a small work entitled *Composition* and was sold for 45,000 francs. Reference: [illegible signature], Le Chef du Bureau des Travaux d'Art, Ministère de l'Education Nationale, letter to Madame Fahr El Nissa Zeid, 13 December 1955 (in French, my translation). FZA.

39 *Far-el-Nissa Zeid* (Paris: Dina Vierny, 1953), p. 32.

40 Ibid., p. 30.

41 'Un peintre des Mille et une Nuits', *Paris-Presse*, 29 December 1953.

42 M. G., 'Das Profil', *Die Weltwoche*, 14 March 1952; and 'Eine Iranische Künstlerin', *Berner Tagblatt*, 12 March 1952.

43 'À la galerie aujourd'hui: Fakhr-El-Nissa-Zeid expose ses œuvres du 10 au 28 novembre', *Les Beaux-Arts*, undated clipping, p. 16 (in French, my translation). FZA.

44 Laurence Bertrand-Dorléac, op. cit., p. 419.

45 René Huyghe, 'La querelle de l'art figuratif', *Art et style*, No. 2, June 1945.

46 Adamson, op. cit., p. 101.

47 The notion of abstract landscape predates Estienne. Exhibitions were held under this orientation during the occupation in Paris as a form of resistance. The idea was that abstraction is linked to nature because it represents the union of man with the world.

48 Nathalie Reymond, op. cit., p. 47.

49 Adamson, op. cit., p. 196.

50 Adamson, op. cit., pp. 198–9.

51 Charles Estienne, 'Le Lièvre de Mars', *Alice vous invite … In Wonderland* (Paris: Galerie Kléber, 1955). FZA.

52 Michel Ragon, 'Poliakoff, Pichette, Far-El-Nissa Zeid', *Cimaise*, December 1955 (in French, my translation).

53 Jacques Busse, 'Prédominance de l'abstraction au XX siècle', <http://www.realitesnouvelles.org/pdf/predominance_abstraction.pdf> (accessed 2 January 2017).

54 D'Orgeval, op. cit., p. 21.

55 Parinaud, op. cit., pp. 21–43.

56 She would often pay advertising street posters to be made and posted for her individual exhibitions in Paris, as well as for her London ICA show.

57 Philip Granville, 'Letter to Fahr-el-Nissa, 19 July 1955 (in French, my translation). FZA.

58 Suha Shoman, personal interview with the author, 11 October 2016. Serge Poliakoff had famously invited the press to photograph him next to his newly acquired Rolls-Royce in 1958.

59 Theodor Adorno, *Minima Moralia* (NY and London: Verso, 2005), p. 21.

60 I estimate that *Break of the Atom* was made in the early 1950s because by 1962 Fahrelnissa had already moved well beyond her kaleidoscopic vortexes. It is inexplicable that she would have returned to it for one giant work.

61 George Butcher, 'Fahr-El-Nissa', *Middle East Forum*, December 1957, p. 21.

62 Wassily Kandinsky, *Concerning the Spiritual in Art* (Toronto: Dover Publications, 1977), p. 31.

63 Ibid., p. 52.

64 The painting's inspiration was an incident that occurred when Fahrelnissa was travelling by car through Basel to go to Zurich for her exhibition in March 1952, when three young men emerged from the celebration for the carnival and sprayed her with confetti.

65 Diary, 17 February 1952.

66 Diary, 28 September 1943.

67 Maurice Collis, 'Fakhr-El-Nissa Zeid at the Beaux-Arts, Brussels', *Art News and Review*, undated clipping, pp. 2, 5.

68 Roditi, op. cit., p. 190.

69 Diary, 15 February 1959.

70 Robert Rosenblum, 'The Abstract Sublime' (1961), <http://www.artnews.com/2015/03/27/beyond-the-infinite-robert-rosenblum-on-sublime-contemporary-art-in-1961/> (accessed 2 January 2017).

71 Quoted in Julien Alvard and R. V. Gindertael, op. cit., p. 278.

72 Quoted in Roditi, op. cit., pp. 196–7.

73 Wassily Kandinsky, op. cit., pp. 12–13.

74 Ibid., p. 14.

75 Quoted in Roditi, op. cit., p. 193.

76 Diary, undated 1960 entry.

Chapter VI

1 Devrim, op. cit., p. 205.

2 Ibid., pp. 198, 204.

3 Ibid. p. 210.

4 Diary, 13 February 1959.

5 Devrim, op. cit., p. 210.

6 Press conference, 1984.

7 Quoted in Roditi, op. cit., p. 190.

8 In her family biography, Shirin Devrim writes of finding a similar text, dated 14 February and written in English, a language Fahrelnissa that used in her diaries only in the 1980s in Jordan. However, the French text written on 11 February may have been the transcription of a

spur-of-the-moment feeling, which she then translated into English in her diary, most likely as a draft for a letter she wrote to an English friend, as she was wont to do.

9 Diary, 11–15 February 1959.

10 Devrim, op. cit., p. 201.

11 Ibid., pp. 202, 215.

12 Ibid., p. 15.

13 Diary, 11–15 February 1959.

14 Fahrelnissa dated these works to 1958 in the 1984 book about her.

15 Devrim, op. cit., p. 215.

16 There is a confusion in a few of the exhibition catalogues about a solo exhibition at Galerie d'Aujourd'Hui in Brussels. Fahrelnissa sometimes dated it to November 1956 and at other times, to November 1959. There is an invitation card for the former date. The latter is induced by a review in a Belgian publication by R. V. Gindertael. In all probability, there was only one exhibition in 1956, and the 1959 review may be just a reprint.

17 Dina Vierny, letter to Fahr-el-Nissa, 1961. FZA. French.

18 Charles Estienne, 'Portrait du peintre', *Fahr-El-Nissa Zeid* (Paris: Dina Vierny, 1961).

19 'L'Aventure de l'art abstrait', op. cit., p. 9.

20 Parinaud, op. cit., p. 27.

21 Michel Courtois, *Arts*, May 1961.

22 Fahrelnissa Zeid, 1980s undated red notebook (in French, my translation). FZA.

23 A *tombeau* is a seventeenth-century type of French musical composition commemorating the death of a notable person. They are characterized by a slow and meditative rhythm.

Chapter VII

1 Diary, 14 Jul 1969.

2 Devrim, op. cit., p. 216.

3 Ibid., pp. 218–19.

4 Ibid., p. 219.

5 Mustafa Bülent Ecevit's mother was the painter Fatma Nazli Ecevit, a contemporary of Fahrelnissa who followed her by a few years at the art academy. He would serve four times as prime minister of Turkey from 1974 to 2002.

6 Quoted on a unnumbered page of *Fahrüniza Zeid: 1951–1961 Retrospektif Sergi* (Istanbul: Güzel Sanatlar Akademisi and Hitit Müzesi, 1964).

7 Claude Bonnefoy, 'La princesse Fahr-El-Nissa-Zeid', unknown publication, No. 962, 15 May 1964, p. 14 (in French, my translation). FZA.

8 Nurullah Berk, 'Fahrünnisa Zeyid', *Cumhuriyet*, 6 June 1964 (in Turkish, translated by Janset Shami).

9 Zeynep Yasa Yaman, 'An artist and an explorer beyond ideologies in a globalized world', *The Centenary of Fahrelnissa Zeid* (Amman: Darat al Funun-Khalil Shoman Foundation, 2001), p. 12.

10 Press conference, 1984.

11 At her 1969 exhibition opening, Fahrelnissa claimed she was applying the ideas of Pierre Restany, the founder of the Nouveau Réalisme movement in her new show. See Goksin Sipahioglu, 'Prenses Fahrunnisa Zeyd'In Actigi Sergi Buyuk Ilgi Topladi', undated press clipping (in Turkish). FZA.

12 Abdullah Salah, Jordanian ambassador, letter to HRH Fahrelnissa, 22 November 1965. FZA.

13 Charles-Louis Foulon, 'Des beaux-arts aux affaires culturelles (1959–1969)', *Vingtième Siècle, Revue d'histoire*, Vol. 28., No. 1, p. 30.

14 Fahrelnissa Zeid, copy of letter to Jean Jacques Jaujard, 17 June 1966 (in French, my translation). FZA.

15 It appears that she was also on friendly terms with his partner, the writer Louise de Vilmorin, who dedicated a copy of her novel *Madame de* to Fahrelnissa with the words: 'To the Princess Zeid with all my love and my admiration.' From Fahrelnissa's private library, conserved at Darat al Funun, Amman, Jordan.

16 Devrim, op. cit., p. 220.

17 'Fahrelnissa Zeid: À Paris 1949–1975', documentary.

18 This a reference to Malraux's 1967 autobiography *Antimémoires*: 'Les antisculptures de Malraux', *Le Nouveau Candide*, October 1967, No. 339.

19 Press conference, 1984.

20 Issam El-Said later became a researcher in the aesthetics of Islamic art and geometry, a published author, and a recognized multimedia artist.

21 Press conference, 1984.

22 'Fahrelnissa Zeid: À Paris 1949–1975' documentary.

23 René Barotte, untitled press clipping from an unknown publication, 1969 (in French, my translation). FZA.

24 Philippe Piguet, 'Katia Granoff (1895–1989)', Encyclopædia Universalis, <www.universalis.fr/encyclopedie/katia-granoff/> (accessed 15 February 2017).

25 The catalogue references this as excerpted from a 21 November 1955 letter from Breton to Fahrelnissa written in Lorient, his Brittany home (in French, my translation). The Breton website, however, dates it from his visit to her 1953 exhibition: <www.andrebreton.fr/work/56600100333290>

26 Anne-Marie Cazalis, 'Par-ci, par-là

avec Cazalis: Les peintures de la tante du roi Hussein – La carte de la chartreuse', *Elle* (in French, my translation), 27 October 1969.

27 'Les os de poulet', *La Galerie des Arts*, 1 October 1969, No. 77, p. 10.
28 Mondher Milad, 'À travers les galeries', *Combat*, 3 November 1969.
29 Bernard Gheerbrant, 'L'odyssée de Fahr el nissa Zeid', *La Galerie des Arts*, 15 September 1969, No. 76, pp. 26–7.
30 Quoted in Julien Alvard and R. V. Gindertael (eds), op. cit., pp. 280–1 (in French, my translation).
31 'Fahrelnissa Zeid: À Paris 1949–1975' documentary.
32 In the 1984 book, this work is wrongly dated to 1954.
33 René Barotte, 'La princesse Fahrelnissa Zeid, peintre des Mille et Une Nuits', clipping from unknown publication, 21 October 1969 (in French, my translation). FZA.

Chapter VIII

1 Devrim, op. cit., pp. 220–1, 224.
2 Diary, 6 December 1970; 13–14 September 1971; 6 March 1972.
3 Fahrelnissa Zeid, draft of letter to Raymond, 28 October 1972. FZA.
4 Fahrelnissa Zeid, draft of letter to Wicdan, 8 August 1972. FZA.
5 Diary, 14 February 1959.
6 Sonia Nigolian, 'Rencontres à Paris … la princesse Fahr-El Nissa-Zeid', *Revue du Liban*, No. 695, 22 April 1972.
7 Fahrelnissa Zeid, draft of letter to Wicdan.
8 Devrim, op. cit., p. 225.
9 Diary, 15 February 1959.
10 Fahrelnissa Zeid, copy of letter to Jean-Jacques Jaujard, 17 June 1966 (in French, my translation). FZA.
11 Quoted in *The Centenary of Fahrelnissa Zeid* (Amman: Darat al Funun, 2001), p. 27.
12 Quoted in André Parinaud, 'Le goût du portrait', *La Galerie*, April 1972, No. 115, p. 72 (in French, my translation).
13 Ibid.
14 Fahrelnissa Zeid, 'Comment mes portraits prennent naissance', 1972. Undated two-page handwritten note (in French, my translation). FZA.
15 Devrim, op. cit., pp. 231–3.
16 Fahrelnissa later donated Estienne's portrait to the Musée d'Art Moderne de la Ville de Paris.
17 Guillaume Apollinaire, *Oeuvres Poétiques Complètes* (Paris: Gallimard, 1956), p. 553 (in French, my translation).
18 Fahrelnissa Zeid, *Fahrelnissa Zeid: Portraits et peintures abstraites* (Paris: Katia Granoff, 1972) (in French, my translation).

19 René Barotte, 'Fahrelnissa Zeid: Le peintre qui va au-delà des êtres et des choses', *Fahrelnissa Zeid: Portraits et peintures abstraites* (Paris: Katia Granoff, 1972) (in French, my translation).
20 André Parinaud, 'Fahrel-Nissa: le soleil du cœur', *La Galerie*, No. 117, June 1972 (in French, my translation).
21 Fahrelnissa's sketches of the period show her recopying El Greco and Modigliani paintings in detail.
22 Jeanine Warnod, 'Mercredi … rive droite : Place Beauvau – Fahrelnissa Zeid', *Le Figaro*, 14 June 1972 (in French, my translation).
23 Bernard Gauthron, 'Fahrelnissa Zeid', *La Revue moderne des arts et de la vie*, July 1972, p. 22 (in French, my translation).
24 Parinaud, 'Fahrel-Nissa: le soleil du cœur', op. cit.

Chapter IX

1 Devrim, op. cit., p. 235.
2 Fahrelnissa Zeid, 'Letter to visitors', 18 November 1976. FZA.
3 Edward Said, *On Late Style: Music and Literature Against the Grain* (New York: Vintage, 2007), p. 6.
4 Said saw Adorno's position as above all theoretical: he hailed in Beethoven's last period a constitutive unsynthesized fragmentariness as prototypical of modern music's future intransigent aesthetic form. He may have also seen in it an implicit mirror of his own lifelong contrapuntal and oppositional energy to a number of ideologies and political and economic dispensations.
5 Edward Said, op. cit., pp. 5, 13–14.
6 'Roger Bissière 1886–1964', < http://www.applicat-prazan.com/en/artistes/roger-bissiere/> (accessed 2 January 2017) (in French, my translation).
7 Ruba Assaf, 'Interview with Suha Shoman', *Faces & Places*, Jordan TV, 1993.
8 Fahrelnissa Zeid, *Fahrelnissa Zeid and her Institute* (Amman: Fahrelnissa Zeid Institute of Fine Arts, 1981), p. 23.
9 Hind Nasser, personal interview with the author, 1 October 2016.
10 Suha Shoman, personal interview with the author, 2 October 2016.
11 A singular gift that Fahrelnissa made to Suha Shoman corroborates her fascination with space. She gave her favourite student in 1988 an approximately A4-size sketchbook of fifty-eight pages that she filled, apparently in one sitting, with observations on art, life, and the origin of the universe, but mostly

with a synthesis of a lifetime of readings on her belief in an atemporal life force, pre-existing our current solar system and biological structures, a cosmic energy that may be tapped into via a collective unconscious.
12 Hind Nasser interview.
13 'L'Institut Royal des Beaux-Arts Fahr El Nissa Zeid', in Wolfgang Becker (ed.), *Fahr El Nissa Zeid* (Aachen and Paris: Neue Galerie-Sammlung Ludwig and Institut du Monde Arabe, 1990).
14 Meg Abu Hamdan, 'Stained glass artist teaches unique craft', *Jordan Times*, undated clipping. FZA.
15 Suha Shoman interview.
16 Hind Nasser interview.
17 Janset Berkok Shami went on to write *Fahrelnissa and I: A Memoir*, a biography focused on their friendship and common Turkish culture.
18 Edward Said, op. cit., pp. 23–4.
19 Fahrelnissa said she had met him in late 1920s Paris. She would tell her students in the 1980s of her admiration for his portraits.
20 Fahrelnissa Zeid, *Fahrelnissa Zeid and her Institute* (Amman: Fahrelnissa Zeid Institute of Fine Arts, 1981), p. 20.
21 Ulrich Loock, 'Transitions and Translations', in Sarah Rogers and Eline van der Vlist (eds), *Arab Art Histories* (Amman: Khalid Shoman Foundation, 2013), pp. 316–17.
22 Wolfgang Becker, 'Fahr El Nissa Zeid et l'École de Paris', *Fahr El Nissa Zeid* (Aachen and Paris: Neue Galerie-Sammlung Ludwig and Institut du Monde Arabe, 1990).
23 Edward Said, op. cit., p. 113.
24 Jean-Marie Larieux, 'L'École d'Amman prend son essor', *Arts-Magazine*, undated clipping, p. 35 (in French, my translation). FZA.
25 Fahrelnissa Zeid, 'Letter to visitors'.

Acknowledgments

This book would not have existed without Fahrelnissa Zeid. For three years, I would go to her home on Wednesday afternoons to paint in her studio, show her the sketches I had made the previous week, and generally imbibe her advice, souvenirs, and the dazzling decorative palimpsest of her upstairs salon. I was the only teenager among her regular group of students. I further benefited from her extraordinary indulgence when she included two of my paintings in her seminal 1981 group exhibition. I am indebted to my parents, and especially to my mother Aïcha Lemsine, who gave me this unique opportunity by asking Fahrelnissa to take me on as a student. This book represents the unexpected accomplishment of a project that Fahrelnissa and my mother entertained. After reading her two novels published in Paris in the mid-1970s, Fahrelnissa asked my mother to write her biography. She agreed of course but preferred to write a novelized version. The book did not materialize in the end because her publisher did not deem Fahrelnissa sufficiently famous at the time. In a way, this book fulfils that wish and their friendship.

I am forever indebted to HRH Prince Raad bin Zeid and HRH Princess Majda Raad for welcoming me into their home for weeks of research. They generously entrusted me with unprecedented access to a massive archive of eight decades of trilingual correspondence, personal diaries, sketchbooks, newspaper clippings, and photographs, etc. They also patiently filled in the gaps in my knowledge and gave me insights into important events of Fahrelnissa's life. My thanks go also to HRH Prince Mired bin Raad and to HRH Princess Fakhrelnissa bint Raad, who is successfully walking in her namesake's footsteps.

This book would not have been possible without the generous writing grant awarded to me by the Arab Fund for Arts and Culture, and an Authors' Foundation grant from the London-based Society of Authors. I am also indebted to the hospitality and support of the Khalid Shoman Foundation-

Darat al Funun in Jordan, which generously hosted me while I conducted my research. My thanks go to its entire welcoming team, in particular to its founder Suha Shoman, to the Darat's director Luma Hamdan, and to its resourceful and hard-working archivist and librarian Yanal Janbak.

I am also thankful to Fahrelnissa's students and friends who gave me lengthy interviews. To her protégée, artist Suha Shoman, who has tirelessly promoted her mentor's legacy for decades, in Jordan and around the world. I am also grateful to Sharifa Hind Nasser for her detailed insights, and to Rula Shukairy for her recollections. I also thank Janset Shami for showing me her art works and for offering me a copy of her biography. My gratitude also goes to Olivier Lorquin for his generous availability and good-humoured recollections of the woman he called 'marraine'.

Another daunting task in this enterprise was to constitute a coherent and representative iconography. Fahrelnissa was a prolific artist and her vast output is yet to be fully known. I am thankful to the staff of many institutions who generously helped me track down her works and provided me with high-resolution reproductions. At the Elgiz Museum, Can and Sevda Elgiz, Kimberly Ann Duguluer, and Selin Turam. At the Huma Kabakci Collection, Ms Kabakci and Esra Besiroglu. At the Papko Art Collection, Oner Kocabeyoglu and Zeliha Unal. Darat al Funun artistic director Eline Van der Vlist. Elif Bayoglu at Sotheby's. Dr Joy Beckman, director of the Wright Museum of Art. At IKSV Foundation, director Bige Orer, Ozkan Canguven, and Esra Cankaya. At Istanbul Modern, director Levent Calikoglu and Serkan Terzioglu. At Mathaf, the Arab Museum of Modern Art, director Abdellah Karroum and Lina Ramadan. Samir Chalabi at Alif Art auction house. At National Museums Scotland, Friederike Voigt, senior curator, and Clare Hyatt. Dr Helen Scott, curator at Edinburgh Museums. Sandra Crow at Dovecot Studios. Allison Derrett at the Royal Collection. Rachel Ellison at the Cincinnati Art Museum. Michele M. Wong at the Grey Art Gallery. At the Palais des Beaux-Arts in Brussels, Billiet Tarquin and Veerle Soens. Cédric Angoujart at the Musée des Beaux-Arts de Brest. Sara Logue at the Seeley G. Mudd Manuscript Library. Laurence Le Poupon at the Archives de la Critique d'Art. The staff of the Carnegie Museum of Art, the

Kunst and Kulturarchiv Dusseldorf, the Pera Museum, Stiftung Museum Kunstpalast, and Stiftung Kunstsammlung Nordrhein-Westfalen.

My gratitude also goes to those who provided invaluable support at different stages of my research: my father Ahmed Laïdi; Dr Domitille d'Orgeval, historian of the Salon des Réalités Nouvelles; Yves Chevrefils-Desbiolles, head artistic archivist at the IMEC; Chantal Mathieu and Erik Levesque at the Réalités Nouvelles archive; Dr Sameh Haneyah; Sato Moughalian; Husam Suleymangil; Secil Yilmaz; Dr Samia Touati; Dr Amin Alsaden; Dr Ilhan Ozan; Philip Mansel; Salwa Mikdadi; Maysaloun Faraj; Paula Johnson; Najlaa Elageli; Shurooq Amin; Khalil Joreige; Cathy Khattar; Manal Kanaan; Zaina El-Said.

Writing is a lengthy, arduous, and solitary endeavour. I thank those who supported me with their friendship: Liana Bader, and Fahrelnissa student Ufemia Rizk. My husband Akram for his unwavering support, and our daughter Shams for her loving cheerleading. Last but not least, my editor and publisher Andrew Brown who instantly believed in this challenging project. He had the calm, foresight, skills, and talent to bring it through while making everything appear effortless. Of course, any errors in the text are entirely my responsibility.

In closing, I am grateful for the genius of Fahrelnissa to whom I strove to do justice.

The author acknowledges the generous support of the Arab Fund for Arts and Culture

Picture credits

Courtesy Fahrelnissa Zeid Archive, Amman
6, 66–7, 68, 76, 80, 81, 83, 166, 184, 185, 202, 206–7,
229, 231, 247, 248, 249r, 253, 255, 256

Courtesy the author and Fahrelnissa Zeid Archive, Amman
2, 32, 42, 70l, 71, 74b, 75tl, 92, 95, 98, 99b, 102, 107, 110, 111, 125,
130, 142, 161r, 167, 171, 214, 220, 225, 226, 227l

Ara Güler Doğuş Sanat ve Müzecilik A.Ş.
212, jacket

Christie's, London
148–9, jacket

Huma Kabacki Collection
120

Khalid Shoman Collection, Amman
64, 233, 238, 267, 268, 269

Sharifa Hind Nasser, Amman
261

Sotheby's, London
162, 163

Oner Kocabeyoglu / Papko Art Collection
165, 187, 251

Wright Museum of Art Collection, Beloit College
119 (Laura Aldrich Neese Fund Collection)

The publisher would also like to thank Fatos Ustek for her essential help
in locating the copyright holder of the Ara Güler portrait, and to Çağla Sarac
and Ipek Altay of the Doğuş Group for supplying the image and granting us
permission to use it in this book.

Index

Abdiyah, Princess 94, 195
Abdul Ilah, Prince 195
Adil, Fikret 24, 57, 68–9, 77
Adil, Remide 28, 57
Adorno, Theodor 172, 259
Alia, Princess 261, 265, 269
Alia, Queen 269
Aliya, Queen 52, 94, 131, 177
Allendy, Colette 142, 147
Allori, Cristofano 32–3
Al Said, Nouri 195, 219
Alvard, Julien 156
Amoura, Aziz 262
Atatürk, Mustafa Kemal 11, 18, 30
Auerbach, Erich 18

Bacon, Francis 90, 126, 242
Badia, Princess 195
Barotte, René 155, 241, 246–7
Bazaine, Jean René 153, 217
Berger, Aliye (sister) 15–17, 19, 21, 52–3, 73, 240, 257
Berk, Nurullah 58, 216
Bisharat, Mamdouh 267–9
Bissière, Roger 38, 43, 90, 108, 243, 247, 260, 263
Blanc, Charles 61–2, 179
Bonnard, Pierre 37, 61, 63, 81, 90, 164
Bosch, Hieronymous 80
Braque, Georges 126
Breton, André 141, 152, 170, 222
Brocquy, Louis le 71–2, 96
Brueghel the Elder, Pieter 33, 50, 54–5, 80, 84, 88, 114
Butcher, George 61, 100, 130

Cadoo, Emil 4, 222
Casals, Pablo 52, 272
Cazalis, Anne-Marie 222
César 95–6
Cevat Pasha (uncle) 12–14
Chadwick, Lynn 95
Chagall, Marc 90, 141, 152, 170, 216–17, 220
Chaibia 273
Chevalier, Denys 143, 156
Chirico, Giorgio de 96
Clert, Iris 244, 245
Collis, Maurice 70, 72, 90, 96, 100, 186, 250, 253
Courtois, Michel 200–1

Delaunay, Robert 128, 141
Devrim, Faruk (son) 28

Devrim, Izzet Melih (first husband) 26, 28–30, 33, 37, 46–7, 50
Devrim, Nejad (son) 21, 28, 49, 90, 101, 108, 139–41, 154, 160–1, 167
Devrim, Shirin (daughter) 12, 21, 28, 31, 33, 43, 45–6, 48, 51, 57, 69, 73, 90, 98, 100–1, 146, 198, 214–15, 240, 271
Donatello 34
Dongen, Kees van 39, 266
Dubuffet, Jean 152, 170, 217
Dufy, Raoul 77, 90, 101

Ecevit, Mustafa Bülent 215
Elizabeth, the Queen Mother 95, 98
El-Said, Issam 219–20, 272
Eren, Cemil 216
Erner, Ayshe (sister) 13, 15, 17
Estienne, Charles 140, 144, 147, 153–6, 160–1, 164, 166–71, 177, 200–1, 210, 244, 250, 252, 272
Eyuboglu, Bedri Rahmi 60
Eyuboglu, Eren 60

Faisal I, King 46–7
Faisal II, King 47, 90, 94, 96, 195–6
Ferré, Léo 200
Francastel, Pierre 152
Freund, Gisèle 141, 167

Gaulle, Charles de 216, 218
Gazarossian, Koharik 63
Ghazi, King 52
Gheerbrant, Alain 170
Gheerbrant, Bernard 170, 172, 223
Gogh, Vincent van 62, 179
Granoff, Katia 220, 244, 250, 255
Granville, Philip 96, 128–9, 172, 199
Grousset, René 50

Hamdan, Meg Abu 107, 261
Hammoudi, Ala-Uddin 171
Hamoudi, Jamil 98, 144, 146
Hanim, Hakiye (sister) 15, 17, 19
Hanim, Ismet (mother) 13, 16, 24
Hassan, Prince 239, 252, 254
Hitler, Adolf 48, 50

Hiyam, Princess 195
Hoff, Hans 53, 69–70, 213
Hussein, King 90, 213, 216, 239, 263, 273

Iolas, Alexander 101–6
Ismail, Namik 39–40, 57
Izer, Zeki Faik 58

Jaray, Lea 96, 98, 199
Jaujard, Jacques 217–18, 241
Joumblatt, Jeanette 261, 265
Jung, Carl 8, 63, 269

Kandinsky, Wassily 8, 122, 153–6, 169, 177, 190–2, 223
Klein, Yves 142, 171
Koral, Fureya (niece) 19, 39, 40, 215, 272

Lam, Wifredo 90, 126
Larock, Marc 250
Larock, Rose 244, 250
Lhôte, André 50
Lind, Margaretha (Princess Majda) 213, 257, 261, 265, 269
Lorquin, Olivier 240, 250–1, 271

MacNeice, Louis 96
Mahieddine, Baya 273
Malraux, André 216–19
Manessier, Alfred 154, 217
Mango, Rabab 261, 265
Mary, Queen 95, 98
Matisse, Henri 38, 61, 77, 83, 140, 152, 164
Maurois, André 103, 142–5, 156
Michelangelo 34–5
Moore, Henry 90, 95, 126
Mullaly, Terence 100, 127, 129
Müşfik, Mihri 24

Nabis, Les 37, 91, 153
Nasser, Hind 261, 265, 269
Nefissa, Queen 195

Ouvaliev, Dora 145

Parinaud, André 108–9, 116, 155, 200, 255, 271–2
Parsons, Betty 104–5
Patmore, Derek 61, 130
Penrose, Roland 96, 126–7
Picabia, Francis 38, 61, 91, 126, 141–2, 152, 170, 217

Picasso, Pablo 38, 61, 91, 126, 152, 217
Pichette, James 170
Pieris-Hunt, Varuni 263
Poliakoff, Serge 141, 154, 164, 168, 170, 172, 217
Pollock, Jackson 104, 105
Proust, Marcel 172

Qattan, Nawal 265

Raad bin Zeid, Prince (son) 48–9, 51, 109, 196, 213, 219, 248, 250, 252, 257, 260
Ranson, Paul-Élie 37
Raphael 33–5
Rizk, Leila 265
Rizk, Ufemia 261, 265
Roditi, Édouard 146, 188, 191
Rosenblum, Robert 190
Rouault, Georges 142, 143
Rubens, Peter Paul 35–7, 190

Said, Edward 7, 259
Saroyan, William 215
Schwitters, Kurt 128
Shakir Kabaaghacli, Cevat (brother) 15–17, 21, 257
Shakir Kabaaghacli, Suat (brother) 15, 17, 198
Shakir Pasha (father) 12–13, 15, 16, 21
Shami, Janset 265
Shoman, Khalid 267–8
Shoman, Suha 107, 260–1, 265, 267, 269, 273
Shukairy, Rula 265
Soulages, Pierre 154, 217
Spinoza, Baruch 63, 191
Staël, Nicolas de 141, 153

Toklas, Alice B. 139
Tzara, Tristan 141, 170

Vandercam, Serge 141
Vierny, Dina 164, 199, 240, 271–2
Vuillard, Édouard 37, 63

Zeid, Prince (second husband) 46–8, 50–3, 90–1, 94, 97, 131, 195–9, 213, 216–18, 220, 227, 239–40, 246, 248, 249, 252–5, 273
Zubyan, Alia 261, 265